THE COLOR

OF THE MOON

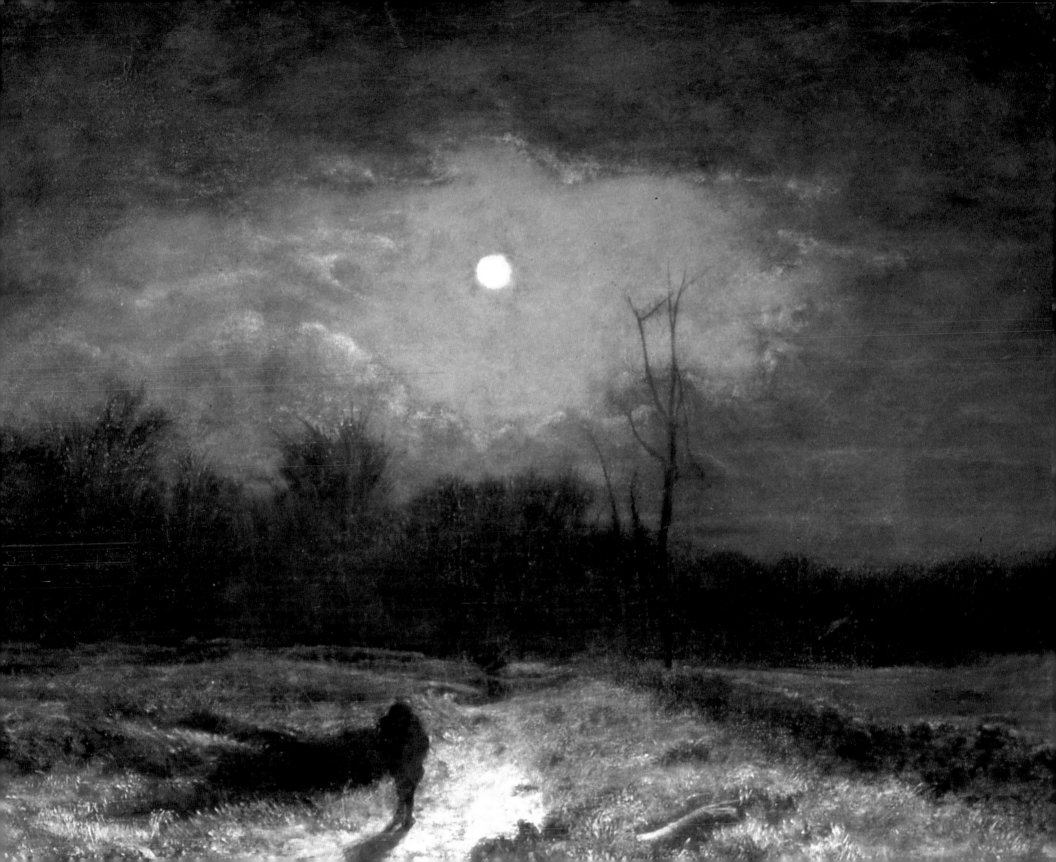

THE COLOR

OF THE MOON

LUNAR PAINTING IN AMERICAN ART

HUDSON RIVER MUSEUM · JAMES A. MICHENER ART MUSEUM · FORDHAM UNIVERSITY PRESS

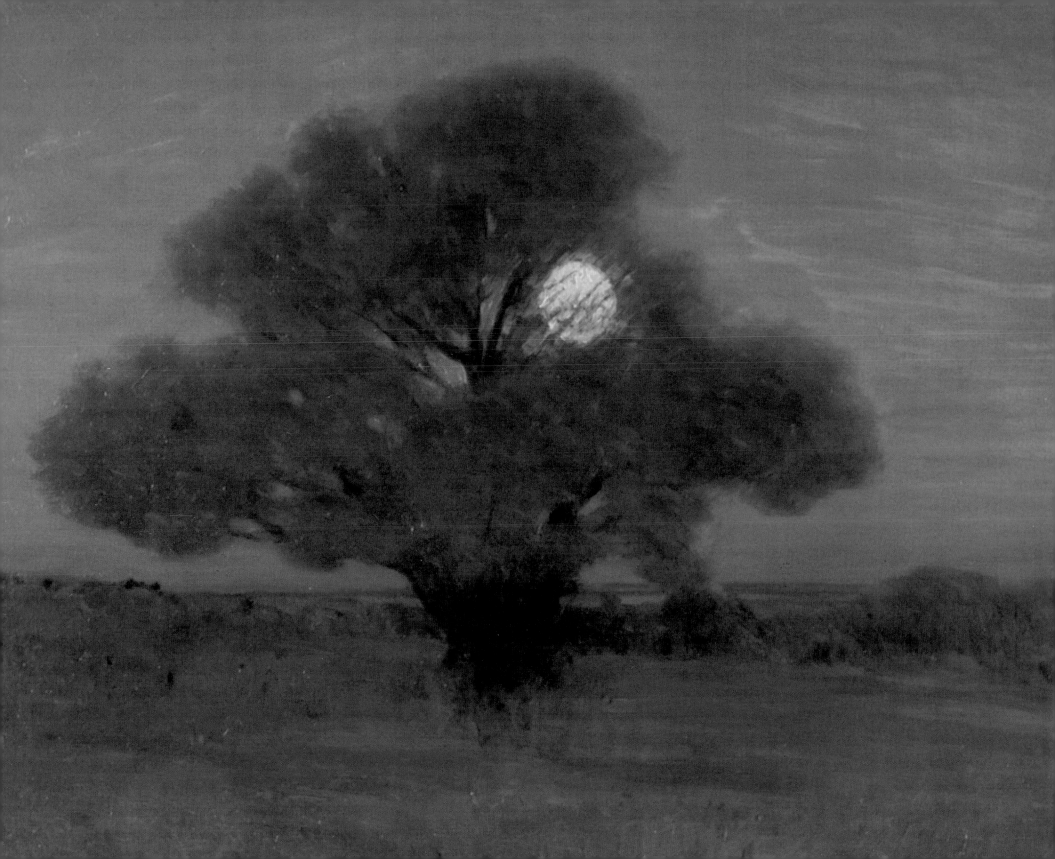

MOONSET

Leaves of poplars pick Japanese prints against the west.
Moon sand on the canal doubles the changing pictures.
The moon's good-by ends pictures.
The west is empty. All else is empty. No moon-talk at all now.
Only dark listening to dark.

Carl Sandburg

This catalog is published in conjunction with **The Color of the Moon: Lunar Painting in American Art**
on view at the Hudson River Museum, Yonkers, New York, from February 8 through May 12, 2019
and the James A. Michener Art Museum, Doylestown, Pennsylvania, from June 1 through September 8, 2019.

The exhibition and catalog have been made possible by the Mr. and Mrs. Raymond J. Horowitz
Foundation for the Arts, Inc.

The Color of the Moon exhibition and catalog are in memory of and with profound gratitude to longtime
Hudson River Museum supporter Marjorie S. Isaac.

Published by the Hudson River Museum, James A. Michener Art Museum, and Fordham University Press.

The Color of the Moon is part of the Hudson River Museum's exhibition series *The Visitor in the Landscape*,
which explores the intersection of people and the natural world.

Editors Laura Vookles and Bartholomew F. Bland
Publication Manager Linda Locke
Design Natasha Mileshina

Cover: Oscar Florianus Bluemner, **Moon Radiance**, 1927. Karen and Kevin Kennedy collection
Frontispiece: George Inness, **Christmas Eve**, 1866. Montclair Art Museum

Hudson River Museum
511 Warburton Avenue
Yonkers, New York 10701
hrm.org

James A. Michener Art Museum
138 South Pine Street
Doylestown, Pennsylvania, 18901
michenerartmuseum.org

Fordham University Press
Joseph A. Martino Hall
45 Columbus Avenue
New York, NY 10023
www.fordhampress.com

ISBN 978–0–9232–8097–1 (Fordham University Press)

CONTENTS

FOREWORD

The Hudson River Museum and the James A. Michener Art Museum are delighted to present *The Color of the Moon: Lunar Painting in American Art.* In 2019, the 50th anniversary of the first human landing on the moon, we delve into our complex relationship with our closest celestial body. American artists have long celebrated people's love of this ever-present, ever-changing feature of the night sky, which is a universal and unifying vision shared by everyone on earth.

As museum directors, we think of the words of another museum director, astronaut Michael Collins, who led the transformation of the National Air and Space Museum in the 1970s. After piloting the command module during the Apollo 11 mission, Collins proposed, "I think a future flight should include a poet, a priest and a philosopher. Then we might get a much better idea of what we saw." We like to think he would gladly add a painter to that list. In *The Color of the Moon,* we have gathered together for the first time 150 years of American artists who devoted considerable effort to the moon as a feature of our own landscape. At the Hudson River Museum, *The Color of the Moon* is part of an ongoing series of exhibitions exploring the intersection of people and natural world, which we call *The Visitor in the Landscape.* Artists have a special ability to help us understand how we relate to places and each other, and these themes have been a touchstone through exhibitions ranging from *Paintbox Leaves: Autumnal Inspiration from Cole to Wyeth* to *Industrial Sublime:*

Modernism and the Transformation of New York's Rivers, 1900–1940, which was also published by Fordham University Press. All eight *Visitor in the Landscape* exhibitions have featured elegant and insightful catalogs funded by the Mr. and Mrs. Raymond J. Horowitz Foundation for the Arts, Inc. *The Color of the Moon* is additionally in memory of and with profound gratitude to longtime Hudson River Museum supporter Marjorie S. Isaac.

The Michener Art Museum, which collaborated with the Hudson River Museum on the 2016 exhibition *Oh Panama!: Jonas Lie Paints the Panama Canal,* is an ideal partner in this current project. Just as the Hudson River Museum is devoted to American art, including landscape paintings tied to our location on the banks of the historic Hudson River, so too does the Michener Art Museum respond to its location in Bucks County, Pennsylvania. Our collections and exhibitions enrich our understanding of American art in our respective regions, where artists continue to seek communion with nature to observe and paint the rural and sylvan views at all times of day.

So many factors go into planning and implementing a project like *The Color of the Moon.* In order for our museums to present this spectacular overview, co-curators Laura Vookles and Bartholomew Bland began with their own big dreams five years ago. They are to be thanked for assembling such a comprehensive exhibition and book. Many institutions, galleries and private collectors have made this

Cat. 38. James Hendricks (American, 1938–2017). **Moon Sites**, 1969, detail. Acrylic on canvas. 48 1/4 x 48 1/4 in. Hudson River Museum. Gift of the artist, 1972 (72.38)

exhibition possible and are thanked in the Acknowledgments on the following pages. We hope you enjoy and are enlightened by *The Color of the Moon* as much as the people who have done so much fine work bringing it to fruition. We are proud to make these works available to an even wider audience in this volume.

Masha Turchinsky
Director
Hudson River Museum

Kathleen V. Jameson, Ph.D.
Director
James A. Michener Art Museum

ACKNOWLEDGMENTS

The Color of the Moon was a creative spark kindled from years of working together on American landscape exhibitions at a museum with vibrant Planetarium programming that features, of course, the moon. Research and loan planning began in earnest in 2015. An exhibition and publication with this scope became a team undertaking that required the hard work and cooperation of over one hundred individuals and fifty lending institutions. We are grateful for the contributions of each and every one, which includes a generous grant from The Mr. and Mrs. Raymond J. Horowitz Foundation for the Arts, and the support of our exhibition co-organizer and second venue, the James A. Michener Art Museum.

We are grateful to Hudson River Museum Director Masha Turchinsky, without whose enthusiasm and support this exhibition would not have been possible. All of the staff of the Museum have been integral to the success of *The Color of the Moon,* particularly Registrar Alyssa Dreliszak, who arranged all loans and book illustrations, Senior Art Technician Jason Weller, who installed the exhibition, and Assistant Curator Theodore Barrow, who contributed a catalog essay. Samantha Hoover, Deputy Director for Advancement, Communication, and Administration, spearheaded fundraising and marketing efforts, supported by Tara Dawson, Development and Communications Associate, and Camille Knop, Design and Content Manager. Marc Taylor, Manager, Planetarium and Science Programs, was a crucial source of information and also curated a related exhibition, *A Century of Lunar Photography—and Beyond.* Essential research and administrative assistance was provided by Elizabeth Stewart, Visitor Services and Curatorial Assistant; Valerie Thai, Curatorial Intern; Diana Vazquez, Registrar Intern; and Laura Gardner, Curatorial Volunteer. Saralinda B. Lichtblau, Assistant Director, Education assembled a schedule of scholarly public programs to raise interpretation of the exhibition to the highest bar. We would also like to thank Director Emeritus Michael Botwinick, who greenlighted the exhibition during his tenure. This beautiful book is due greatly to the efforts of guest publication manager Linda Locke and graphic designer Natasha Mileshina, as well as our esteemed colleagues at Fordham University Press, Director Fredric Nachbaur, and Marketing Director Kate O'Brien-Nicholson, who have collaborated with us now on five impactful publications. Scholars Melissa Martens Yaverbaum and Stella Paul wrote essays that enrich the catalog's artistic content with historical context. We thank our partners at the James A. Michener Art Museum for embracing our exhibition proposal and working as partners to bring *The Color of the Moon* to a broader audience. In addition to Executive Director Kathleen Jameson, other key collaborators at the Michener have been Laurie McGahey, Deputy Director/Senior Director of Advancement, Wendi Johnson, Curatorial Assistant, Registrar Kathryn Lynch, and Chief Preparator Bryan Brems.

An exhibition of this nature is impossible without numerous loans and we so appreciate the institutions, galleries and private collectors who generously agreed to be a part of *The Color of the Moon.* A formal list

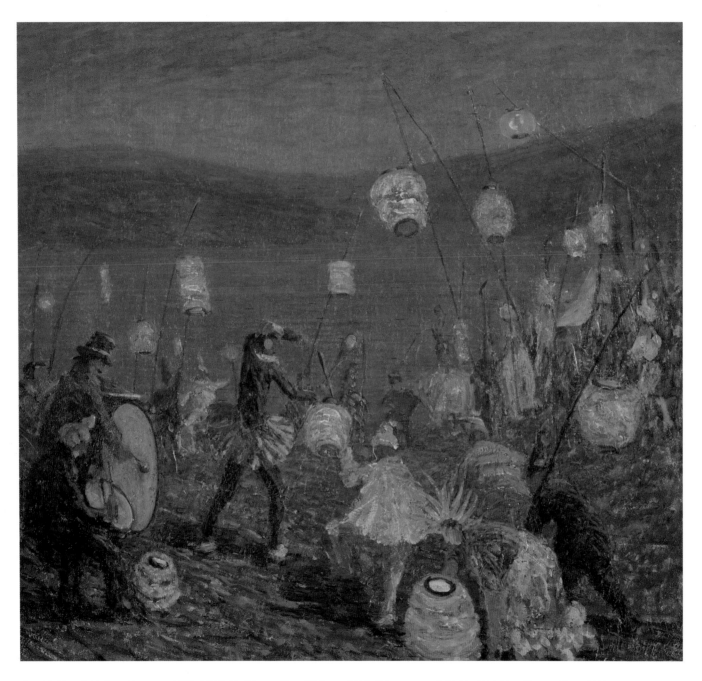

Cat. 39. Harry L. Hoffman (American, 1871–1964). **The Harvest Moon Walk,** ca. 1912. Oil on canvas, 24 1/4 x 26 1/4 in. Florence Griswold Museum
Anonymous Donation, 1972 (1972.214)

follows, but numerous people must be thanked as well. Collectors Eileen Farbman, David and Laura Grey, Robert Grey, Robin Gosnell, Karen and Kevin Kennedy, Norma Marin, Mr. and Mrs. Washburn Oberwager, artist Red Grooms and Lysiane Luong Grooms, the family of artist Sanford Gifford, and anonymous lenders shared key works that would normally enrich their homes. Many thanks go to the following individuals at galleries, institutions and private collections: Jan and Warren Adelson, Hubbard Toombs (Adelson Galleries); Sara Bliss (American Illustrators Gallery); Suzan D. Friedlander (The Arkell Museum at Canajoharie); David Scott Parker, Walter Buck, Sarah Bliss (Associated Artists, LLC); Sandy Pearl, Ken Sims (Bernard Goldberg Fine Arts, LLC); Louis Zona, Patrick McCormick (Butler Institute of Fine Arts); Caitlin Condell, Steve Langehough (Cooper Hewitt, Smithsonian Design Museum); Samuel D. Sweet, Antonia Moser, Allison Nicks (Delaware Art Museum); Nick Capasso, Lisa Crossman, Aminadab "Charlie" Cruz Jr. (Fitchburg Art Museum); John Henry, Tracee Glab, Peter Ott, Heather Jackson (Flint Institute of Arts); Becky Beaulieu, Amy Kurtz Lansing, Jenny Parsons, Mell Scalzi (Florence Griswold Museum); James Mundy, Karen Casey Hines, Mary-Kay Lombino, Joann Potter (The Frances Lehman Loeb Art Center at Vassar College); Tracy Gill, Simeon Lagodich (Gill & Lagodich Gallery); Eric W. Baumgartner, Debra Gail Wieder (Hirschl & Adler Galleries); Marc Baron (The Lambs Foundation); Ken Lopez (Ken Lopez Bookseller); Jody Rose (Norma Marin Collection); Lora Urbanelli, Gail Stavitsky, Kimberly Kruse, Alison Van Denend (Montclair Art Museum); Whitney W. Donhauser, Matt Heffernan (Museum of the City of New York); Diana Thompson (National Academy Museum); Earl A. Powell III, Paula Binari (National Gallery of Art); Louise Mirrer, Margi Hofer, Marci Reaven, Mark Schlemmer (The New–York Historical Society); Adelia Rasines, Anthony M. Speiser (Newington–Cropsey Foundation); Laurie Norton Moffatt, Jill Gellert, Martin Mahoney, Thomas Mesquita, Venus Van Ness (Norman Rockwell Museum); Andrea Cerbie (The Olana Partnership); Christopher Flagg, Ronna Dixson (Olana State Historic Site); Erin Coe, Joyce Henri Robinson, Beverly Balger Sutley (Palmer Museum of Art); Alexander Till (Pennsylvania Academy of the Fine Arts); Dave Bahssin (Post Road Gallery); Stephanie Stebich, Annie Farrar, Eleanor Jones Harvey, Virginia M. Mecklenburg (Smithsonian American Art Museum); Audrey Malachowsky, Diane Matyas, Janice Monger, Donna Pagano (Staten Island Museum); Alex Nyerges, Nancy T. Nichols, Howell W. Perkins (Virginia Museum of Fine Arts); Rebecca Massie Lane, Daniel Fulco, Kay Palmateer (Washington County Museum of Fine Arts); Lisa Dorin, Diane Hart (Williams College Museum of Art); Mark D. Mitchell, L. Lynne Addison, Brandon Cobb (Yale University Art Gallery); Thomas Sokolowski, Donna Gustafson, Kiki Michael, Margaret Molnar (Zimmerli Art Museum at Rutgers University).

The following people and organizations were helpful in providing images and rights for comparative illustrations and arrangements for a number of the loans: Meghan Brown (Art Resource Inc); Andrea Fisher,

Maria E. Murguia (Artists Rights Society); Allison Munsell-Napierski (Albany Institute of History & Art); Art Institute of Chicago, Leslie Bean; Bridgeman Images; James Kohler (The Cleveland Museum of Art); Betsy Carpenter, Lorraine DeLaney (Colby College Museum of Art); Meghan Finch (Detroit Institute of Arts); Daryl Bergman (Gemini G.E.L. LLC); Katherine Baumgartner, Andrea Morino (Godel & Co. Fine Art, Inc.); Maria Friedrich, Julie Graham, Gro Engelstoft (Graham & Friedrich Fine Art Advisors); Ester Harrison, Rick Watson (Harry Ransom Center, The University of Texas at Austin); Michael W. Schantz, Lisa Chalif, Andrew Schaeffer (The Heckscher Museum of Art); Andrew Schoelkopf, Kathryn Fredericks (Menconi + Schoelkopf); Shelby Rodriguez (Museum of Fine Arts, Houston); Miriam Cady (Philadelphia Museum of Art); Nina Sangimino (Questroyal Fine Art LLC); Kate Igoe, Heidi Stover (Smithsonian Institution Archives); Kayla R. Carlsen, Laura West (Sotheby's Inc.); Kate Menconeri (Thomas Cole National Historic Site); Christopher B. Steiner; Don Treadway, Dave Warren (Treadway Gallery, Inc.); Carly Olds (Viacom Inc.).

Last, but never least, we appreciate additional research, loan assistance, and other scholarly assistance from Elizabeth Broun, John Childrey, Patrick DiJusto, Genevieve Ellerbee, Mary Faraci, Penelope Joan Fritzer, Takako Hara, Kirsten Jensen, Ashley Lum, Valerie McKenzie, Christina Olsen, Kevin Ritter, Lynne Schillaci, James M. Sousa, Janet Maddox and the late Kenneth Maddox.

Laura Vookles and Bartholomew F. Bland

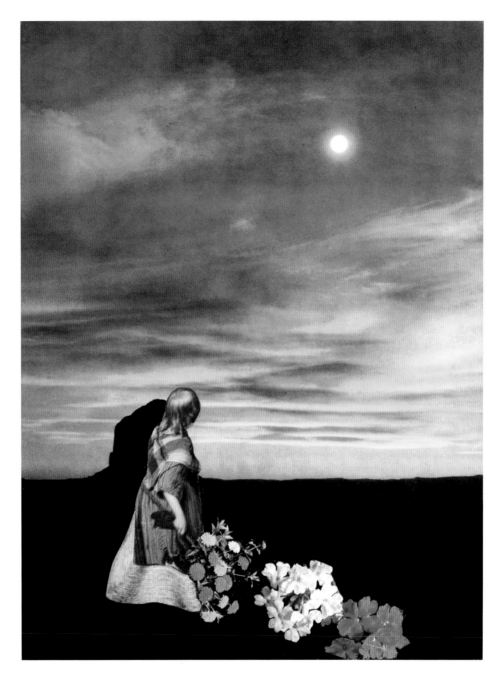

Cat. 23. Joseph Cornell (American, 1903–1972). **Portrait of Emily Bronte**, ca. 1962. Paper/canvas board collage, 12 x 9 in.
Hudson River Museum. Gift of C & B Foundation, 1975 (75.22.3) © The Joseph and Robert Cornell Memorial Foundation
/Licensed by VAGA at Artists Rights Society (ARS), New York, NY

LENDERS

ADELSON GALLERIES

AMERICAN ILLUSTRATORS GALLERY

THE ARKELL MUSEUM AT CANAJOHARIE

ASSOCIATED ARTISTS, LLC

BERNARD GOLDBERG FINE ARTS, LLC

BUTLER INSTITUTE OF FINE ARTS

COOPER HEWITT, SMITHSONIAN DESIGN MUSEUM

DELAWARE ART MUSEUM

EILEEN FARBMAN

FITCHBURG ART MUSEUM

FLINT INSTITUTE OF ARTS

FLORENCE GRISWOLD MUSEUM

THE FRANCES LEHMAN LOEB ART CENTER AT VASSAR COLLEGE

GILL & LAGODICH GALLERY

DAVID AND LAURA GREY

ROBERT GREY

RED AND LYSIANE LUONG GROOMS

HIRSCHL & ADLER GALLERIES

KAREN AND KEVIN KENNEDY

KEN LOPEZ BOOKSELLER

THE LAMBS FOUNDATION

THOMAS JOSEPH MANSOR

NORMA MARIN

MENCONI + SCHOELKOPF

MONTCLAIR ART MUSEUM

MUSEUM OF THE CITY OF NEW YORK

NATIONAL ACADEMY MUSEUM

NATIONAL GALLERY OF ART, WASHINGTON, DC

THE NEW-YORK HISTORICAL SOCIETY

NEWINGTON-CROPSEY FOUNDATION

NORMAN ROCKWELL MUSEUM

MR. AND MRS. WASHBURN OBERWAGER

OLANA STATE HISTORIC SITE

PALMER MUSEUM OF ART

PENNSYLVANIA ACADEMY OF THE FINE ARTS

POST ROAD GALLERY

PRIVATE COLLECTIONS

SMITHSONIAN AMERICAN ART MUSEUM

STATEN ISLAND MUSEUM

VIRGINIA MUSEUM OF FINE ARTS

WASHINGTON COUNTY MUSEUM OF FINE ARTS

WILLIAMS COLLEGE MUSEUM OF ART

YALE UNIVERSITY ART GALLERY

ZIMMERLI ART MUSEUM AT RUTGERS UNIVERSITY

ARTISTS

GERTRUDE ABERCROMBIE	BIRGE HARRISON
GEORGE AULT	CHILDE HASSAM
EDWARD BANNISTER	JAMES HENDRICKS
XAVIER J. BARILE	HARRY L. HOFFMAN
SUSIE M. BARSTOW	WINSLOW HOMER
ALBERT BIERSTADT	JOHN O'BRIEN INMAN
RALPH BLAKELOCK	GEORGE INNESS
OSCAR FLORIANUS BLUEMNER	ROY LICHTENSTEIN
GEORGE HENRY BOGERT	JOHN MARIN
CHARLES BURCHFIELD	LOUIS REMY MIGNOT
HOWARD RUSSELL BUTLER	EDWARD MORAN
THOMAS CHAMBERS	SAMUEL FINLEY BREESE MORSE
FREDERIC EDWIN CHURCH	WILLIAM EDWARD NORTON
THOMAS COLE	HOWARD PYLE
JOSEPH CORNELL	ROBERT LEWIS REID
JASPER FRANCIS CROPSEY	NORMAN ROCKWELL
E. E. (EDWARD ESTLIN) CUMMINGS	WARREN W. SHEPPARD
MAURITS FREDERIK HENDRIK DE HAAS	EDWARD STEICHEN
LOUIS PAUL DESSAR	HENRY OSSAWA TANNER
ARTHUR DOVE	ELIHU VEDDER
ARTHUR WESLEY DOW	HANS WEINGAERTNER
SANFORD ROBINSON GIFFORD	JOHN FERGUSON WEIR
FRANK RUSSELL GREEN	JAMIE WYETH
RED GROOMS	MARGUERITE THOMPSON ZORACH

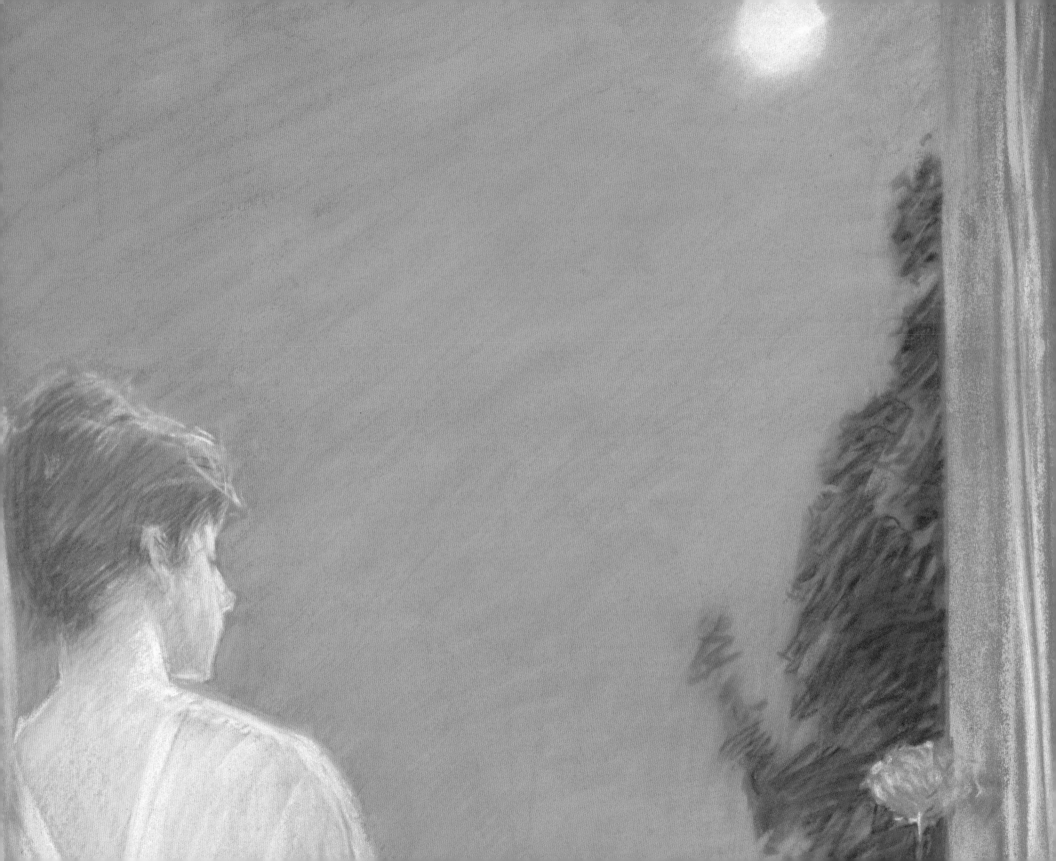

INTRODUCTION

The moon in American landscape painting is the story of sharing our sense of place here on Earth.

We love the moon because we love the landscape in which we see the moon. We love home. The moon reminds us we are home because far away, it is yet reassuringly close. We love the moon as it rises on the horizon above us, its reflective, maternal glow our world's comforting nightlight. The moon, mute and implacable, hovers silently as it observes the silliness of humankind's foibles, our sea of outrageous fortune. The moon couldn't possibly be icy, barren rock. Certainly it must be green cheese.

The two great orbs—our sun and our moon—which move across the sky every day and night, are wondrous and yet always present. The rising sun and moon are the literal definition of "everyday events" that sometimes can be a trifle ho–hum. "Yes, yes," we think to our-selves as we hurry along to more important things, "There they are again: beautiful, reliable, and there they are." We forget that we are so dependent on the sun and the moon to shape our sense of time and place in our lives. The daily miracle continues, and we shrug.

We cannot gaze directly at the sun and imagine going to its surface. Savior and destroyer, brilliant and blinding even from afar, we dare not approach. We've learned from Icarus' disastrous attempt to fly towards it, the sun burned his wings beyond repair. We know better, now, not to approach too closely.

Like the tide, though, we feel the moon's pull. It inspires religion, it inspires science, it inspires art (Cat. 59). Its phases help us create our calendars and define our lives. Romantic painters and poets

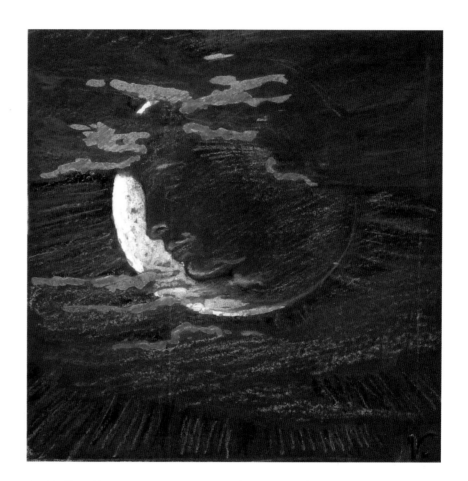

Cat. 59. Elihu Vedder (American, 1836–1923). **Luna, Christmas**, 1882, detail. Watercolor and pastel and black and blue ink on artist's board, 12 3/8 x 10 7/8 inches. Gill & Lagodich Gallery

Cat. 37. Childe Hassam (American, 1859–1935). **On the Balcony**, 1888, detail. Pastel on paper laid down on canvas, 29 5/8 x 17 3/4 in. Adelson Galleries

recognized the power of the moon and its symbols that have remained significant for us over centuries. We see the moon everywhere. It shines on all of us.

The Color of the Moon is a chapter in the Hudson River Museum's series The Visitor in the Landscape, and the collection of objects and essays gathered in this book and the accompanying exhibition, traces the positions, places, and phases of the moon on a landscape across more than 150 years of art and imaginings. In the five essays that follow, we encounter a range of artistic responses to the moon. In "Mapping the Colors of the Moon," Stella Paul shows us a moon that "always colored our thoughts, shaping and tinting myth and ritual, guiding travelers, regulating the tides, marking time, inflecting love and romance through its special light." In "Romancing the Moon: The Allure of the Hudson River School Nocturne," Bartholomew Bland looks at the silver-drenched moonscapes of America's Hudson River School artists to show how the ethos of the early 19th-century Romantic age influenced landscape painting. Theodore Barrow looks at art during the Civil War, through the blaze of electrification that led to a new century, and how the dazzling brushstrokes of the era were dappled with moonlight in "The Moody Moon of the Gilded Age." Laura Vookles sheds light on "The Modernist Moon: Painting in Poetry and Prose," tracing how modern artists reconciled a romantic Moon with the harder, faster edginess of a new era. In "Imagining a Trip to the Moon," Melissa Martens Yaverbaum tracks our moon's journey through the American imagination and popular culture, as humans strove to finally touch the moon in space. The book concludes with catalog entries of the exhibited works, each selected to portray a different facet of the moon's allure and examined to reveal subtle shades of meaning in the painters' placement of the moon in the night sky.

"We are all of us visionary artists for one familiar object, the moon," said English artist and author Philip Gilbert Hamerton, and his words ring as true today as they did in his mid-1880s book Imagination in Landscape Painting.[1] Hamerton explains that when we look at the moon, "We do not think of the heavy globe of rock with prodigious cloudless mountains, sun-heated to an intolerable temperature. That is the scientific conception … but in ordinary times the moon means for us a crescent or a disc of silvery and sometimes of golden splendour, the brightest thing that we are able to look upon in nature." Understanding the reality of the moon has not dimmed its poetry for us (Fig. 1).

The moon never appears in a painting by accident. When painted on a canvas, we look for the way that the artist uses its form and light to contribute to the aesthetics of the scene. From Thomas Cole in the 1830s to Jamie Wyeth in 1969, the artists in The Color of the Moon paint a subject that evokes feelings in us all. When we see the moon at its fullest, we look for heightened drama. The moon carries freighted meaning— longing, passing time, haunting, even death. As it travels across the sky, it trails a hundred connotations. It is an invaluable shorthand and does the "heavy lifting" for symbolism. In writing, a word that is rich in symbolism is known as an "objective correlative" because it objectifies or evokes the emotions associated with it. The moon in a painting does this same work, without words. It shows us action taking place in deep nighttime, when myth and superstition come to life for us.

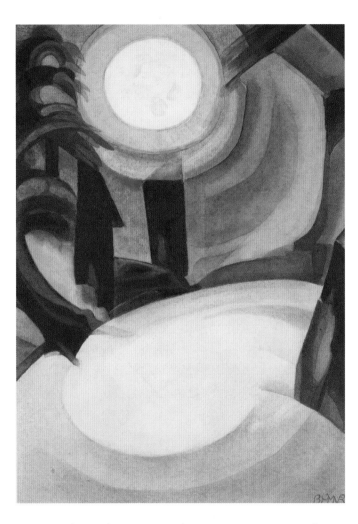

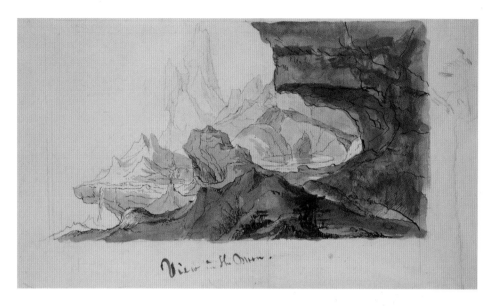

Fig. 2. Thomas Cole (American, born in England, 1801–1848). **View on the Moon**, 1829. Pen and black ink and gray wash over graphite pencil on off–white wove paper, 6 7/8 × 12 1/4 in. Detroit Institute of Arts. Founders Society Purchase, William H. Murphy Fund, 1939 (39.358.A)

Fig. 1. Oscar Florianus Bluemner (American, born in Germany, 1867–1938). **Silver Moon**, 1927. Watercolor and pencil on paper laid down on board, 13 5 /16 x 9 15/16 in. Karen and Kevin Kennedy collection. Photograph Joshua Nefsky

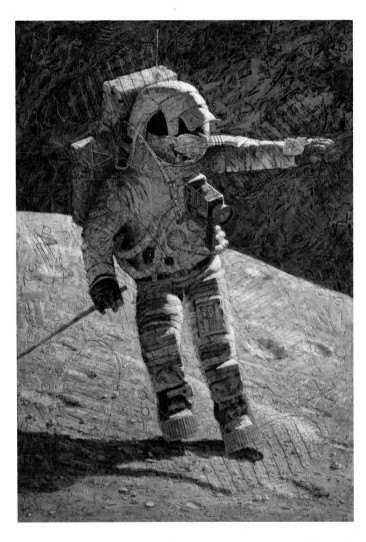

Fig. 3. Alan Bean (American, 1932–2018). **Jack Schmitt Skis the Sculptured Hills**, 2000. Textured acrylic with moon dust on aircraft plywood, 35 x 50 in. Courtesy of Leslie Bean

Two hundred years ago, the Hudson River School painters depicted the moon with a deep romanticism during a period of much speculation about the rocky surface of this Earth satellite. The key artist in the early years of this movement, Thomas Cole, sketched a mysterious drawing of the moon's surface (Fig. 2), carefully depicting it to look like the craggy Catskills he knew so well. His misconception reflects the current thinking of his day, when scientists had long understood that the moon was not a wheel of fire, a flat disk, or polished, mirror–like sphere, as some ancient Greeks thought, but of solid material presumed to be much like the earth.[2] This analogy led to exaggerated interpretation of the shadows of craters as dramatic mountains, canyons, and lakes, which cartographers over the past two centuries had strategically named after their political leaders, geographical features of their own countries, important astronomers and so on. Their nomenclature laid claim in advance of arrival, and cultivated a kinship that implied its future acquisition, as the moon became the symbol of a new frontier and the logical extension of imperialistic exploration.[3]

The moon is a moon of many romanticisms. Early 20th–century Americans contemplated the moon during an age when scientists knew more about its composition and movement but remained attracted to its dramatic significance and abstracted shapes. One aspect of the romanticism of the moon was the intriguing possibility that we could fly through space to reach it, our yearning made real. At carnival photo studios in the early 20th century, people were photographed perched on charming cardboard sculptures of "the man in the moon," though the vastness of space in which the moon sat was more

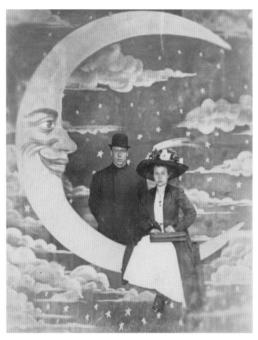
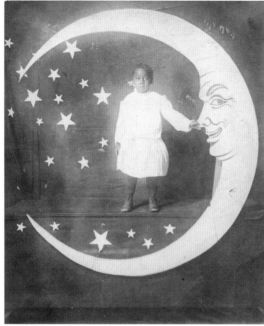
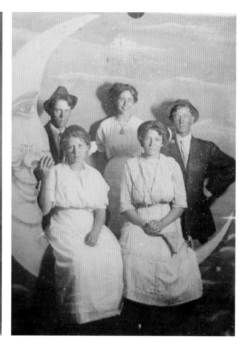
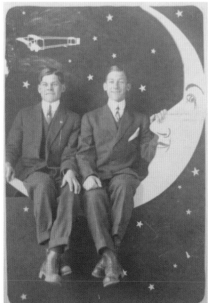

Left to right, top to bottom:

Fig. 4a. **Couple on Paper Moon Studio Prop**, ca.1905. Photographic postcard by Riverview Expo, Chicago, Illinois. Hudson River Museum. Museum purchase, 2018

Fig. 4b. **Child with Paper Moon**, early 20th century. Studio photograph. Oakenroad collection on Flickr

Fig. 4c. **Five People on a Paper Moon**, ca.1905–15. Photographic postcard. Hudson River Museum. Museum purchase, 2018

Fig. 4d. **Two Men on a Paper Moon**, ca.1915. Photographic postcard. Hudson River Museum. Museum purchase, 2018

Fig. 4e. **Woman Posing on Paper Moon Studio Prop**, ca.1940s–50s. Gelatin silver print, Christopher B. Steiner

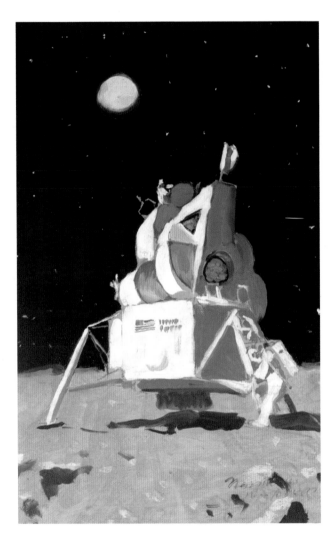

Cat. 53. Norman Rockwell (American, 1894–1978). **Man on the Moon (United States Space Ship on the Moon)–Study,** detail, painted for *Look magazine,* January 10, 1967. Oil on board, 19 3/4 x 12 3/4 in. American Illustrators Gallery (LNM #S418a). Printed by permission of the Norman Rockwell Family Agency. © 1966 The Norman Rockwell Family Entities

fearsome than any wilderness on Earth (Fig. 4). In the post–World War II era, painters and authors portrayed the astronaut, the explorer of space, as the new American hero. NASA commissioned artists to document moon missions. Astronaut and author Alan Bean, one of the dozen men who walked on the moon, spent the rest of his life painting himself and his colleagues as visitors in this new landscape (Fig. 3).

The moon is both part of and apart from our landscape, and our arrival on its surface is the fitting climax that motivated this exhibition. Fifty years ago, in 1969, earth dwellers landed on the moon: the human figure truly and most fully became the visitor in an alien landscape. The magnificent and terrifying journey through unexplored space to strange terrain embodies the definition of "the sublime"—a scene that inspires awe and fear. When humans reached the moon, they did not find what our art, poetry, myths and fairy tales said were there. Instead, the moon was that "heavy globe of rock," where astronauts were forced to lighten their load for takeoff by discarding much equipment, as well as the place to leave their official message, "Here men from the planet Earth first set foot upon the Moon. July 1969, A.D. We came in peace for all mankind." On the moon, they discovered not its romance but a new pull on their emotions, first seen by crew members of Apollo 8 as they orbited the moon in December 1968—the view home, the earth, minute and blue in the distance. William A. Anders, the photographer on Apollo 8, took the iconic, *Earthrise* (Fig. 40), which inspired preservationists around the world.[4] The astronaut later said, "When I looked up and saw the Earth coming up on this very stark, beat up lunar horizon ... I was immediately almost overcome by the thought that here we came all this way to the Moon,

and yet the most significant thing we're seeing is our own planet, the Earth."[5]

 Artists have a way of getting to the essence of things. Before both of these missions, Norman Rockwell anticipated this vision in a study and painting for *Look* magazine to promote the future moon landing in January 1967. The published version of his painting shows the sliver of a crescent Earth (Fig. 39), but an earlier study shows a nearly full Earth (Cat. 53). Like Anders, Rockwell's changed perspective turned our distant longing for the moon on its head. Artists had long shown the moon as a white disc in a painted sky—the earth was now the glowing and unattainable orb.

Laura Vookles and Bartholomew F. Bland

ENDNOTES

1. Philip Gilbert Hamerton, *Imagination in Landscape Painting* (Boston: Roberts Brothers, 1887), 72.

2. Scott L. Montgomery, *The Moon and the Western Imagination*, 2nd ed. (University of Arizona Press, 2001), 15–16.

3. Montgomery, *The Moon and the Western Imagination*, 157–68.

4. Robert Poole, *Earthrise: How Man First Saw the Earth* (New Haven: Yale University Press, 2008), 8.

5. Poole, *Earthrise: How Man First Saw the Earth*, 2.

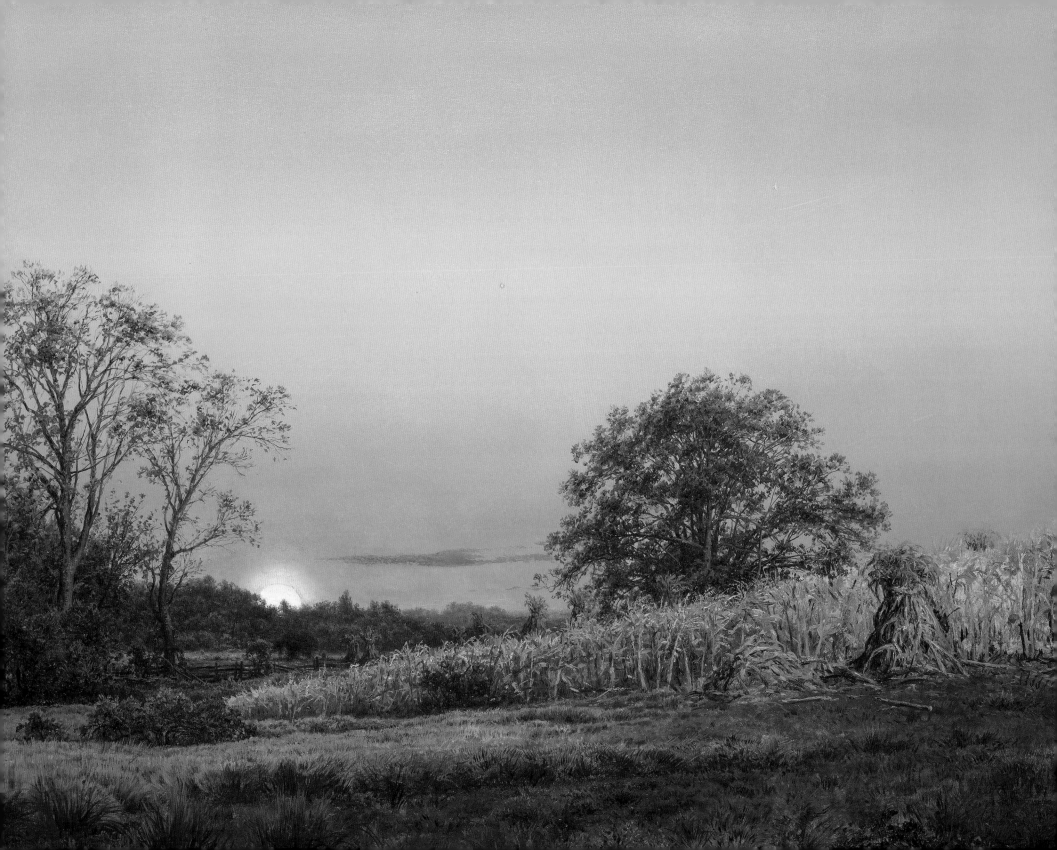

MAPPING THE COLORS OF THE MOON

Stella Paul

Many of the moon's exquisite harmonies play out as interchange with Earth, colored through our atmosphere and our inclinations.

The moon has always colored our thoughts, shaping and tinting myth and ritual, guiding, regulating tides, marking time, inflecting love and romance through its special light. We, in turn, have vividly colored the moon. Pearly white or shimmery silver, pale yellow or ethereal gold, deepest harvest–orange or blood red, limpid blue or even invisible black, we portray the moon in an array of color. Yet when astronauts first entered the lunar orbit in 1968 and saw it close–up, they perceived something different: a gray moon, essentially drained of color. A new gray cast on Earth's sole natural satellite had expanded our moon–spectrum by another (albeit shadowy) hue. Nobody ever said the moon is constant. Just as it shifts in shape, it switches palette, too: it manages to be both stripped of and replete in colors. How can we map such variety? The moon provides one of the most perfect metaphors for human subjectivity and the way in which our perception of the world fluidly changes. In our moonscape of thought and substance, colors layer and co–exist as palimpsests and beacons.

Cat. 46. Louis Remy Mignot (American, 1831–1870). **The Harvest Moon,** 1860, Oil on canvas, 24 x 39 in. The New–York Historical Society, New York, New York. The Robert L. Stuart Collection, the gift of his widow Mrs. Mary Stuart (S–160) Photography © New–York Historical Society

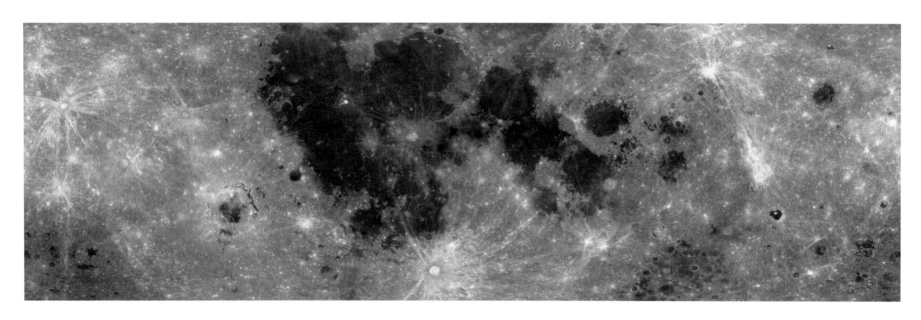

Fig. 5. **A color composite mosaic showing most of the moon's surface, based on images from NASA's Lunar Reconnaissance Orbiter.** Published October 9, 2017. NASA/ Goddard/ Arizona State University

Fifty years ago NASA astronaut Jim Lovell declared that the moon has "No color," other than "grayish beach sand." But even the unremittingly gray moon surface holds surprise and nuance. Look closer at the moon's asphalt–gray crust, and delicate orangey and greenish glass beads—the result of volcanic eruptions—can be found in a porous blanket of mostly dark, brownish–gray rocks, particles, and grains of metallic iron (Fig. 5).

Moon samples also include black glass bits and yellow–brown olivine crystals. Gray itself ranges from darker to lighter, with constituent minerals contributing subtlest penumbral tones, some of which are so delicate as to need analysis by imaging tools that "see" distinctions our merely human eyes cannot. The other thing our eyes never perceive is a dark gray orb when we look up at the sky. Why not? Context is everything. From Earth, by day or at night it can look white, or in any case, light: another stunning turnabout revealing the moon's powerful color–effects. Something very dark can look light by virtue of surrounding background and illumination, an effect well studied by scientists and artists. "Color deceives continually," as artist Josef Albers said in a comment celebrating colors' marvelous fickleness.[1]

Earthbound, around 238,855 miles below, we see the moon as an embodiment of radiance; our closest celestial neighbor is the brightest object in the night sky. The moon and its distinct reflective light are inextricable. And color itself is bound up with light. Even before Isaac Newton's 17th–century revolution in physics proved that color is the integral constituent of light, ancient philosophers and medieval theologians had long debated their interplay—so the moon's light is fundamental

to any thoughts about the moon's color. But the moon's light is borrowed from the sun, rather than generated internally. Sunlight reflecting on the moon's dusty surface beams back to Earth 400,000 times fainter than through direct transmission. It's the same light, encompassing sunlight's full spectrum, yet curiously altered. Moonlight can illuminate darkness but seemingly rob color from the objects on which it shines. A red rose will look gray by moonlight. Specially designed moon gardens, meant to focus on moonlight's unique color–cancelling effects, feature white or silvery blooms. Nor can we read well by moonlight—not even the brightest full moon; moonlight creates a little blind spot, slightly blurring human vision because of the same anatomical feature in our eyes that allows the light to "drain" color. The light falls just below the threshold at which color–sensitive receptors (cones) in the retina function effectively, but above the bar for our retinas' light receptors (rods). Rods are scant, though, in the central patch of the retina, which we use for reading.

Still, under the right circumstances moonlight can perform surprisingly like sunlight, refracting into nighttime rainbows (moonbows), appearing as glowing, colored rings of light (lunar halos) or as apparitions of pale light shafts (moon pillars). Encountering such phenomena is uncommon and transporting (Fig. 6). But even standard encounters in moonlight can be affecting. Nineteenth–century author Nathaniel Hawthorne wrote about the moon's unusual "spiritualized" light, which disembodies everyday objects to make them strange and remote, articulating a world of difference between sunlight and moonlight, though they are physically the same. Two–hundred and fifty years earlier, Shakespeare had given silver moonlight pride of place, where this special

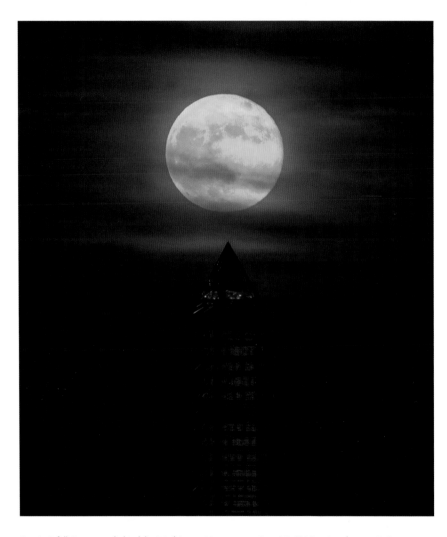

Fig. 6. A full Moon rises behind the Washington Monument on June 23, 2013, in Washington D.C. Published October 9, 2017. NASA

light made mischief and magic, beaming the pathway for topsy–turvy enchantments and misunderstandings, and finally illuminating love and fertile promise (Fig. 7). The Romantics codified moonlight's metaphorical links with love. Keats colored the moon both "golden" and "silver," and described its "amber rays." Byron, calling his fellow poets "moon–struck bards," declared, "Deep secrets to her rolling light are told."[2] Moonlight walks were careful forays into interpreting a glowing, seductive moon that above all sparked love.

Serenely soft silver might alternatively be perceived as chaste reserve or steely coldness. And where some see a silvery light, others perceive ashen effects. Some 20th–century poets shifted a benign moonglow into other hues and a darker frame of mind. Sylvia Plath wrote, "This is the light of the mind, cold and planetary. / The trees of the mind are black. The light is blue."[3] Blue holds an important position in a discussion about the moon and its colors. It's a brilliant poetic metaphor. The color also manifests as a visual effect of our retinas' photoreceptor cells when we stare long enough at a gray, moonlit landscape, in a phenomenon called blueshift. There are also times when the moon seems to become visibly blue.

The moon's light, having first come from the sun, then travels through Earth's atmosphere—a consequential filter. If our high atmosphere is filled with particles of a precise size (slightly wider than 900 nanometers), they will scatter wavelengths of red light, but leave blue light–waves. Fine ash from forest fires or major volcanic eruptions creates the unusual, perfect conditions to make the moon look bluish. The dust plume after Indonesia's Krakatoa erupted in 1883 turned the moon blue (to our

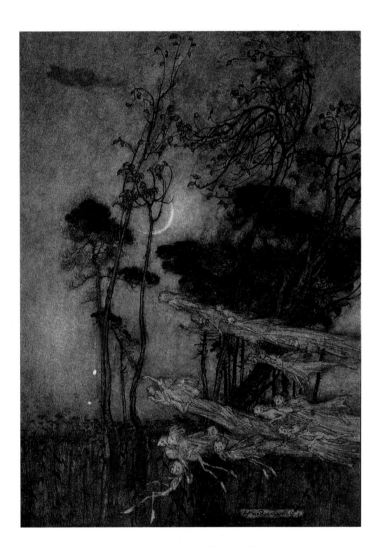

Fig. 7. Arthur Rackham (English, 1867–1939). ...the moon, like to a silver bow New–bent in heaven, color illustration from *A Midsummer Night's Dream* by William Shakespeare (New York: Doubleday, Page & Co., 1908). Hudson River Museum. Museum Purchase, 2018

eyes) for two years. When the sun—or the moon—is low on the horizon, light has further to travel and shorter blue wavelengths scatter through particles and air molecules, leaving longer, red ones: a familiar catalyst for luscious red sunsets. It's also responsible for red moons, which occur more commonly than very infrequent blue–toned moons. A particular red–hued moon seen during a total lunar eclipse is even given the vivid name "blood moon" (Fig. 9). A combination of seasonal changes in atmosphere, including the amount of dust in the air and variances in the angle at which the moon rises and sets also regularly contribute color. A "harvest moon" in the fall—low enough on the horizon and large enough to illuminate farm work well into the night—can have a distinctive orange appearance.

Many of the moon's exquisite harmonies play out as interchange with Earth, colored through our atmosphere and our inclinations. Leonardo wrote, "the Earth and the Moon lend each other light,"[5] referring to another interesting phenomenon—earthshine—in which sunlight reflects off the moon and is then re–reflected back from Earth, creating a unique shadow effect on the moon. It's not always visible. But the premise that Earth and our moon have an active relationship is universal, and this has been a subject of deep thought for millennia, if not longer. What did we know (or think) and when did we know it? Attitudes echo layers of belief; the moon has always been a cipher for whatever we bring to it. Whether sacred or secular, ideas about the nature of the cosmos position the moon as a key protagonist. Affiliated with goddesses and gods in diverse cultures—from Sumerian Nanna to Greek Selene to Roman Diana to Hindu Soma to Shinto Tsukiyoma—the personified moon explains origins and controls behaviors. In the realm of philosophy and description of

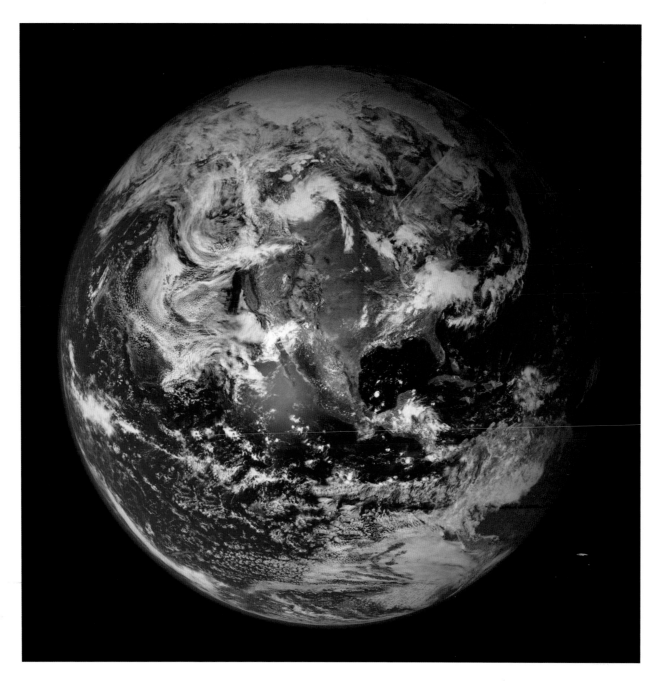

Fig. 8. "Blue Marble" photograph of Earth from the moon, February 8, 2002. NASA Goddard Space Flight Center

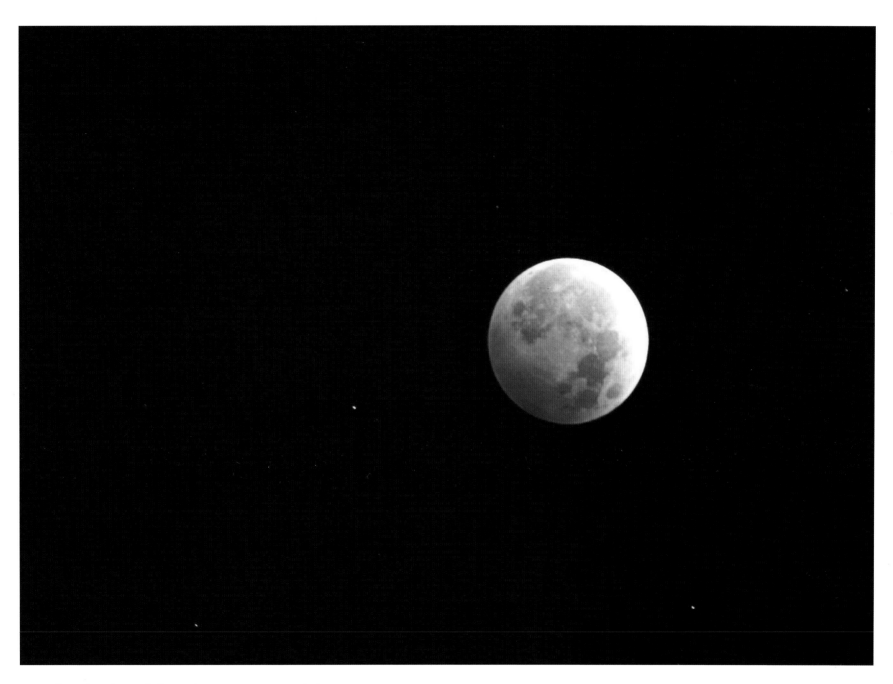

Fig. 9. A lunar eclipse photographed on October 8, 2014. NASA/Bill Dunford

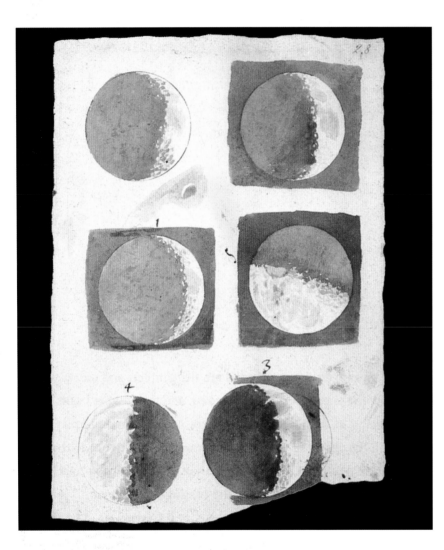

Fig. 10. Galileo Galilei (Italian, 1564–1642). **Moon Phases**, 1616. https://commons.wikimedia.org/wiki/File:Galileo_moon_phases.jpg

natural phenomena, the ancients advanced numerous theories. Aristotle proposed a divided cosmos: sublunary and supralunary. Below the moon, there was change and corruption. Above, all was perfection. Perhaps the largely perfect moon, nevertheless, had variations in "density" or somehow reflected some of our terrestrial condition. Could that explain the blotchy markings on its surface? Even in a world before telescopes, the naked eye could see some features of the moon's surface; and visible lunar spots and dark shades sparked the imagination. Ideas ranged from many cultures' "man in the moon" to contemplation of moonscapes in an ancient satire by Lucian of Samosata about an imaginary trip to the moon almost two millennia before Jules Verne's or H.G. Wells' breakthrough science fictions about space travel. Before telescopes, Jan van Eyck and Leonardo both depicted meticulous portrayals of lunar markings. The 17th century, though, was a watershed, shifting ideas about celestial and terrestrial physical laws, bringing paradigms to heliocentric rather than Earth–centered viewpoints, and inventing a new tool for seeing distant objects. In 1609, Thomas Harriot and Galileo Galilei (Fig. 10) both observed the moon through telescopes and rendered it in drawings—mapping the moon in new terms. Several centuries later, Apollo brought us to a new vantage point and a different way of mapping the moon and its color. Significantly, a byproduct of that proximal viewpoint is a new context for Earth: a chance to see our home planet from vast distance. In an iconic NASA photograph documenting this new interplay between our planet and its moon satellite, Earth appears a stunning blue orb marbled with swirling white (Fig. 8).

Finally, color is not always used as a visual descriptor; it can be purely conceptual as well. The moon vividly participates in every realm. A few last thoughts about colorful language and proverbs relating color and the moon. Did anyone ever believe the moon to be made of green cheese? No, it's a metaphor for gullibility, and the enduring proverb was already popular in the 17th century. Further, this "green" is more likely a synonym for a state of un–ripeness than for hue. But the imaginative link between "moon" and "green" persists. Another centuries–old saying denotes rarity: "once in a blue moon." The "blue moon" referenced here relates to the occurrence of additional full moons during a calendar month or a season and has nothing to do with the apparent color of those extra phases.

In the end, colors and the moon go together—whether we are talking language or scientific inquiry, vision or art. The many colors of the moon might be literal or metaphorical, manifested visually or conceptually. Artists have the unique power to capture all of this, and reflect it back to us. Nineteenth–century French astronomer Camille Flammarion described the moon as "a reflection of a reflection" which "resembles a mirror in which we may see the luminous state of the Earth"[6] (Fig.11). The works of art in this book are not only beautiful; they are also alignments of observation and creativity about their subject, mirroring an extraordinary range in color and thought.

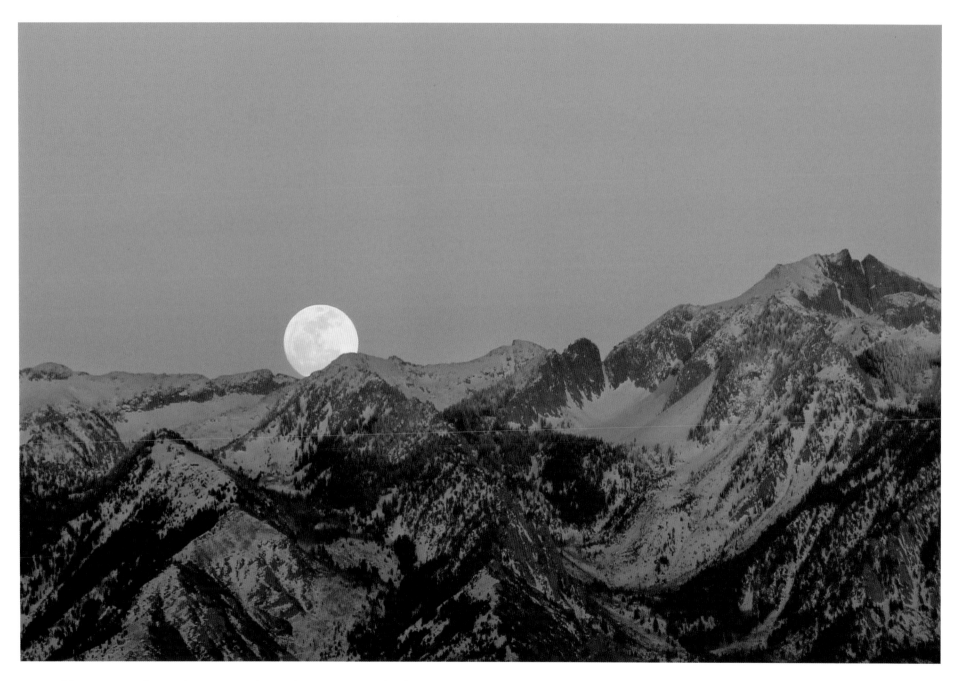

Fig. 11. **A full Moon rising over the Wasatch Mountains in Utah on March 15, 2014.** NASA/ Bill Dunford

ENDNOTES

1. Josef Albers, *Interaction of Color,* (New Haven: Yale University Press, 1963), 1.

2. Lord Byron (George Gordon), *Don Juan,* Canto XVI, 1823.

3. Sylvia Plath, "The Moon and the Yew Tree," published 6 months posthumously in *The New Yorker,* "Seven Poems," Aug. 3, 1963.

4. Full photographic credit: **NASA Goddard Space Flight Center.** Image by Reto Stöckli (land surface, shallow water, clouds). Enhancements by Robert Simmon (ocean color, compositing, 3D globes, animation). Data and technical support: MODIS Land Group; MODIS Science Data Support Team; MODIS Atmosphere Group; MODIS Ocean Group Additional data: USGS EROS Data Center (topography); USGS Terrestrial Remote Sensing Flagstaff Field Center (Antarctica); Defense Meteorological Satellite Program (city lights).

5. Leonardo da Vinci quoted in Bernd Brunner, *Moon: A Brief History,* (New Haven: Yale University Press, 2010), 71.

6. Camille Flammarion, *Popular Astronomy,* trans. John Ellard Gore, (Cambridge: Cambridge University Press, first published in 1894, quotation from 2014 edition), 100.

ROMANCING THE MOON: THE ALLURE OF THE HUDSON RIVER SCHOOL NOCTURNE

Bartholomew F. Bland

Before gaslight transformed the moon's power from an encompassing glow into a nightlight behind the glare of a street light, artists saw the moon's possibilities to conjure romantic ideas.

A huge orange moon rises up into the night sky, while fairies cavort in its magic light. The viewer can almost hear the cackle of witches. In John Ferguson Weir's *Halloween* (Fig. 12), we see a perfect lush Romanticism—a belief in the unknown, the mystical, and the moon, which by the time Weir painted his celebration of lunar magic, had already been an important undercurrent of American landscape painting for half a century. Temptress Moon, the perfect visual symbol of romance embedded in America's moonscapes and landscapes, rests within the grasp of the group of 19th-century artists who created the nation's first distinct artistic style—the Hudson River School.

Fig. 12. John Ferguson Weir (American, 1841–1926). **Halloween**, 1866, detail. Oil on canvas, 16 x 10 ½ in. The Butler Institute of American Art, Youngstown, Ohio (958–O–146). See image full size on page 54

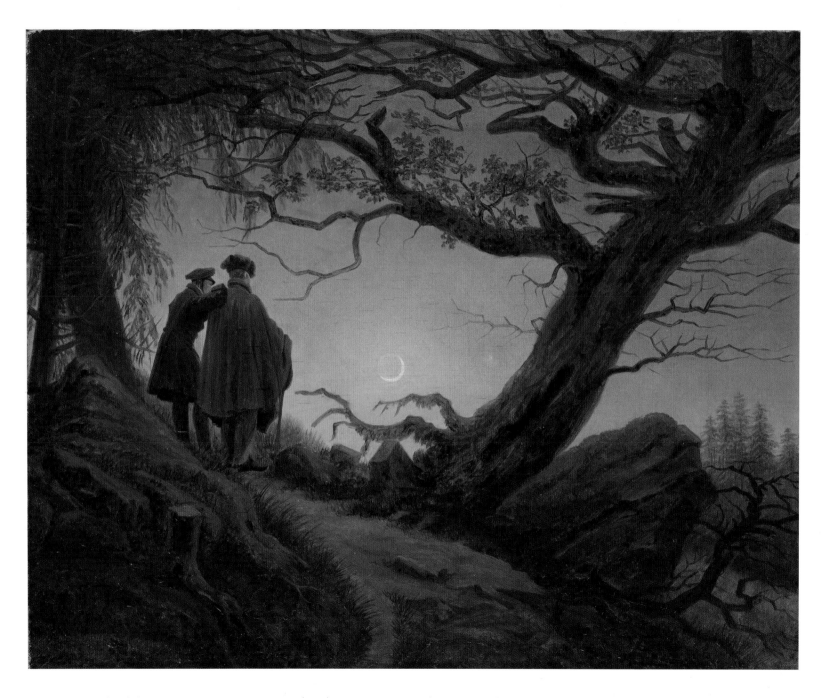

Fig. 13. Caspar David Friedrich (German, 1774–1840). **Two Men Contemplating the Moon**, ca. 1825–30. Oil on canvas, 13 3/4 x 17 1/4 in. The Metropolitan Museum of Art. Wrightsman Fund, 2000 (2000.51)

The Hudson River School drew its name from the proliferation of landscape painters who idealized the scenery of the Hudson River Valley, and later, a wider American landscape, and other "exotic" parts of the world, stretching from the lavender–tinted Rocky Mountains to the icy azure of the Arctic Circle. The art scene in the United States was made up of painters whose ideals and aesthetic were deeply influenced by European Romanticism, the movement in both literature and art that swept across Europe and on to the United States in the early 19th century.

Romanticism emphasized heightened emotion, subjectivity, and the intimate response of the individual, and it challenged 18th–century rational ideas we associate with the Enlightenment, the philosophical ideas that swept European culture and posited that humanity could be improved by an embrace of rational change and scientific discovery.

For many artists, such as the German Romantic artist Caspar David Friedrich in works like *Two Gentlemen Contemplating the Moon* (Fig. 13), the moon was not just the source of illumination but a presence that transformed the actual subject of the painting. Viewers of paintings with moonlit landscapes experienced a reflective mood, signaled by the presence of the moon's light on the surface of water, which was usually present in the composition to show the dancing quality of moonlight. These paintings so often represent scenes of fear, longing, and dreams, and landscapes featuring the moon are at the heart of the idea of Romanticism.[1] In many ways, landscapes with geographic detail obscured anticipate the dream world of the Freudian mind. In *Two Gentlemen Contemplating the Moon*, Friedrich develops the viewer's rapport with the anonymous men, turned away from the viewer, as well as the beauty of the softly lit moon landscape they observe. Friedrich's men become substitutes for the "visitor in the landscape"—they signal how we should feel in the presence of the moon's beauty. The artist tells us what we already know. We feel awe and reverence. We feel the presence of the sublime.

When Thomas Cole, the first Hudson River School painter, was launching his career in the 1820s, art patrons would certainly have recognized the long tradition of symbolic connotations of the moon that had been built into a recognizable visual and literary vocabulary over several thousands of years, long before the Hudson River School painters began painting the moon onto their canvases. Greek mythology had emphasized the gendered duality of the sun and the moon, personified by the masculinity of the "Sun God" Apollo, who representing truth, knowledge, and light, contrasted with his twin, the feminine Artemis (later conflated by the Romans with the goddess Diana), known as a huntress, the keeper of forest realms and clandestine human rendezvous in forests dappled by moonlight, although the goddess herself prized her virginity, destroying any who threatened it.

The idea of the sun and the moon as embodiments of a gendered male and female dichotomy has persisted in art, as it has in mythology, for centuries. Two small canvases by the Hudson River painter Frederic Church exemplify the idea of gendered duality, as it continued into the 19th century. Church was enjoying considerable professional success when he created two paintings "two little

Fig. 14. Frederic Edwin Church (American, 1826–1900). **Sunrise** (also known as **The Rising Sun**), 1862. Oil on canvas, 10 1/2 x 18 in. Olana State Historic Site, 1981 (OL.1981.12)

Cat. 20. Frederic Edwin Church. **Moonrise** (also known as **The Rising Moon**), 1865. Oil on canvas, 10 x 17 in. Olana State Historic Site, 1981 (OL 1981.11)

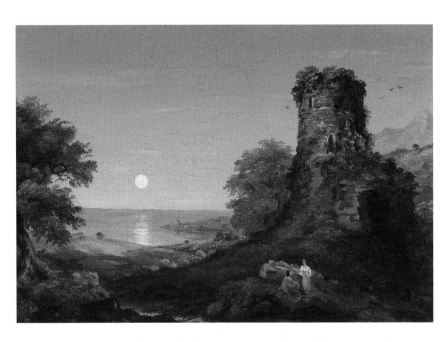

Fig. 15. Thomas Cole (American, born in England, 1801–1848). **Tower by Moonlight,** ca. 1838. Oil on canvas, 10 1/8 x 14 1/8 in. Thomas Cole National Historic Site. Gift of David and Laura Grey

gems, the 'Rising Sun' and 'Rising Moon' allegorical in their nature, expressive of the artist's [sic] welcome to the son and daughter added to the family circle."[2] He painted *Sunrise* (*The Rising Sun*) (Fig. 14), to celebrate the birth of his son Herbert Edwin on October 29, 1862, a child beloved by his parents. The sun in the painting is the perfect emblem of a hopeful future. *Sunrise* is infused with the pleasure of the artist's happy anticipation for the future of this boy, "in the hush world of the dawn of life, there is the subtle tremor of expectancy as all future possibilities remain open."[3]

The Rising Sun did not originally have a pendant, but Church painted the other half of what became a de facto pair three years later, *Moonrise* (*The Rising Moon*) (Cat. 20), celebrating the birth of Church's daughter Emma Frances in 1865. In this scene, the moon rises over a quiet sea—the painting's mood infused with calm and hope.

The Church family's happiness was dashed with the shocking death of Herbert from diphtheria on March 18, 1865, and his sister followed him to the grave just a week later. The canvases of a hopeful future were almost overnight transformed into melancholy memorials to tragedy. Several years later, likely in the mid–1870s, when the grief was not as fresh, the Churches hung *Sunrise* and *Moonrise* together as a pair in their sitting room at Olana, the family's Moorish–inspired estate near Hudson, New York, where they can both be seen to this day.[4]

As we see, the idea of gender as two polarities attaches itself to the sun and the moon—a focus on ideas and characteristics that tend to be aesthetic and emotional opposites: male/female; light/dark; rational/irrational; spiritual/sensual; and, intellectual/

Left: Cat. 21. Thomas Cole (American, born in England, 1801–1848). **Autumn Eve at Vallombrosa**, n.d. Oil on board, 8 3/4 x 7 in. The Frances Lehman Loeb Art Center at Vassar College. Gift of Matthew Vassar, 1864 (1864.1.19)

Fig. 16. Thomas Cole. **Vallombrosa**, ca. 1831. Oil on board, 7 1/8 x 5 7/8 in. Albany Institute of History & Art. Purchase, 1958 (1958.16)

emotional. With a similar sense of polarity, Romanticism duels with rationality, emotional frenzy weighs against restrained Classicism. In 19th-century painted landscapes, this division appears in the fantasized architecture of Thomas Cole: the blazing sun against the walls of an ancient temple versus the moonbeam shining down on an ivy-covered medieval castle.

The image of the ruined tower in moonlight—poetic architectural decay—gives stimulus to the poetry of decay and was a repeated motif in the works of Thomas Cole. Born in England in 1801 at Bolton-le-Moors, in Lancashire, Cole immigrated at 17 with his family to the United States, first to Steubenville, Ohio, then to Philadelphia. A great success as a landscape painter, Cole is credited as the Father of the Hudson River School, and his influence on younger landscape artists who followed him is widely recognized. Cole began to make a name for himself in 1825 based on a series of plein air sketches of the Hudson Valley that he created and showed with some success in New York City.[5] Cole's moonlit canvases in *The Color of the Moon* from the 1830s, fairly early in his career, have the overt flavor of romanticism about them, which ran through his work of that period. Although undated, *Autumn Eve at Vallombrosa* (Cat. 21), is a plein air sketch, and probably dates from mid-1831, when Cole produced a similar sketch entitled *Vallombrosa* (Fig. 16), showing the monastery at the same site, about 19 miles outside of Florence.[6] Cole made these sketches during his five-year tour of Europe, which he began in 1829.[7] In the daylight version of the sketch, Cole has included the small figure of an artist, who is drawing on a promontory

opposite the site, a wink to the viewer that Cole occasionally inserted into his landscapes, and which could occasionally border on camp.

In *Autumn Eve at Vallombrosa* Cole takes the same-sized canvas board used horizontally for his daytime sketch and turns it to a vertical orientation. The foreground of the vertical painting deepens into black shadow, and creates a moodier sense of isolation around the monastery. In both the horizontal and the vertical compositions, the sky is reduced to a fairly small proportion of the canvas, and in the evening scene the moon is not the full and lush sphere of *Landscape (Moonlight)* (ca. 1833–34) (Cat. 22), or *Tower by Moonlight* (ca. 1838) (Fig. 15), but is reduced to a small crescent, a mere single brushstroke clinging to the horizon line, in danger of slipping into the forest.

Cole may have been particularly intrigued by the historic monastery, because John Milton famously referenced Vallombrosa in his epic poem *Paradise Lost* (1667), with the lines:

> Thick as autumnal leaves that strow the brooks
> In Vallombrosa, where th' Etruria shades
> High over-arch'd imbow'r.[8]

Cole was likely familiar with the contemporary 1828 Romantic poem *Vallombrosa* by William Sotheby, and Sotheby's and Milton's specific references to autumn likely suggested Cole's title, *Autumn Eve at Vallombrosa*, which in its daylight variant appears to be somewhat more summer-y:

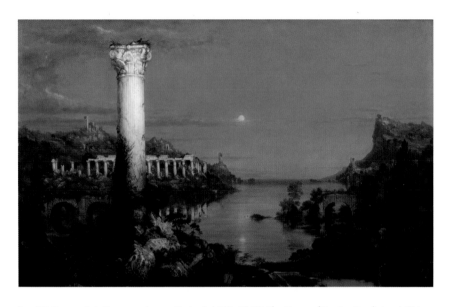

Fig. 17. Thomas Cole (American, born in England, 1801–1848). **The Course of Empire. Desolation.** 1836. Oil on canvas, 39 1/2 x 63 1/2 in. The New-York Historical Society. Gift of The New-York Gallery of the Fine Arts, 1858 (1859.5)

Must I then leave you, hermit haunts! nor trace
Once more the scenes that, varying on my way,
Made, like a transient dream, the summer day?

No more search out the consecrated place
Where o'er a Milton's harp a seraph rose,
As Autumn thickly strow'd her leaves o'er
Vallombrose?[9]

Unlike his small, quickly executed plein air sketches, Cole's *Landscape (Moonlight)* was a larger production worked up at the artist's studio in New York, from studies produced in Europe and painted for Cole's great patron Luman Reed.

As with *Autumn Eve at Vallombrosa*, Cole's visual art was inspired by the work of another Romantic poem, this time, Lord Byron's 1816 poem *Parasina*, about the incestuous love of Queen Parasina for her stepson, both gruesomely beheaded when their affair was discovered. Cole was proud of *Landscape (Moonlight)* and this work was shown at the National Academy alongside lines from Byron's poem, although scholars have noted that Cole metaphorically "drew a veil" over the lurid subject matter. In Cole's moonlight scene, a figure on the left of the canvas romantically plays the lute for a listening woman, while in the tower the glowing red torchlight suggests the illicitness of a bordello that two men enter to make their way to the tower's lighted window, perhaps to catch the lovers *in flagrante*. A tomb surmounted by a crucifix at the base of the composition is gently

illuminated by moonlight and acts as a moral counterpoint to the sordid activities suggested in the tower and infuses the work with a Christian counterbalance. Cole takes artistic license with the events as described by Byron, but there is the strong implication that the moonlight provides the necessary concealment for illicit acts under the cover of darkness. The moon bears witness to events, but tells no secrets. In a letter from Cole to his wife, we learn that she held the common belief that the new moon was bad luck if seen over the left shoulder, though Cole humorously tweaks her superstitions as bad omens turn to good luck for his career:

> I was very much down, for several days, after I left you
> & one evening there was a new moon + of course
> I looked point blank over my left shoulder of course
> I thought of your warning to me on that subject. But you
> must mark the fearful result I received a commission from
> Mr. [Jonathan] Mason the very next morning… The next
> morning, I receive a commission from a Mr. [George W]
> Austen for a $500 picture—and last evening, the Art
> Union purchased my two pictures. So, you see what
> looking over the left shoulder does.[10]

Luman Reed, a New York City merchant in the 1820s and a patron of the arts, commissioned *Landscape (Moonlight)*, and also Cole's famous *Course of Empire* series (1833–1836), which traces the rise and fall of an allegorical empire that viewers of that day took

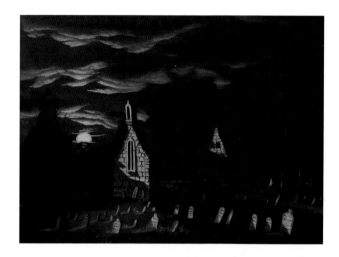

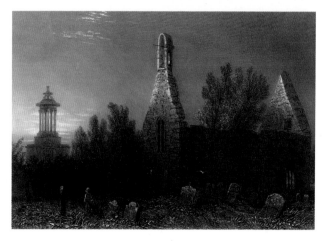

Cat. 18. Thomas Chambers (American, born England, 1808–1869). **Old Sleepy Hollow Church**, ca. 1850. Oil on canvas, 18 3/4 x 24 3/8. Flint Institute of Arts. Gift of Edgar William and Bernice Chrysler Garbisch, 1968 (1968.18)

Fig. 18. William Henry Bartlett (English, 1809–1854). **Alloway Kirk with Burns' Monument**, 1838. Steel engraving in Scotland Illustrated by William Beattie, 11 x 8 1/2 in. Hudson River Museum. Museum purchase, 2018

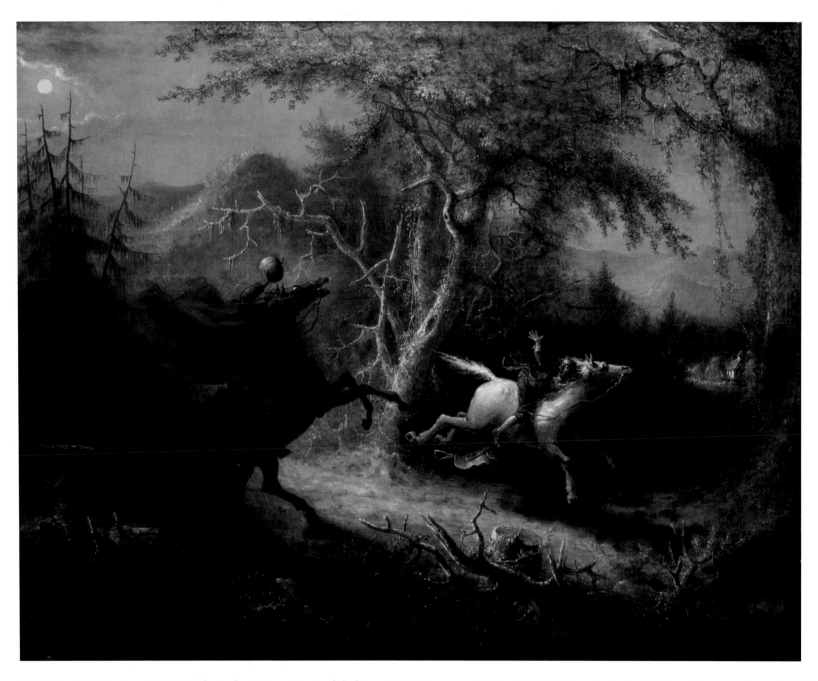

Fig. 19. John Quidor (American, 1801–1885). **The Headless Horseman Pursuing Ichabod Crane,** 1858. Oil on canvas, 26 7/8 x 33 7/8 in. Smithsonian American Art Museum. Museum purchase made possible in part by the Catherine Walden Myer Endowment, the Julia D. Strong Endowment, and the Director's Discretionary Fund, 1994 (1994.120)

to parallel the young United States republic. Depending on their outlook, they tended to see the series either as a warning of the dangers of imperial overreach or a prophecy of the nation's coming greatness. In his famous sequence, Cole varied the times of day as a metaphor for the rise and fall of empire: dawn appears in the *Primitive State* of the series, moving on to high noon at the peak of Empire to dusky twilight in the final of five panels, *The Course of Empire: Desolation* (Fig. 17). In this final picture, the shattered buildings and the remains of the classical buildings are still visible. Reason has been defeated, and the viewer is shown a romantic and poetic vision: a single ruined column stands at the center of the canvas. On its capital rests a nesting bird, the symbolic harbinger of hope for the future. Cole's final panel deliberately conjures the idea that the cyclical nature of history may continue. The sunrise in the first painting is mirrored in the last by a rising moon, a soft lavender sky reflected in the still bay surrounded by wreckage, and a pillar lit by the last rays of sunset. The moon arrives to preside over the sorrowful, though peaceful scene.

Tower by Moonlight (ca. 1838) is a smaller effort by Cole to feature another painted full moon. Completed after the monumental undertaking of *The Course of Empire* series, Cole returns again to the poetry of the ruined tower lit by the moon in landscape, a composition similar to the one in *Landscape (Moonlight.)* Rather than show the depth of dark night as in the earlier picture. Cole uses, instead, the soft lavender twilight, a color combination of setting sun and rising moon similar to *Desolation*. As in *Desolation*, the stillness of the sea, infuses the picture with a calmness that inspires our thought. *Tower by Moonlight* has a morbid undertone. The tower suggests the passage of time and faded glory—a castle to which the ruined tower belongs is a military structure, fallen into decay, and suggests violation and defeat. Even more overtly, a sarcophagus acts as a *memento mori*. The strolling young couple stop to contemplate the fleetingness of love and youth as the moon rises.[11]

Thomas Cole's moonlit scenes are visual exemplars of the Romantic movement expressed in American landscape painting, and he was representative of a much broader trend of American landscape—the impulse to depict highly romanticized scenes. Another Englishman, Thomas Chambers, born seven years after Cole, and, like him, an emigrant to the United States, drew inspiration from popular works of literature, underscoring the relationship between art and the written word during the Romantic period. Chambers was a painter of middling success, never achieving Cole's acclaim. Known for both marine scenes and landscapes, he also adapted images of popular engraving from works such as W.H. Bartlett's *American Scenery*.[12] Such workmanlike methods probably held him back from the first ranks of painters and he gradually faded into obscurity. However, his reputation began to rebound in the 20th century, and it is clear why. Chambers' hard-edged line and bold colors appeal to the modern eye. Chambers' *Old Sleepy Hollow Church* (Cat. 18), painted around 1850, is a perfect example of the way the artist combines both the Romantic impulse and the elusive quality of semi-trained "outsider" art. Here, Chambers is vague about his light source

illuminating the night sky, and it is clear that not all the light in the picture is being derived solely from the moon. This unseen artist-augmented light source represents a kind of visual "cheating" that a number of critics have commented upon in moonlit scenes. It points up the difficulty of using a single weak light source to provide the viewer's eye with sufficient narrative detail, when the artist attempts to use the moon as his or her sole source of illumination.[13]

The painting's title is almost certainly suggested by Washington Irving's story "The Legend of Sleepy Hollow," contained in his volume *The Sketch Book of Geoffrey Crayon, Gent*, first published in 1820, and written a generation before Chambers painted his canvas. Irving's story, though, had entered the popular consciousness and the American literary canon, where it has remained firmly entrenched. Chambers' painting is an example of the fairy-tale book quality of his best work and could almost function as the animation cell for Irving's narrative. To enhance the suitably creepy atmosphere of the graveyard, Chambers depicts the famous meeting of the hapless school teacher Ichabod Crane with the fearsome Headless Horseman.

An opening in the trees now cheered him with the hopes that the church bridge was at hand. The wavering reflection of a silver star in the bosom of the brook told him that he was not mistaken. He saw the walls of the church dimly glaring under the trees beyond. He recollected the place where Brom Bones's ghostly competitor had disappeared. "If I can but reach that bridge," thought Ichabod, "I am safe."

Washington Irving, "The Legend of Sleepy Hollow", 1820[14]

In *Old Sleepy Hollow Church* the moon is full, and convincingly lights up the sky in the background, its edges obscured by wisps of clouds. The gravestones, though, receive almost spotlight illumination from a brilliant unseen light source at the left of the canvas. Chambers uses the light of the moon and that from the unseen source, suggesting it is supernatural or demonic to showcase the horror of the graves and intimate that the Headless Horseman lies in wait nearby. Chambers' success in both this work and *Storm-Tossed Frigate* (1845), is to combine a rollicking storybook painting style with frightening subject matter to provide the viewer with a frisson of pleasure.

In fact, Chambers may not have originally intended his piece to stimulate the audience's association with Irving's well-known story. The title of the piece may have been given to it by a Hudson Valley collector, who drew a natural parallel to Irving's story. A convincing case has been made that before Chambers' work developed an Irving-themed narrative, the source material was actually an 1838 etching by well-known artist William H. Bartlett of *Alloway, Kirk, with Burns' Monument* (Fig. 18), which showed the setting for a famous narrative poem by the Scottish writer Robert Burns.[15] Burns's poem involved a ghostly pursuit by the drunken hero Tom O'Shanter who envisioned seeing a coven of witches and fled across the "Bridge of Doune" to safety. Chambers changes the composition, replacing the identifiable monument to Robert Burns that appears in the Bartlett pictures with foliage and replaces the soft, elegiac light of the unseen moon in the engraving with storybook Gothic dread, and a dark night

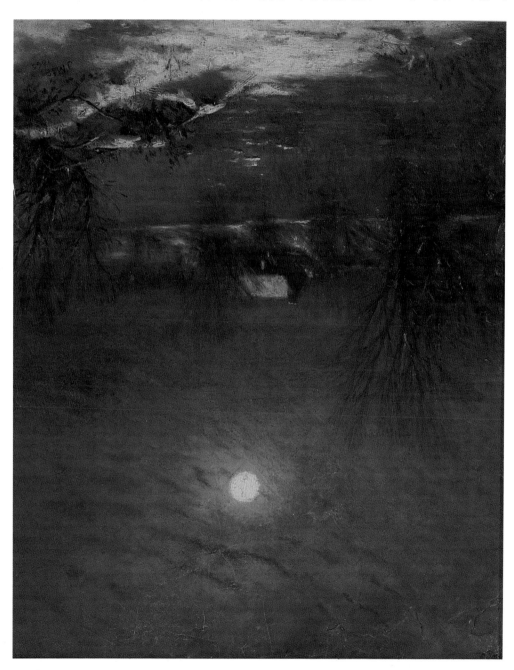

Fig. 20. Jarvis McEntee (American, 1828–1891), *Under a Full Moon*, 1865. Oil on canvas, 12 x 10 in. Photograph: Sotheby's, Inc. © 2018

that paradoxically emphasizes the harshness of the moon's light, and makes the huge moon the illuminated focal point of the picture.

John Quidor, a painter of literary and historical subjects, frequently depicted genre scenes drawn from the moonlight. His 1858 painting, The Headless Horseman (Fig. 19), is an interesting pictorial contrast with Old Sleepy Hollow Church. Here, the old church that Chambers portrayed in ruins is surrounded by eerily leaning stones pushed into a cozy vignette on the right side of the canvas. Rather than ominous, the little church appears a harbor of safety for the frightened Ichabod. Quidor bathes the whole scene in almost glaring moonlight shining from a full moon in the upper left corner of the composition. As with Chambers, the light source is indefinite. On inspection, the strong "spotlight" raking across the central action seems unlikely to be fully emanating from the feeble pale disc that Quidor suggests. Rather than harming the composition, the strong, unsourced light plays up the feeling of a supernatural event in the midnight forest.

Another Chambers' painting, Storm-Tossed Frigate (1845), is a small masterpiece that encapsulates the rather overheated drama loved by Romantic painters. Here, the moon takes center stage to the action, brilliantly illuminating the stormy seas, due to the physics of the light being slightly off-kilter. Although the moon is the light source behind the ship, the waves are lit from the sides and front, which, beyond its storybook qualities, creates a strange Baroque–Surrealist mix that anticipates the later work of Italian artist Giorgio de Chirico. It is possible that Storm-Tossed Frigate was inspired by the novel The Pirate by Captain Frederick Marryat. Marryat's book

Cat. 61. John Ferguson Weir (American, 1841–1926). Christmas Bell, 1866. Oil on canvas, 16 x 10 3/8 in. The Butler Institute of American Art, Youngstown, Ohio (958-O-145)

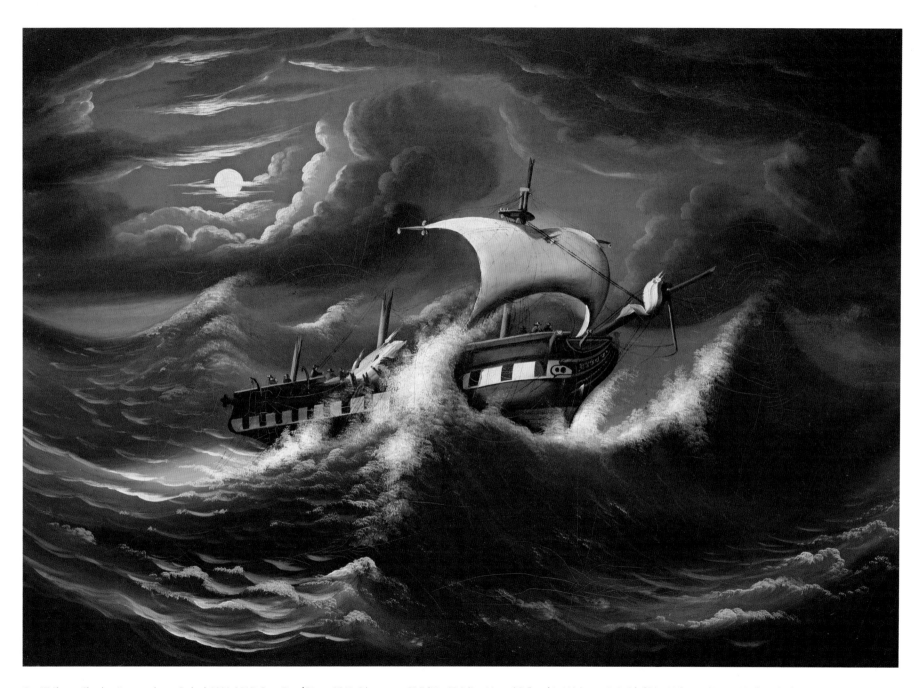

Cat. 17. Thomas Chambers (American, born in England, 1808–1869). **Storm Tossed Frigate**, 1845. Oil on canvas, 21 7/16 x 30 3/8 in. National Gallery of Art, Washington, D.C. Gift of Edgar William and Bernice Chrysler Garbisch, 1969 (1969.11.1)

Fig. 12. John Ferguson Weir (American, 1841–1926). **Halloween**, 1866. Oil on canvas, 16 x 10 1/2 in. The Butler Institute of American Art, Youngstown, Ohio (958-O-146)

was illustrated by the author's close friend Clarkson Stanfield, a well–known marine painter, and Chambers likely was motivated by Stanfield's compositions, although given Stanfield's fame Chambers was perhaps hesitant to stick too closely to copying the compositions of his inspirational source material.

Instead, Chambers gives his piece a more generic feeling by not detailing specific dramatic scenes from the book.[16] He shows a three–masted sailing ship under the night sky, wretchedly tossed by ocean gales. The vessel has already lost two of its masts, snapped by the storm, and the final sail inflates dramatically like a balloon. The falling masts have smashed the deck, emphasizing the precarious situation. Chambers' only minimally suggests the frantic actions of the sailors, who appear as little more than daubs of color. But the moonlit storm provides the action and creates the necessary drama, as the ship lurches forward and the viewer wonders if the last sail can hold against the rushing winds. Chambers paints the sea curling up at the edges of the canvas and the clouds of the sky curving down to meet the outer limits of the horizon. By doing so, the artist creates an effect of looking at the scene as if through a spyglass on the deck of a nearby ship. Chambers' format, literally "telescopes" the action, cleverly focusing the viewer's attention to the action.

A persuasive case has been made for identifying compositional elements in Hudson River School landscape painting that signaled and signified the national trauma of the American Civil War (1861–1865), and there is likewise a strong temptation to read many of the moon paintings created during the years of the Civil War

as metaphors for the darkness that was encroaching on the country. The moon became a beacon of hope, a lantern hung aloft to act as a moral compass.[17]

In 1865, the same year that Frederic Church was painting *The Rising Moon* and experiencing the traumatizing loss of his children, his good friend, the less well-known artist Jervis McEntee, painted *Under a Full Moon* (Fig. 20), where the moonlight falls against icy water and pale snow. The work, showing a tiny illuminated window cozily glowing red, has all the Romantic sensibility of Thomas Gainsborough's *The Cottage Door* (ca. 1778, Cincinnati Art Museum), filtered through the lens of the snug, sentimental, cottages of contemporary painter Thomas Kinkade. Given that the world McEntee knew had been torn asunder by war, the painting is a message of calming reassurance to a troubled world. The focus on the moon, itself, is instructive: McEntee repeatedly wrote about the moon, noting and recording its appearance in his diaries, which provide glimpses into artist's observational process. Descriptions of the moon appear regularly in his diary over decades, and he often noted the pictorial possibilities and romantic effects of light that might be achieved:

August 5, 1873 — The moon is full and last night was as light as day.

December 4, 1886 — At work in my studio until 3 o'clock. Painted the moon on the glittering snow I saw last night and a little autumn picture from one of my studies of this fall.

February 20, 1886 — I . . . have begun a twilight moon rise effect a reminiscence of the Roman Campagna.[18]

Poignantly, McEntee suggested his yearning to capture the beauty of moonlight in a way that signaled he understood nature's beauty trumps the artifice of the painter's canvas:

November 3, 1873 — It has been a lovely day, windy but with grand cloud effects and now the moon is nearly full giving us gloriously beautiful nights. I wish I could paint this vague, mysterious light of the moon.

If McEntee never quite achieved the poetic heights he sought in his moonlit nights, nonetheless, in charming works like *Under a Full Moon*, he did succeed in conveying the dazzling effect of "day for night" that Clement C. Moore famously described in *A Visit from St. Nicholas*, in 1823:

The moon on the breast of the new-fallen snow,
Gave a lustre of midday to objects below.[19]

Moore's poem, better known *as The Night Before Christmas* describes the magical nighttime arrival of St. Nicholas on a moonlit Christmas Eve, and it was painted by John Ferguson Weir, who contributed to our popular visual idea of Santa Claus. As the Civil War raged, Weir continued his success depicting the holiday season. In March 1864, he first presented an image that became known

known as *Christmas Eve* or *Christmas Bell*, and he made at least five variants of it over the next fifteen years.[20] The image is quintessentially Romantic. The giant cast bell is seen chiming, framed by a stone arch in the belfry, adorned with ivy, and is bathed in moonlight that shimmers off the metal. What could be read as an almost ominous scene (*ask not, for whom the bell tolls…*) is transformed by the presence of teeming groups of tiny torch-bearing fairies swarming to the belfry, sitting on its ledge, and animatedly clamoring to pull the bell rope and sound the arrival of Christmas. In each of Weir's versions the portion of the moon visible through the arch varies slightly, as does the quality and color of the moonlight. The largest and last *Christmas Bell*, painted in 1879, has a colder, clear light and far fewer fairies than the earlier golden-toned compositions. By subtly varying the degree of whimsy, Weir allows different degrees of meditative contemplation. What the later piece loses in charm, it gains in stature. But in all of the versions, Weir presents the moon's light on the bell as a moral force of Christian devotion mixed with a joyous paganism to inspire the viewer's soul with the holiness of the holiday.

With his ongoing success painting scenes celebrating the Christmas season, Weir created *Halloween* (Fig. 12), a small canvas dominated by a huge orange harvest moon. Where his *Christmas Bells* hold a moralizing cast, here the moon seems an almost malignant, radioactive force, and again, fairies, or "wee folks" appear in agitated dance in the moonlight and down among the dark foliage and flowers.[21] Weir's inclusion of mullein stalks in the composition not only gives the picture needed vertical thrust, their inclusions were apropos in a picture entitled *Halloween*, as it was said that

witches dipped the stalks in fat to make torches, commonly known as "hag tapers."

The nocturnal, moonlit-dappled paintings of the Hudson River School artists make up a comparatively small subsection of their oeuvre. In the final decades before the growing use of gaslight and urban electrification transformed the moon's power from an encompassing glow into a nightlight receding behind the glare of the streetlight, 19th-century American artists recognized the moon's possibilities to conjure romantic ideas. As a device to heighten romanticism, the moon became much more than a thumbnail-sized disc of white paint on canvas. Instead a few brushstrokes of a painted moon offer us a touch of magic in a world increasingly obsessed with science.

ENDNOTES

1. William Chapman Sharpe, *New York Nocturne: The City After Dark in Literature, Painting and Photography, 1850–1950* (Princeton University Press, 2008), 82.

2. Quoted in Gerald L. Carr, *Frederic Edwin Church: Catalogue Raisonné of Works of Art at Olana State Historic Site* (Cambridge University Press; two vol., 1994), "A Ramble Among the Studios of New York," *Hartford Daily Courant*, Mar. 22, 1865, 2.

3. Carr, *Frederic Edwin Church:* Catalogue Raisonné, 282.

4. Karen Zukowski. Historic Furnishing Report for the Olana State Historic Site (Part II, 2001), 401–402.

5. Elizabeth Mankin Kornhauser and Tim Barringer, *Thomas Cole's Journey: Atlantic Crossings*, with Dorothy Mahon, Christopher Riopelle, and Shannon Vittoria (The Metropolitan Museum of Art, 2018), 97.

6. Christopher Riopelle in Kornhauser, *Thomas Cole's Journey,* 102.

7. The New–York Historical Society curatorial files. Object no. 1858.31.

8. John Milton, *Paradise Lost and, Paradise Regained.* (Signet Classic, 2001).

9. Williams Sotheby "Vallombrosa" in *Italy, and Other Poems* (Gale NCCO, Print Editions, 2017). Accessed at http://spenserians.cath.vt.edu/TextRecord.php?action=GET&textsid=37864

10. Ellwood C. Perry, III, "Thomas Cole's 'The Hunter's Return,'" *The American Art Journal*, 1985.

11. Unsigned article, "Thomas Cole's 'Tower by Moonlight' is Donated" (Thomas Cole National Historic Site Newsletter, Fall 2014), 1. Accessed at https://www.thomascole.org/wp–content/uploads/2016/04/2014_newsletter_fall.pdf

12. National Gallery of Art, Washington, D.C. Thomas Chambers online artist biography. Accessed at https://www.nga.gov/collection/artist–info.1118.html

13. Sabine Rewald, *Caspar David Friedrich: Moonwatchers* (The Metropolitan Museum of Art, 2001), 14.

14. Washington Irving, "The Legend of Sleepy Hollow" in The *Sketchbook of Geoffrey Crayon*, 1820. Accessed at Project Guttenberg: https://www.gutenberg.org/files/41/41–h/41–h.htm

15. Kathleen A. Foster, *Thomas Chambers: American Marine and Landscape Painter, 1808–1869* (Philadelphia Museum of Art/Yale University Press, New Haven, 2008), 60.

16. Foster, *Thomas Chambers*, 22.

17. See Eleanor Jones Harvey *The Civil War and American Art* (Yale University Press, 2012).

18. Jervis McEntee. Diaries 1872–1890. Archives of American Art Online Database. https://www.aaa.si.edu/collection–features/jervis–mcentee–diaries

19. Clement C. Moore "A Visit from St. Nicholas", 1823: Accessed at Project Guttenberg: http://www.gutenberg.org/files/17382/17382–h/17382–h.htm

20. Betsy Fahlman. *John Ferguson Weir; The Labor of Art (*Newark: University of Delaware Press, 1997),54–55.

21. Fahlman. *John Ferguson Weir; The Labor of Art,* 56.

THE MOODY MOON OF THE GILDED AGE

Theodore Barrow

From the subdued clarity of romantic twilight that streaked the sky, up to the end of the Civil War, to the electric haze of the early 20th century, the sheen of the Gilded Age was often moonlit.

The sun specifies, the moon generalizes. As a Gilded Age journalist observed, "In the strong light of the sun, form and color both come out. Sunlight reveals, intensifies; moonlight sheds the spirit of mystery—of poesy—o'er the scene."[1] The Gilded Age—a term coined by Mark Twain and Charles Dudley Warner from a novel of the same name in 1873— bore witness to the reconfiguration of nocturnal spaces in life and art. While the somewhat forgettable novel was about political corruption, the "Gilded Age" blankets the entire late 19th century, from the mid–1870s, and even past 1900. This time, directly following America's Civil War, was a time of rapid development, but marred by corruption, the despoiling of the countryside that contrasted the exhilarating growth of cities, and a highly charged public life dominated by labor strife and racial violence. The Western frontier of the continental United States had been reached, and a trail of blood followed the railroads, which now belted the country. Covering this tawdry reality with a thin layer of artificial gilding seemed an apt metaphor for the whole period. In many paintings, the pale glow of painted moonlight served not to illuminate, but to amplify forms and figures in the night landscape fading into darkness.

Cat. 40. Winslow Homer (American, 1836–1910). **Moonlight**, 1874, detail. Watercolor over graphite on paper, 14 x 20 in. The Arkell Museum at Canajoharie. Gift of Bartlett Arkell

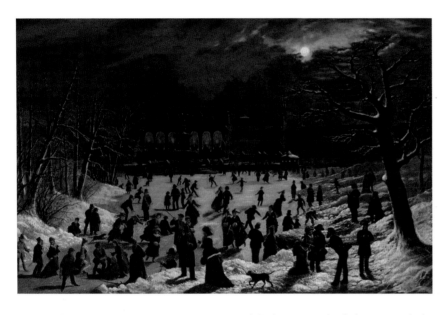

Cat. 41. John O'Brien Inman (American, 1828–1896). **Moonlight Skating, Central Park, the Terrace and Lake,** 1878. Oil on canvas, 34 ½ x 52 ½ in. Museum of the City of New York, 1949 (49.415.2)

With metropolitan development and advances in artificial lighting, an artist's glances toward the moon were necessarily tinged with nostalgia. John O'Brien Inman's 1878 painting *Moonlight Skating, Central Park, the Terrace and Lake* (Cat. 41), emblematizes the relationship of people and nature in the Gilded Age. Although Central Park itself was relatively new, it was the direct product of urbanization and the twinned impulse of anti–urban nostalgia. The snow–covered landscape and frozen lake are bathed in moonlight, outlining the skaters who are enjoying a few more moments of social activity before the night becomes too dark. In the background dark clouds threaten to obscure the moon and the deep shadows are relieved only by the glowing arcade of Bethesda Terrace. Just as the term "gilded" meant artificial and provisional, so too did the moonlit scenes created during this time evoke the passage of time and impermanence. In a society that was beginning to see too much of itself, art became concerned with concealment and obscurity.

We are interested here in the Tonalist artists who painted between the first publication of Jules Verne's *De la terre à la lune* in 1865 and the cinematic adaptation of Verne's fantasy by Georges Méliès in 1902. Deploying a subdued palette and misty forms, these artists stressed harmony over narrative. In this time of radical change, the moon remained a central, potent subject for artists and their audiences. Bookended by romantic scenes of twilight and the phantasmagoric spaces lit by modern electricity, the Gilded Age witnessed one of the most significant shifts in the way that moonlight was painted. Although moonlit nocturnes enjoyed a special place within the history of European art, replete with biblical and mythological associations, American art in the late 19th century was

notable for its sustained and varied attention to the ever–changing color of the moon. From the subdued clarity of romantic twilight that streaked the sky up to and until the end of the Civil War to the electric haze of the early 20th century, the sheen of the Gilded Age was often moonlit.

Perhaps no artist better embodied the Gilded Age than John Singer Sargent. Born to expatriate American parents in Florence, the artist lived a peripatetic existence all over Europe, devoting his work to painting portraits of demimonde, imperiled European aristocrats, and wealthy, notorious Americans. In a rare landscape from his early career, *In the Luxembourg Gardens* (Fig. 21), we get a sense of how the moon figured in the art of cosmopolitan artists of the Gilded Age. Sargent creates a distinctive mood in his scene of the public gardens on the Left Bank of Paris, painting a glowing, if fading, light under a harvest moon. A modern subject of leisure in a public park in Paris demonstrates Sargent's awareness of both the concurrent Impressionist paintings of his friend Claude Monet and his colleagues, as well as the nocturnal harmonies of James Abbott McNeill Whistler (Fig. 22). However, unlike his artistic colleagues, Sargent focuses on the psychological distance between the figures in the park, showing both moments of solitary absorption and stiff, awkward strolling. Within this intoxicating setting the principal couple, though arm in arm, do not look at one another. He contrasts the romantic intimations of moonlight with the social disconnection of the people in the park. The intriguing detail of the moon's reflection in the pool is a vignette of nature's confinement.

Across the ocean and in the midst of technological developments in railroads, factories, photography and electricity following the Civil

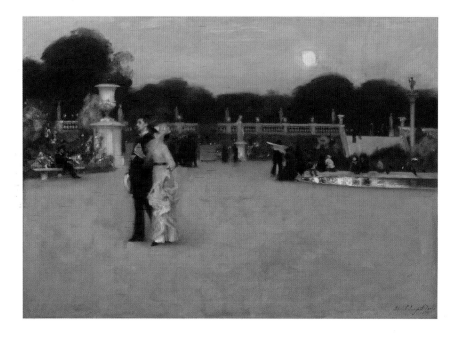

Fig. 21. John Singer Sargent (American, 1856–1925). **In the Luxembourg Gardens,**1879. Oil on canvas, 25 7/8 × 36 3/8 in. Philadelphia Museum of Art. John G. Johnson Collection, 1917 (1080)

War, American artists also explored brooding, moonlit scenes with layers of possible meanings. Many writers and scholars have interpreted this trend in nocturnal art as an inverse reflection of the rapidly–illuminating present.[2] Indeed, in the last years of the 19th century when electricity was soon to be seen everywhere, painting the moon reached a zenith of popularity. Sustaining some of the romantic melancholy of the Hudson River School, these moonlit landscapes juxtaposed time and space, modernity and eternity, the fruitless quibbling of humankind below and the titanic patterns of planets above. If art of the first native–bred school of painters, the Hudson River School, was defined by its attention to radiantly illuminated landscapes in a romantic idiom, the next generation of artists working between the Civil War and the First World War often worked in the long shadows cast by Thomas Cole's twilight scene, *Desolation*, from *The Course of Empire* (1836), (Fig. 17).

As late as the 1890s, Warren Sheppard, in *The City of Paris* (Cat. 56), employed the rhetoric of Hudson River School marine paintings to celebrate the so–named ship's record–breaking transatlantic voyage from Ireland to New York in less than six days. With Gilded Age audacity, the artist flips this traditional romantic reminder that the ship is subject to the awesome power of nature, and stresses, instead, the perseverance of the modern vessel steaming through the moonlit night, as an older sailing ship, in the background, is tossed by the waves. Like sunlight reflected off the moon and skipping across the waves, the sailors' journey echoes the movement of the moon across the sky. For the most part, however, the assuredness and bombastic optimism of the landscapes of the previous generation gave way to suggestive nocturnes.

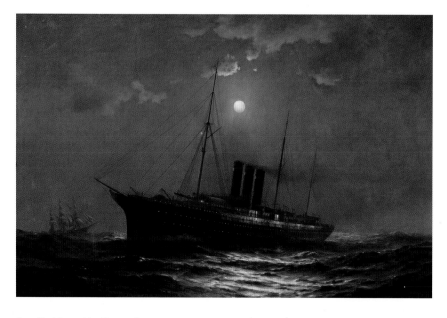

Cat. 56. Warren W. Sheppard (American, 1858–1937). **The City of Paris,** ca. 1892. Oil on canvas, 39 x 60 in. Post Road Gallery, Fine American Paintings

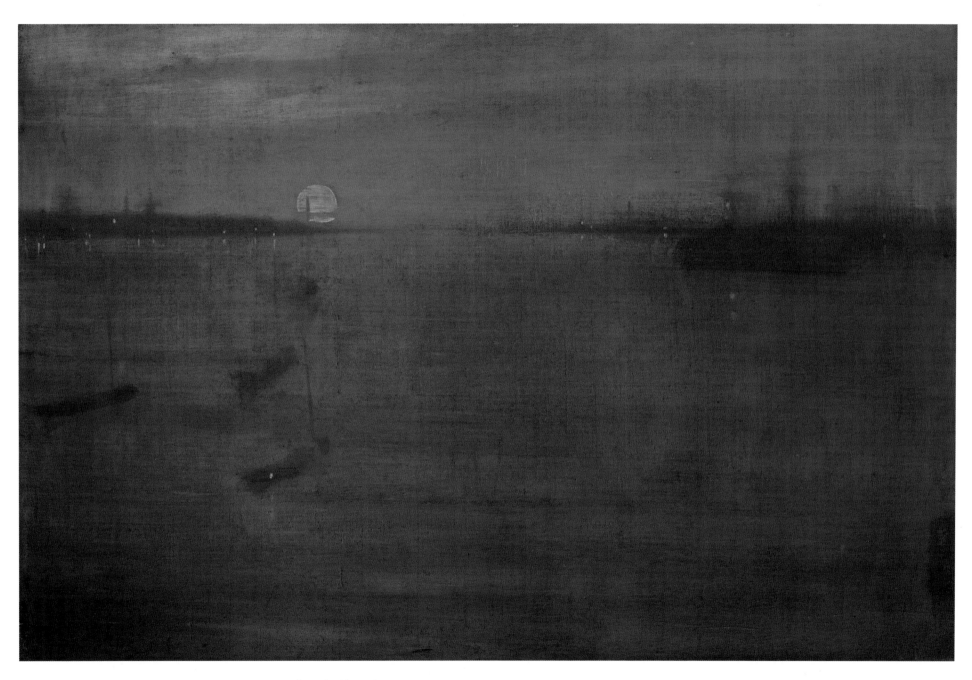

Fig. 22. James McNeill Whistler (American, 1834–1903). **Nocturne: Blue and Gold—Southampton Water,** 1872. Oil on canvas, 19 7/8 x 29 15/16 in. Art Institute of Chicago. Stickney Fund, 1900 (1900.52)

Fig. 23. Winslow Homer (American, 1836–1910). **Searchlight on Harbor Entrance, Santiago de Cuba,** 1901. Oil on canvas, 30 1/2 x 50 1/2 in. The Metropolitan Museum of Art, New York. Gift of George A. Hearn, 1906 (06.1282)

The moon endured as an essential element in American landscape painting through the 1870s, and, in the case of Winslow Homer's *Moonlight (East Hampton Beach)* of 1874 (Cat. 40), moonlight became the foil to a scene of emotional and physical tension. East Hampton was, in many ways, a Gilded Age destination, only made accessible to visitors through the construction of a railroad the year before. Unlike the moonlit voyages and violence of the Romantic generation, Homer's *Moonlight* merely illuminates one of the newly–popular "watering places" enjoyed by young couples flourishing fans and walking sticks.

This watercolor signals a turning point in depictions of the moon in American art in both medium and subject. With the founding of the American Society for Painters in Water Colors in 1866, later called the American Watercolor Society, artists of Homer's generation capitalized on new exhibition venues and a growing market for watercolor. Exhibited in the society's showing at the Brooklyn Art Association in 1875, *Moonlight* was the most expensive watercolor he submitted and probably the largest, at 20 by 14 inches. The $160 listed price, well above the $30 to $100 range for the other watercolors, indicates his sense of the work's significance.[3]

Despite subdued light made by thin washes of watercolor, the artist packs a lot of information into this moonlit scene. Two figures look towards the moonlit horizon. The seated figure on the left tilts her head towards her shoulder, away from the reclining man to her right, in a pose suggesting both reverie and tacit invitation to romance. Moonlight bathes everything in muted glow: a shimmering reflection on the placidly–breaking waves on the right, the faint calligraphy of sea spray. Above,

scattered diagonal clouds cast dark shadows along an eerily–lit beach and illuminate the arm, shoulder, and head of the seated female figure. While the man points his walking stick suggestively at the woman's casually drooping fan, the couple otherwise does not seem close. Both look away from the moon, awkwardly directing their gaze towards the horizon, not at one another. Like Sargent's Luxembourg strollers, this couple seems separated by moonlit distance.

If moonlight had been a Romantic convention used by American artists in the previous generation, Homer challenges this romance in the 1870s. The overdressed figures seem to have overstayed their welcome on the beach, and the moon offers a persistent, if ravishing, reminder that time has passed. Compared to the moonlit beaches in Hudson River School paintings, such as Frederic Edwin Church's *Moonrise* (also known as *The Rising Moon*, 1865) (Cat. 20), Homer, the realist, deflates the romantic pathos of Church's moonlit beach by placing a couple in a suspended state of awkward flirtation that blocks the horizon (and, perhaps, their love).

Towards the end of Homer's career, he returned to the moon as a subject, often juxtaposing artificial light with moonlight. In 1901, in *Searchlight on Harbor Entrance, Santiago de Cuba* (Fig. 23), he again silhouettes a foreground form, here the 16th–century Morro Castle, a vestige of the Spanish Empire in Cuba, with the illuminated sky. Electric searchlights crisscross the sky, competing with the fainter glow of the moon. A demonstration of the superior military technology that brought about a swift victory for the Americans in the Spanish–American War of 1898, the electric light is a symbol of an unnatural future. The intense

Left: Fig. 24. William Morris Hunt (American, 1824–1879). **Stag in the Moonlight**, 1857. Lithograph, 14 x 11 in. National Gallery of Art, Reba and Dave Williams Collection. Gift of Reba and Dave Williams, 2008 (2008.115.2620)

Cat. 43. George Inness (American, 1825–1894). **Spirit of the Night**, 1891. Oil on canvas, 34 5/8 x 49 13/16 in. (framed). Williams College Museum of Art. Gift of Mr. and Mrs. William H. Barnewall, Class of 1924 (61.24)

patch of white on the castle's crenellation on the lower right is compared to the faint glow of the moon above it and underscores the otherworldly power of electricity at the dawn of a new century. Separated by nearly thirty years, Homer's two moonlit scenes demonstrate the enduring place that moonlight held for him as a symbol of the passage of time. In his earlier watercolor, the moon is set against a scene of flirtation and tourism; in the later, oil warfare and the rise and fall of empires form a natural metaphor. Winslow Homer's oeuvre, in fact, spans the Gilded Age, and moonlight remained a recurrent motif for him.

Homer was not alone in his interest in moonlit scenes during the Gilded Age. As we see in the career of John Singer Sargent, the period was defined by cosmopolitanism in the United States, with more wealthy Americans traveling overseas and living as expatriates in close contact with European art and culture. The influence of mid–19th century French Barbizon painting on American artists and aestheticism coming out of England did a lot to redefine and enhance the potential of moonlit, nocturnal scenes for American artists. James Abbott McNeill Whistler has been correctly recognized as cultivating the American landscapists' interest in in the shifting shadows of a twilight scene, but credit must also be given to William Morris Hunt (Fig. 24), another early influence towards nocturnal scenes. It is through Hunt that many New England artists developed a taste for the French Barbizon School, particularly the moody landscapes and subdued tones of Jean-François Millet (1814–1875) and Camille Corot (1796–1875). Hunt's travels abroad and predilections for French art in the second half of the 19th century led artists and collectors to prefer darker tones in landscape paintings and scenes

Fig. 25. Ralph Blakelock (American, 1847–1919). **The Poetry of Moonlight**, 1880–90. Oil on canvas, 30 x 251/4 in. Heckscher Museum, Huntington, New York. August Heckscher Collection, 1959 (1959.92)

Cat. 6. Susie M. Barstow (American, 1836–1923). **Night in the Woods**, ca. 1890–91.
Oil on canvas, 20 x 14 in. Robin Gosnell. Photograph Hawthorne Gallery

of everyday life. Stressing the primacy of perception over technique,[4] the influential artist catalyzed a shift towards the so–called "Tonalist" landscapes of the 1880s through the 1890s. Many artists within this tradition painted dark nocturnes, with an overall tonal unity, which invited introspection.

Moonlight is diffuse, quietly guiding the eye though nocturnal scenes in whispers, not shouts. Another tremendously influential artist for whom painting the moon was a lifelong pursuit was George Inness (1825–1984). Inness, like Hunt, began his career painting adept, sunlit landscapes in the style of the Hudson River School. His 1866 painting *Winter Moonlight (Christmas Eve)* (Cat. 42), though a nocturnal scene, is marked by a clarity of subject and scene that is notably different compared to his *Spirit of the Night* (Cat. 43), painted a quarter of a century later. In the earlier painting, the moon is a wintry beacon, surrounded by a ring of broken clouds, illuminating the snowy path of a solitary wanderer. The moonlit snow is clearly delineated against the dark silhouette of trees in the background, while the sky is a mixture of light and dark tones, with the moon the brightest point. In the later landscape, the moon is a "spirit," as faint as every other element of the landscape, its crisp edge dissolving into the line of clouds. Both the moon above and the bonfire below burn dimly, nearly dissolving into the atmosphere. The thicket of trees blends indistinctly into a bank of mist, balancing the clouds at the top of the canvas, which soon will pass over the moon.

The sun projects light, the moon reflects it. The Gilded Age was one of skepticism and, conversely, deepened spirituality. Inness' Swedenborgian perspective sought a divine balance between nature

and man, the moon casting the meadow below in an elegiac glow and soft shadow. Although his loose brushwork and tonal palette prompted comparisons with contemporaneous Impressionists in France, Inness did not share their objective to paint only the optical impression of observed light. He was more concerned with evocative potential than the precise optical experience of a moment in time. For Inness, one navigated the moonlit landscape through faith, not empirical vision. He once described the moon as "the natural emblem of faith," because it reflected the light of the sun, which in his reading was a symbol of the divine.[5] Concerned more with the "reality of the unseen,"[6] Inness paints the luminescent orb of light disintegrating into the sky behind it. He leaves his forms indeterminate to allow viewers to experience their own metaphysical reflections based on his whispered suggestions.

Ralph Blakelock may be the American 19th-century painter most associated with evocative landscapes under a full moon. Esteemed during his lifetime despite tragic life circumstances that left him institutionalized for schizophrenia, his paintings struck a chord with collectors and viewers, and he left an impressive legacy of lunar art. In *Moonlight on the Columbia River* (ca. 1885) (Cat. 9), Blakelock allows its yellow light to spread laterally across the picture plane, crisply outlining the forms for framing trees and lighting the river below. By contrast, in *The Poetry of Moonlight* (Fig. 25), different shades of moonlight accentuate the distances between forms in the landscape. Layers of effervescent mist amplify and carry the moonlight through the various spaces of Blakelock's landscape, intimating inward discoveries for the viewer.

In nocturnal landscapes, less is more. Nocturnes required longer

Fig. 26. Left, Henry Rankin Poore (1859–1940). **Hound Dog Baying at the Moon**, ca. 1901. Oil on wood. Florence Griswold Museum. Gift of the artist. Right, Henry Ward Ranger (1858–1916). **Bow Bridge by Moonlight**, ca. 1901. Oil on wood. Florence Griswold Museum. Gift of the artist

absorption on the part of the viewer, anticipating the duration of early
cinema by at least a decade. As scholar Helene Valance comments in
Nocturne: Night in American Art, "Nocturne artists asked their beholders
to step back from their daily lives and devote themselves to a kind of
contemplation slowed down by the genre's formal limitations" in the face
of the rapidly accelerating pace of everyday life.[7] In comparison to the
previous generation of bombastic illuminated landscapes on the scale of
history paintings, the size of many late 19th–century nocturnes is intimate,
conducive to private viewing and quiet, peaceful concentration.

Such is the case with Brooklyn–based artist and intrepid mountaineer
Susie M. Barstow, who paints a placid woodland scene, likely from her many
trips through the Adirondacks in *Night in the Woods* (Cat. 6). Because
moonlight often illuminates only a narrow swath of the landscape, many
nocturnal scenes were arranged vertically. While the earlier generation
of landscape painters arranged their compositions along a horizontal,
panoramic vista consistent with sunlit scenes, Barstow chooses the vertical
format to intensify the jewel–box effect of moonlight on the water. Trees
lean diagonally on either side of the moon, a dense thicket establishing
a pyramidal opening towards the moon. A series of flickering reflections
of the moonlight on water repeat notes of brightness from the water to the
sky, reaching a vertical crescendo to the moon. As an independent female
landscape painter, rare in the 19th century, Barstow was a pioneer. Her
depopulated landscapes share the beauty that she found in solitary trips
through the wilderness. Alone in the night's sky, Barstow's moon affirms
the rewards of her excursions.

The limited palettes of Blakelock and Barstow show the
pervasiveness of the Tonalist aesthetic and also the shift in taste within a

Cat. 36. Childe Hassam (American, 1859–1935). **Isle of Shoals**, 1890. Oil on canvas, 9 1/2 x 10 3/5 in.
Fitchburg Art Museum. Gift of Rosamond F. Pickhardt, 1994 (1994.4)

visual culture that included a growing number of black–and–white and sepia–toned photographs. In many ways, the darker–tinted paintings of nocturnal artists were responses to the gauntlet thrown down by photography, and perhaps a consideration of the interiors in which these nocturnes would be seen. With the gaining popularity of Aestheticism in the late 19th century, particularly after the 1876 Centennial Exposition in Philadelphia, Aestheticism favored the flat, decorative qualities of visual arts often in dark tones highlighted by silver and gold. Thus the palette of the domestic interior darkened, turning from the pastels of the Greek Revival towards rich burgundies, gilding, and the ebonized wood of late 19th-century interiors. Moonlit landscapes blended well with the darkening interiors in wealthy American homes.

The Florence Griswold house in Old Lyme, Connecticut, had a unique Tonalist décor. An early 19th–century ship captain's home, it was, by the 1890s, run by a daughter of the family, as a boarding house, which became a residence and gathering place for a summer colony of artists. Their first leader, Henry Ward Ranger, collaborated with Henry Rankin Poore, around 1901, to paint a dusky moonlit scene on a door in the house (Fig. 26), and other artists in the Lyme Art Colony added more paintings over the years. On the right panel of the door, Ranger painted deep–rutted tracks to draw the eye towards the quaint Bow Bridge stretching across the Lieutenant River, a sight familiar to all of the artists staying in the house. This quiet, depopulated panel harks back to the Romantic landscapes of the Hudson River School, which juxtaposed manmade forms with nature, while the dark, subdued colors and indistinct forms are classic elements of the Tonalist movement to which Ranger belonged. On the left, Poore, a painter of animals, has placed a dog, howling at the moon, an age–old posture for the animal, and one expected by its master.

There are exceptions to the rule of murky, moody moonlight. In the 1890s some American artists began to adopt the brighter palette of the French Impressionists. Beginning with Childe Hassam's radiant *Isle of Shoals* (Cat. 36), the artist transforms what could have been a dark, mysterious seascape into a ravishing celebration of aquatic blues and white. The scattered islands off the coast of New Hampshire were an enduring source of subjects for the American Impressionist. Although many of Hassam's views of the Isle of Shoals focus on the dramatic rock cliffs and luminous multicolored gardens, here he juxtaposes the dark form of a modern fishing boat against the lustrous reflection of a full moon, the artificial lights on the fishing boat harmonizing with the stars, moon, and, most distinctly, the reflection of the water. Notice the moon's reflection is significantly brighter than the moon itself. After Ranger moved away from Old Lyme in 1904, Hassam would assume leadership of the Old Lyme Art Colony, bringing Impressionism to the Connecticut countryside.

By 1900 artificial, electric light flooded cities and suburbs, and moonlight became an artistic choice, rather than a nocturnal matter of fact for artists. With the opening of Edison's first dynamo on Pearl Street in downtown New York in 1882, the city glowed with unnatural pools of luminosity only partially relieving the darkness. Darkness was now an option, not a condition. Accordingly, the meaning of moonlight became more muddled, offering interpretative choices and deliberate ambiguities for artists.

Henry Ossawa Tanner was another painter, like Inness, for whom moonlight carried spiritual significance. And, like Sargent, Tanner

Cat. 58. Henry Ossawa Tanner (American, 1859–1937). **The Good Shepherd**, 1902/1903. Oil on canvas, 26 15/16 x 31 15/16 in. Zimmerli Art Museum at Rutgers University. In memory of the deceased members of the Class of 1954 (1988.0063). Photograph Peter Jacobs

is the consummate American artist of the Gilded Age, whose biography reflects the paradoxes of America's cosmopolitanism. His father was an African American minister and political activist who befriended Frederick Douglass, the freed slave and famed Abolitionist. Tanner studied under Thomas Eakins at the Pennsylvania Academy of Fine Arts, but he left Philadelphia for France at the end of the 19th century because of the highly–charged racial atmosphere of the United States. He remained an expatriate. In France, his subjects shifted from the genre scenes of his early career to religious themes, often focusing on mysterious sources of light. While his subject matter was somewhat traditional in European art, Tanner's execution was radical. A return to the mysticism of Catholic prayer among the French avant–garde dovetailed with this African American artist's own faith, finding fuller expression in his nocturnes. In *The Good Shepherd* (Cat. 58), the moon bathes the entire scene in a haze of blue and green, though the moon is all but obscured by two trees. Between the trees, the solitary figure of a shepherd seems on the move, his indistinct flock below. The good shepherd was a popular theme in the sermons of Tanner's father, as was the notion of movement, unity, and belonging referred to in the Gospel of John, "And there shall be one fold, and one shepherd" (10:14–16). Tanner's application of paint is thick, loose and expressionistic, allowing for individual details of the landscape to be seen, while the face and body of the shepherd obscured, becomes more universal. Indirectly lit and suggestive, rather than specific and descriptive, the landscape is consonant with the religious content of the painting. As Tanner later reflected, "it is not by accident that I have chosen to be a religious painter. I paint the things I see and believe."[8] In this early version of what would become one of the artist's favorite subjects,

the moon is almost fully obscured, yet without its light, nothing would be seen: an apt metaphor for faith carried out in a progressively advanced painterly style.

By the end of the Gilded Age, moonlight could mean a lot of different things—faith and spirituality, the passage of time, the optical effects of reflected light, or, in the case of *The Harvest Moon Walk,* an excuse to have a good time (Cat. 39). Painted around 1912, Harry L. Hoffman's moonlit depiction of Old Lyme artists and townspeople reveling in an October harvest moon festival becomes a study of contrasts: figures and the landscape, light and shadow, the vegetal costumes and the illuminated lanterns, whose warm oranges, yellows and reds contrast with the cool colors of the landscape. Here, the moon only casts a glow, providing light which is the backdrop for the whimsical scene in the foreground. Depicting a playful ceremony near the Lyme Art Colony that was, in fact, staged in moonlight, Hoffman compensates for the moon's absence by painting bouncing Japanese lanterns in his playful tribute to ancient lunar festivals.

The moon offered wide possibilities for artists during the Gilded Age and the result is paintings that reward us with many meanings. Today, we find ourselves in a similar Gilded Age, marked by even greater social inequalities; our nocturnes are now illuminated by small screens. As these expanding technologies demand our attention well into the night, we recall the ever–changing colors of the moon. Paintings of the moon still evoke timeless feelings of mystery and awe. Then as now, we find ourselves in a world much the same as the world of our predecessors, especially under moonlight.

ENDNOTES

1. Chandos Fulton, "Moonlight Effects," *The Aldine* (Jun. 1874), 122.

2. Particularly, Joachim Homann, *Night Vision: Nocturnes in American Art, 1860–1960,* with contributions by Daniel Bosch, Linda J. Docherty, Alexander Nemerov and Hélène Valance (Bowdoin College and PrestelVerlag, 2015), and Hélène Valance, *Nocturne: Night in American Art, 1890–1917,* translated by Jane Marie Todd (Yale University Press, 2018).

3. Lloyd Goodrich, edited and expanded by Abigail Booth Gerdts, *Winslow Homer, v. II, 1867 through 1876* (Spanierman Gallery, 2005), 311. Gerdts points out that *Moonlight* "is substantially larger than any surviving watercolor painting by Homer up to this time." According to "Inflation Calculator," U.S. Official Inflation Data, Alioth Finance, 7 Sep. 2018, https://www.officialdata.org/, these dollar amounts convert to $3,536.93, $663.17 and $2,210.58, as far as purchasing power in 2018.

4. Helen Knowlton, *W. M. Hunt's Talks on Art (1875–1885).* Although much of Hunt's work was destroyed in a disastrous fire in 1872, Knowlton's publications helped spread his ideals.

5. George Inness, *New York Evening Post* (May 11, 1867).

6. George Inness, *New York Herald* (Aug. 12, 1894).

7. Henry Ossawa Tanner, quoted in *The Advance* (Mar. 20, 1913), 14.

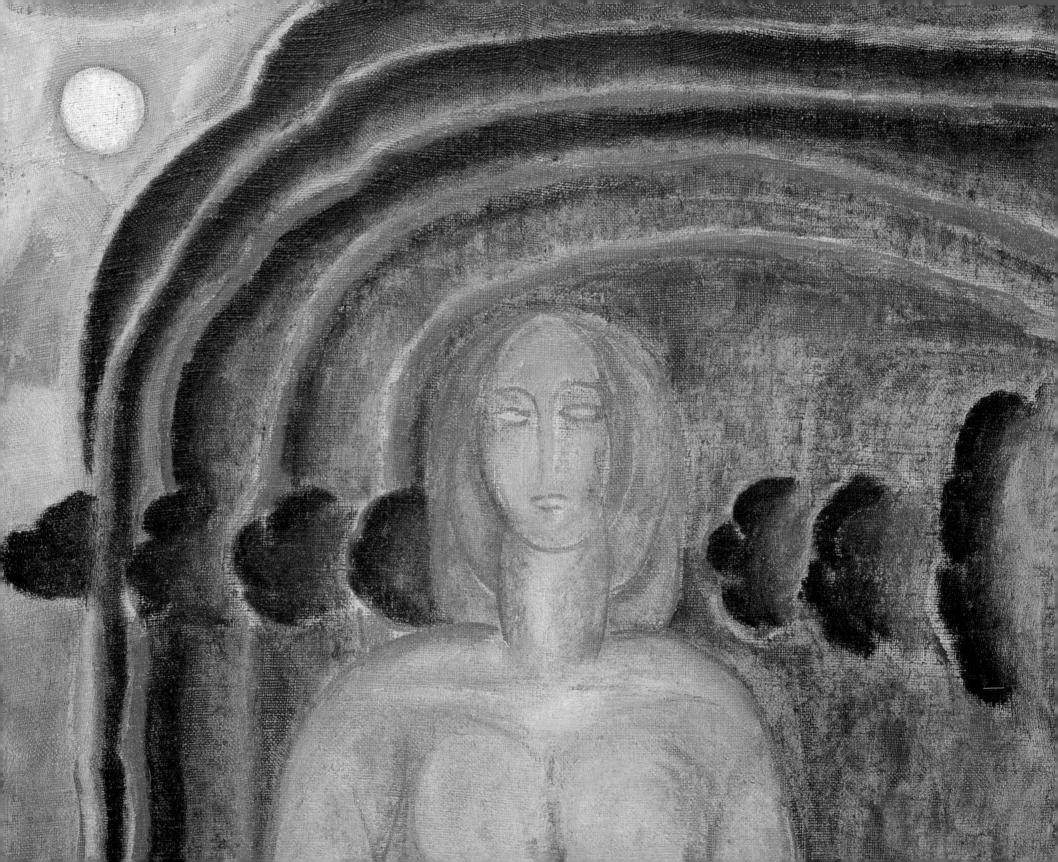

THE POETRY AND PROSE OF PAINTING THE MODERN MOON

Laura Vookles

Modernist painters and poets invoked the moon with conscious intent for its potential meaning, not just as a visual device.

Marguerite Thompson Zorach shares with early 20th–century Modernists, such as Edward Steichen, Oscar Bluemner and Arthur Dove, a devotion to the moon as a symbol and to moonlight as a catalyst for artistic experimentation. In her 1916 painting *Figure in Moonlight* (Cat. 64), a mysterious nude woman with the aura of a goddess looms above the horizon of the harbor town. The moon casts a silvery sheen on her pale skin; her eyes are blank or closed. This was not the first time Zorach painted the night. While she was studying in France and traveling with her aunt, this young artist from California created *Les Baux, Moonlight* (1910, Whitney Museum of American Art), with an unseen moon reducing colors to a deep cool palette and simplified forms that were influenced by Cezanne, the artist, and the flattened geometry of the Cubism movement. In 1912, Thompson moved to New York, married painter William Zorach, and became part of a vital center for Modernist painters and poets, all connected to the photographer Alfred Stieglitz and his gallery, named 291.

Cat. 64. Marguerite Thompson Zorach (American, 1887–1968). **Figure in Moonlight**, 1916, detail. Oil on canvas, 23 1/2 x 18 in. Palmer Museum of Art. Penn State (73.106)

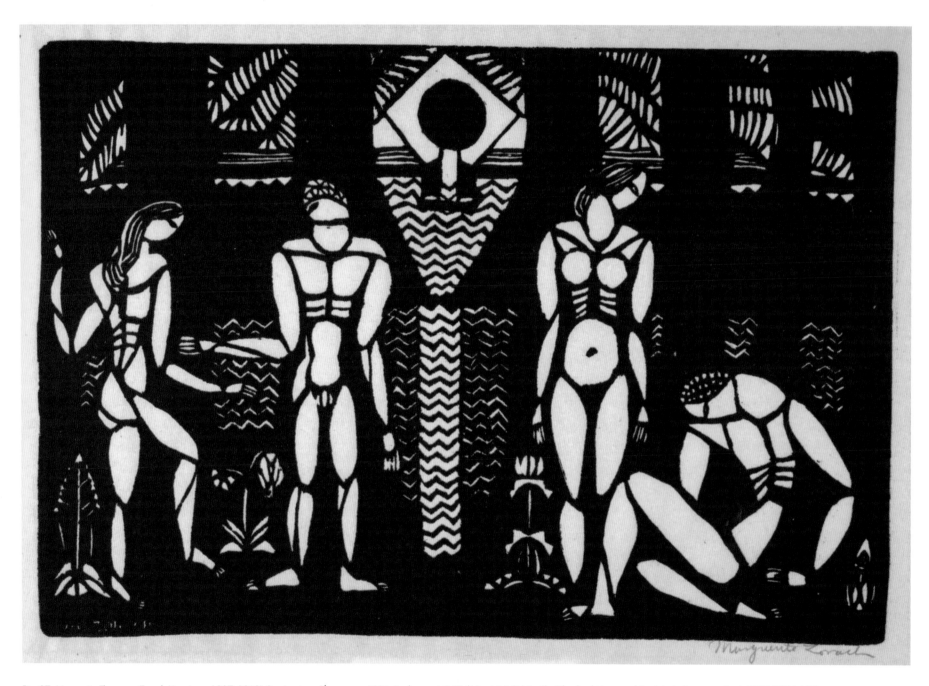

Fig. 27. Marguerite Thompson Zorach (American, 1887–1968). **Provincetown Players**, ca. 1916. Linoleum cut, 7 13/16 x 11 9/16 in. The Cleveland Museum of Art. John L. Severance Fund, 2001 (2001.139)

Marguerite and William Zorach spent the summer of 1916 on Cape Cod in Provincetown, Massachusetts, where she painted *Figure in Moonlight*. The composition reveals her Modernist progression towards flattened space and overall two-dimensional design, at the same time that she drew upon traditional Western gender references in which the moon is considered as feminine, associated with mystery, cycles and water.[1] In delineating her woman with smooth, simple shapes, Zorach was clearly looking at Archaic Greek statues. She was also in New York in 1914, when Stieglitz exhibited African art and the European Modernist sculpture of Constantin Brâncuşi. Her woman represents the allegory of "Life" from a play called *The Game*, put on by the Provincetown Players. She designed the set for the one-act theatrical production, in which Life rolls dice with Death to save the lives of two potential suicide victims. The backdrop, recorded in photographs and in a linoleum print (Fig. 27), featured a prominent central moon and the same stylized waves seen in *Figure in Moonlight*.[2] Influence and collaboration between artists and writers is a hallmark of the early 20th century and the moon appears often in the work of both groups. Zorach herself wrote poetry and, a few years later, created a strikingly visual image of experiencing the moon:

The moon rose…
She drew a path of golden fire across the ocean
Straight to us…[3]

A related painting from the same summer records Zorach's attraction to the moon for its possibilities of design and meaning. *Provincetown: Sunrise and Moonset* (1916, Sheldon Museum of Art) displays a much greater degree of Cubist fragmentation of form and time. In the center foreground, there is a suggestion of a figural shape in motion—poised between day and night—the moon on the right a traditionally feminine symbol and the sun on the left, masculine.

During the first half of the 20th century, Zorach was only one of many artists who turned to the subject of the moon—some occasionally, others on a regular basis. As recent scholars have pointed out, in the last decades of the 19th century the annihilation of darkness produced by street lights seems to have encouraged a renewed interest in nature and in nocturnal scenes lit only by the moon. The softening cloak of night and the perfect orb glowing above were conducive to increasing degrees of abstraction; details of the landscape dissolved into simplified forms and contrasts.[4] These Modernist painters, like the Imagist poets and other writers, invoked the moon with conscious intent as to its potential for meaning, not just as a visual device. Their works form a continuum from the prose of practical illustration to imagery meaningful in storytelling to some of the most poetic lunar renditions of any age. Poet H.D. (Hilda Doolittle) summed up the deep emotions that could be conjured by lunar references: "Are we unfathomable night/ with the new moon/ to give it depth/ and carry vision further, or are we rather stupid,/ marred with feeling?"[5] As a visual or a poetic image, "moon" was replete with age-old meaning—from changeability to the eternal, from depth of night to a light in the dark, from loss to love. Artists continued to

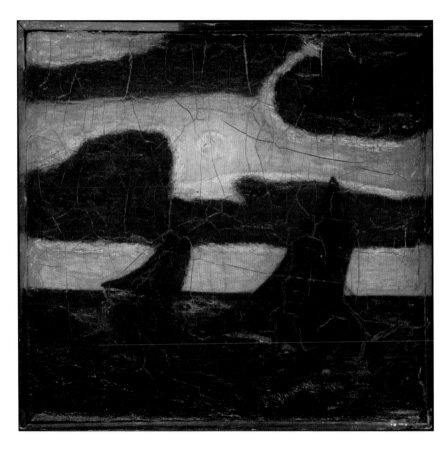

Fig. 28. Albert Pinkham Ryder (American, 1847–1917). **Moonlight Marine,** 1870–90. Oil and possibly wax on wood panel, 11 1/2 x 12 in. The Metropolitan Museum of Art, New York. Samuel D. Lee Fund, 1934 (34.55)

plumb these associations even during the mid–century developments in non–representational art. In fact, during the 1960s, science turned to artists again—this time to create a heroic narrative of the United States government's massive effort to achieve a lunar landing.

Marguerite Zorach was painting and writing about the moon during the fruitful years of Modernist development that followed the monumentally influential "Armory Show" of 1913. The Association of American Painters and Sculptors organized this exhibition, officially titled the International Exhibition of Modern Art, which premiered in New York City at the 69th Regiment Armory. Smaller versions of the show traveled to Chicago and Boston. It was the first time many Americans saw contemporary Fauvist, Cubist, and Futurist art from Europe. Avant–garde American artists participated, including the elderly Albert Pinkham Ryder, considered a Father of American Modernism. Ryder, who explored darkness and moonlight as much as any late 19th–century painter, was known to take long walks at night, observing the effects of moonlight on the landscape. Then, in the studio, he created striking scenes of full, round moons over seascapes of sinuous, simplified forms, which had a strong influence on Arthur Dove, John Marin, George Ault, and other Modern painters. Ryder exhibited two of these lunar masterpieces, *Moonlight Marine* (Fig. 28) and *Moonlit Cove* (mid 1880s), at the Armory Show.[6]

Joining Ryder in lunar painting were two artists of paramount importance for early Modern developments before the Armory show: Arthur Wesley Dow and Edward Steichen. Today, Dow is better known as the teacher of the iconic 20th–century landscape painter Georgia O'Keeffe.

Cat. 30. Arthur Wesley Dow (American, 1857–1922). *Marsh Creek*, ca. 1914. Color woodcut, 4 1/2 x 7 in. Hirschl & Adler Galleries

He taught at Pratt Institute, the Art Students League, and from 1904 until his death, Teachers College, Columbia University. He advocated the design principles of composition over direct observation of nature, and studied Japanese prints and their design concepts, even serving as an assistant curator of Japanese art at the Boston Museum of Fine Arts. The moon featured prominently in many of the Japanese prints he admired and in his own print efforts (Cat. 30). When he began to work in oils again, he painted *Moon Caught in Tree* around 1910 (Cat. 31). The geometrical structure of this composition is based on simple forms—the triangular shape of the tree dividing the sky into two more. Dow focuses on the effect of the moon's light gleaming through the branches of the trees, with a luminosity that could only be created in an oil painting, not a woodblock print. Around the same time, poet Amy Lowell crafted an effective image of this type of visual transformation, when the mind cannot quite grasp what the eyes are seeing: "The night is sliding towards the dawn... / A torn moon flees/ Through the hemlock trees..."[7] Dow's point of exactly circular light in a generally dark painting is compositionally striking. He reminds us that including the moon in a painting is never random, especially when we know Dow stressed building the composition from the mind, not external observation. Clearly the moon is the entire point of this scene.

After the Armory Show, Dow would teach O'Keeffe at Columbia in 1916. She then spent time teaching and painting in Texas, making experimental watercolors with a highly developed sense of design, influenced by Dow and the Japanese prints he admired. She painted two versions of the moon peeking out from behind trees (Fig. 29), that recall

not only his lessons but also paintings by Edward Steichen, which she may have seen earlier through their mutual connection with Alfred Stieglitz. That these paintings are moonscapes reminds us that the early Modernists were still largely focused on new forms of representing the world around them. O'Keeffe continued to paint the moon throughout her life. In the 1920s living on the 33rd floor of a New York City skyscraper, she painted the moon from her apartment window. When she moved permanently to New Mexico in 1946, she incorporated the luminous orb in her desert still lifes.

Edward Steichen, renowned as a master photographer, was also a painter during the first 20 years of his career. His lunar experiments stand out in the early 20th century for several reasons. His painting Yellow Moon from 1909 (Cat. 57) and a few other canvases relate to a photograph he took in 1904. During this period, Steichen, Alfred Stieglitz, and other photographers in the United States and abroad sought to distinguish their work from the snapshots of amateurs and engaged in a variety of creative manipulations in camera, on the negative and even in the printing process, for painterly effects. The term Pictorialism refers to their consciously aesthetic approach. In 1903, Steichen wrote to Stieglitz of being bowled over by a moon at Lake George:

We had a moon night before last—the like of which I had never seen before—the whole landscape was still bathed in a warm twilight glow…and into this rose a large disc of brilliant golden orange in a warm purplish sky…. Everything is so magnificent—so lavish—one can't help responding to it.[8]

In all versions of Steichen's moonlit scenes, the moon shines through tall, thin trees and the scene is reflected in the foreground pond. Even more than Dow, Steichen reduces the scene to a design. The screen of trees intersected by the horizontal lines of ground, pond and background woods provides a structure, while also limiting the perceived depth of the composition. The pale blue of his nighttime scene suggests that the artist may have been painting outdoors using bright acetylene outdoor lamps, similar those used by miners in the early 20th-century. Steichen was specifically mentioned in a 1909 article in a lighting journal that discussed painters and photographers using these acetylene lamps to help them capture images accurately at night.[9] Compared to the dark mood of his photographs, Steichen's oil palette was influenced by the time he spent in France and his admiration for the contemporary painters he met there.[10]

The visual experiments of Steichen, O'Keeffe, and Dow turned during the first World War into a more introspective poetry of expression—a looking to the moon for meaning in a world grown self-destructive. Carl Sandburg, in his 1918 poem "Moonset"[11] captures in only a few lines the duality of visual and narrative meaning, which might be found in moon gazing. The second and third lines recall the reflections on water in Steichen's photography and painting, which disappear with the moon: "Moon sand on the canal doubles the changing pictures./ The moon's good-by ends pictures." In the last line—"only dark listening to dark"—the empty black night suggests the angst of war.

Another artist, whose career had barely begun before World War I, would have perhaps the deepest interest in astronomy of all 20th-century

Cat. 14. Charles Burchfield (American, 1893-1967). Moon and Queen Anne's Lace, 1960
Watercolor and gouache on paper laid down on board, 44 ¾ x 34 ¾ in. Private collection
Photograph Questroyal Fine Art, LLC

painters, and with unique results. For 50 years Charles Burchfield painted nature in watercolor and oil—including "the infinite spaces of the skies" and phenomena of heavenly bodies.[12] Though he made serious astronomical observations about the night sky, Burchfield's scenes are more evocative of his spiritual responses to the outdoors than realistic. Often Burchfield's depictions, though enlarged in scale, are based on his accurate notes about the phases of the moon or the positions of various constellations.[13] From the watercolor Twilight Moon (1916, Columbus Museum of Art), he painted the year he completed his art studies, Burchfield continued to paint the moon until his late paintings of the 1960s, like Moon and Queen Anne's Lace (Cat. 14).

Perhaps the Modernist to search most agonizingly for life's meaning in the moon, as well as in the sun, was Oscar Florianus Bluemer. Part of the Stieglitz circle, Bluemer had shown five paintings at the Armory Show in 1913 and at Stieglitz's gallery 291 in 1915, but his abrasive and paranoid attitudes stemming from depression had alienated Stieglitz.[14] He painted the moon as early as 1917 and, in 1922, made the small watercolor study Earth Sets on Moon (Fig. 30), showing a red earth seen from a rocky lunar foreground. A few years later, in 1928, a new and stunning series of Bluemer's colorful moon and sun paintings inspired Stieglitz to hold another show of his work at The Intimate Gallery.[15] Sadly, the painter's creative impulse was the unexpected death of his wife in 1926. He wrote to Stieglitz from Braintree, Massachusetts, where he had moved from New Jersey 40 years ago that "If [only] I had a vision 40 years ago that I should sit in this very corner of the world, more alone with myself... than the man in the moon! Hence I am painting moons; lunatica."[16]

Fig. 30. Oscar Florianus Bluemer (American, born Germany, 1867–1938). Earth Sets on Moon, 1922. Watercolor over graphite, 6 15/16 x 4 3/4 in. The Museum of Fine Arts, Houston, The Alice C. Simkins Collection. Gift of Alice C. Simkins, 2015 (2015.453)

Cat. 29. Arthur Dove (American, 1880–1946), *Moon*, 1935. Oil on canvas, 35 x 25 in. National Gallery of Art, Washington, D.C. Collection of Barney A. Ebsworth, 2000 (2000.39.1)

Many see these paintings as expressions of his desire for a divine unity of matter in the universe—to imagine his wife's matter flowing into a connection with the universe.

Ascension, part of the 1928 show (Cat. 11), features a dark blue sky with a luminous moon, ringed in green, yellow and red–orange. Bluemner had methodically charted certain colors as conveyors or stimulators of particular emotions—blue for serenity, green for repose, yellow for aggression, and red for passion per se: vitality, life, struggle, even himself.[17] Bluemner's approach to the moon was emotional, almost physical, and he wanted viewers to experience his paintings in much the same way:

Look at my work in a way as you listen to music—look at the space filled with colors and try to feel, do not insist on 'understanding,' what seems strange.[18]

He created his moon with concentric circles of color that pulsate with the life that was gone and for which he grieved. It brings to mind lines of just a few years before by poet William Carlos Williams:

Blessed moon

noon

of night

that through the dark

bids Love

stay...[19]

Between the two world wars, Arthur Dove rivaled Bluemner as an explorer of abstracted moon subjects. Writing to Bluemner after seeing the 1928 exhibition at The Intimate Gallery, he expressed his admiration for the work, especially one of the red moons: "It burns harder than fire. I like that sort of heat."[20] Dove's *Moon* from 1935 (Cat. 29), depicting a brilliant full moon shining from behind a tree, shows the progression of 25 years from Dow's *Moon Caught in Tree*, which at the time it was painted was an innovative design idea. Another scholar writing of Dove's fascination for the physics of nature and themes of connectivity, has interpreted the "tree trunk" as rays or waves radiating between the moon and the earth.[21] In the larger story of abstraction in American Modernism during the first half of the 20th century, Dove shared with Burchfield, and even John Marin, this concern with emotional, physical and non–visual responses to nature.

Two years after he painted *Moon*, Dove again painted another, during a lengthy separation from his wife "Reds"—the artist Helen Torr. Unlike Bluemner, Dove's loss was only temporary, caused by Torr's need to care for her injured mother in Hartford. Alone in upstate New York, Dove looked to the moon almost as an alternative companion. *Me and the Moon* (1937), at the Phillips Collection, takes its title from a popular song Dove could have heard on the radio, recorded by the Hal Kemp Orchestra, with the lyrics: "Me and the Moon are wondering where you can be. Me and the Moon are lonely for your company."

The gleaming disc of the moon overhead and its constant presence for everyone seems to inspire thoughts of the moon as a person keeping watch over all parts of the earth. We may be reminded of the old nursery rhyme: "I see the moon and the moon sees me. The moon sees somebody I want to see. God bless the moon and God bless me. And God bless the somebody I want to see." Portions of these lines and their underlying expression appear in 19th–century references.[22] The idea of the moon "seeing" you and your loved one simultaneously making a connection across a distant separation can be comforting, and perhaps Dove felt it so.

The poet E. E. Cummings [Edward Estlin], an abstractionist with words, revealed his own fanciful notions about the moon and his love when he wrote: "it's you are whatever a moon has always meant."[23] Like many other poets in the first half of the 20th century, Cummings' imagery is highly visual and his moon references resonate with the devotion of painters of the moon. Like the painters, this poet reflects a romanticism about his subjects in nature that harks back to the Transcendentalists: "round a so moon could dream (I suspect) only God himself."[24] His notion that human thought cannot completely comprehend divine creation echoes some of the moonlight musings of the major 19th–century Transcendentalist Henry David Thoreau: "The light is more proportionate to our knowledge than that of day."[25]

Fig. 31. Gertrude Abercrombie (American, 1909–1977). **Night Arrives**, 1948. Oil on board, 20 x 26 in. Zach and Elizabeth Nelson collection. Photograph Treadway Galleries

Cat. 1. Gertrude Abercrombie. **Woman under the Moon**, 1946. Oil on board, 8 1/8 by 10 1/4 in. Tommy Mansor, Treadway Gallery. Photograph Tommy Mansor and Treadway Galleries

Cummings not only references the moon over 100 times in his poetry but was also a painter of the moon himself.[26] While this aspect of his career is usually overlooked, during his lifetime Cummings painted often and regarded himself as much an artist of images as of words. In *Pale Moon* (Cat. 26) the cool colors and indistinct forms suggest the way darkness and the silver moonlight soften and deconstruct objects. The paintings recall Steichen's nocturnes and O'Keeffe's Texas watercolors of the moon.

In the wake of the economic and cultural upheaval of the Great Depression, followed by the Second World War, we find artists turning to the moon with a different view that stemmed from European Surrealists like Giorgio de Chirico and René Magritte. George Ault, who started his career painting moody moons in the vein of Dow and Steichen, painted in hard–edged style, related to Precisionism, but differing in tone and subject from those sun–drenched industrial landscapes. Ault instead evokes the same disquietude as de Chirico's long night shadows in deserted squares. Ault retreated to upstate New York and painted numerous night scenes, often showing the moon or at least moonlight.[27] Painted in 1943 while war was still raging, works such as *Old House, New Moon* (Cat. 3), reflect the era's unrest. His spare, simplified forms, coupled with a strong sense of design, give his paintings a bleak austerity: control of one's surroundings, encroached by the chaos of darkness.[28] His crescent sliver of light recalls a line from Cummings: "there's the moon, thinner than a watch spring."[29]

Gertrude Abercrombie envisioned her true self in painting after painting of an enigmatic woman in a long dress under a full moon. The artist, who cultivated a persona as the bohemian queen of Chicago, expressed herself in the Surrealists' irrational, dreamlike combinations of imagery. The painter, who was also a musician and cultivated an artistic circle of jazz greats including Dizzie Gillespie, exhibited her paintings in Chicago and New York City galleries throughout the 1940s and 1950s. In her dreamlike scenes, often nighttime landscapes, she always portrayed herself, often with eyes closed, and through idiosyncratic images commented on her emotional journey through life. The moon, water, seashells, barren trees and towers are frequently recurring symbols. In *Woman Under The Moon* (Cat. 1), she wears a white dress and veil, a bride of the night walking along a grass-green path, the only sign of life in a barren landscape. In *Night Arrives* (Fig. 31), she dons orange-red, a favorite hue that, like white, contrasts with her dark surroundings. She painted this scene in 1948, the same year she left her first husband, the lawyer Robert Livingston, for music critic Frank Sandiford.[30] She stands straight, like the distant tower, while a harlequin mask on the back of her head faces a low, full moon. On the horizon, a speeding whale exhales a plume of water contrasting her rigid stillness. It is hard not to interpret the scene as a dreamlike representation of her inner turmoil. Around the same time, poet Wallace Stevens also devised unearthly associations of women and the moon:

> The frequency of images of the moon
> Is more or less. The pearly women that drop
> From heaven and float in air, like animals
> Of ether[31]

Painters continued painting the moon more realistically as we see it, even though the trend toward non–representational abstraction

was sweeping the mid–20th century art world. In 1949, John Marin still reigned preeminent as one of America's greatest living artists. Like Bluemner and Dove before him, that year he compared appreciating paintings to listening to music and he describes his delight at viewing a particularly striking moon, only a few blocks away from his home in Cliffside Park, New Jersey:

> The other night —I saw the full moon arising suspended over our city—It gave me a—thrill—Of a verity—Should not our picture embrace—a thrill based on a—life experience …. For the thrill begotten—looking at the good picture—hearing the good piece of music—Ah—to have had that—[32]

The scene must have inspired Marin to paint *Full Moon* (Cat. 45), an unusual subject for a period when seascapes were his primary focus. In flattened space and fractured forms, the painting reflects Marin's Cubist roots and, in its energetic brushwork reminds that his work paved the way for the frenetic surfaces of Abstract Expressionism. The coordinating frame, a hallmark of Marin's oil paintings, ties the composition even more to the surface and the boundaries of the artwork as an object.[33] At a time when Jackson Pollack (1912–1956) was already making his early drip paintings, Marin's moon reinforces his lifelong ties to nature and tangible subject matter, however uniquely treated.

In the 1960s, Pop Artists reasserted the importance of representation, appropriating everyday imagery as high art. Roy Lichtenstein, famous

Cat. 45. John Marin (American, 1870–1953). **Full Moon over the City No. 2**, 1949. Oil on canvas, 24 x 28 1/2 in. Norma Marin, courtesy Meredith Ward Fine Art, New York. Photograph Luc Demers © 2018 Estate of John Marin / Artists Rights Society (ARS), New York

Fig. 32. Robert Rauschenberg (American, 1925–2008). **White Walk** (from *Stoned Moon* series), 1970. Lithograph, 42¼ x 29 ½ in. © 2018 Robert Rauschenberg Foundation / Licensed by VAGA at Artists Rights Society (ARS), NY. Photograph GEMINI G.E.L. LLC

for comic book scenes depicted in a style based on commercial printing, veered from that subject matter in 1965 to focus on the outdoors. *Moonscape* (Cat. 44, back of book), is a screen print on blue Rowlux, a plastic the artist used in several works. The iridescence of the material suggested the movement of light or water. The artist bought a house near the beach in Southampton, New York in 1970, but he painted *Moonscape* in a small Manhattan studio five years earlier. Not one to work outdoors, Lichtenstein's scenes are based on his imagination, or perhaps the backgrounds of comic book illustrations, in which a cloud passing across the moon was a common nighttime motif.[34]

Lichtenstein was aware of the real–life race to the moon as he created his works. Photography had sufficiently advanced since the early 20th century to document the amazing aeronautical work of the United States space program, NASA. However this science program valued artists for another capacity— their ability to promote the challenges and glory of the space program as historical subjects of fine art. From 1962 to 1974, NASA ran an "Artists Cooperation Program" to cultivate public approval and ensure a lasting legacy for its efforts beyond potentially more ephemeral news coverage. Wanting to guarantee the inclusion of high profile artists in a variety of styles, they hired National Gallery of Art Curator Hereward Lester Cooke, himself a painter, as a consultant.[35] Asked to participate, Andrew Wyeth declined but recommended his artist brothers–in–law, Peter Hurd and John McCoy II, and his son, Jamie Wyeth.[36] Only 16 years old, Jamie joined the program in time for the ultimate event—the launch of Apollo 11 and the first landing on the moon—and painted several watercolors of the launch site in Florida

Cat. 63. Jamie Wyeth (American, born 1946). **Moon Landing**, July 1969. Oil on canvas, 29 x 43 in. Adelson Galleries

(Cat. 62, back of book). Dozens of artists participated in the program over the years; their legacy ranges from the detailed realism of Norman Rockwell to the cutting–edge silkscreen experiments of Robert Rauschenberg [Fig. 32]. The National Gallery of Art mounted large exhibitions called *Eyewitness to Space*, in 1965, and in 1969, *The Artist and Space*, after the successful moon landing.[37]

Many of these space–inspired works painted under the auspices of NASA embraced glorified frontier or even spiritual narratives with astronauts as America's new conquering heroes, defying death to explore a new horizon.[38] It was an experience with the moon and its many meanings that most of the artists never forgot. Returning to Maine Jamie Wyeth gazed upon the moon and his surrounding landscape with new eyes. From his Monhegan Island home he painted a nighttime ocean with an historic tugboat bollard in the foreground that he called *Moon Landing* (Cat. 63). Years later he recalled, "I painted this after my visit to Cape Kennedy [now Cape Canaveral] imagining that this was the surface of the moon and earth was in the distance—the bollard appeared like the 'lunar lander.'"[39]

Wyeth's words are a commentary on the poetic vision of the moon for American artists in the 20th century, even as humans reached its most prosaic rocky surface.

ENDNOTES

1. Linda J. Docherty in Joachim Homann et al., *Night Vision: Nocturnes in American Art, 1860–1960* (Bowdoin College and PrestelVerlag, 2015), 27–28.

2. Unpublished research notes from the Palmer Museum of Art at Pennsylvania State University. Collected and documented by graduate assistant Kristina Wilson in 2012.

3. "The Moon Rose," *Poetry Magazine*, 1919.

4. Hélène Valance in *Night Vision: Nocturnes in American Art*, 11.

5. H.D. (Hilda Doolittle), from "Sigil," *Collected Poems, 1912–1944*, New Directions Publishing, Feb 17, 1986, p. 417.

6. *The Armory Show at 100* website, developed at the New–York Historical Society by Ryan McCarthy, Web Developer. http://armory.nyhistory.org/about.

7. Amy Lowell, from "The Last Quarter of the Moon," 1914. Viorica Patea, "The Poetics of the Avant-garde: Modernist Poetry and Visual Arts," SPELL: Swiss Papers in English Language and Literature, v. 26 (2011), 137–152. Accessed 09.09.2018.

8. Quoted in Dennis Longwell, *Steichen: The Master Prints 1895–1914, the Symbolist Period* (The Museum of Modern Art, 1978), 94. Steichen was on his honeymoon, staying in Stieglitz's father's house.

9. *Acetylene Journal, Devoted to lighting and Kindred Subjects*, v. 11, n. 5 (Chicago, Nov. 1909), 180.

10. Elizabeth Johns, Sarah Cantor, *One Hundred Stories: Highlights from the Washington County Museum of Fine Art* (Washington County Museum of Fine Art, 2008), 172.

11. Carl Sandburg, *Cornhuskers* (H. Holt, 1918), 117. The entire poem is printed in the front pages of this book.

12. Quote from J. G. Townsend, ed., *Charles Burchfield's Journals: The Poetry of Place* (Albany: SUNY Press, 2000).

13. J. Patrick Harrington, "The Moon, the Stars, and the Artist: Astronomy in the Works of Charles E. Burchfield," *The American Art Journal*, v. XXII, n. 2, 33 ff.

14. Discussed by Barbara Haskell, *Oscar Bluemer: A Passion for Color* (New York: Whitney Museum of American Art, 2005).

15. *Oscar Bluemer: New Paintings*, The Intimate Gallery, The Anderson Galleries Building, Feb. 28–Mar. 27, 1928. Bluemer exhibited at least 12 paintings that showed moons, with titles such as *Loving Moon* (The Brooklyn Museum), *Moon Radiance*, and *The Lamp of Sleep* (Yale University Art Gallery).

16. As quoted in Jeffrey R. Hayes, *Oscar Bluemer* (New York, 1991), 129.

17. Haskell, *Oscar Bluemer*, 98.

18. Roberta Smith Favis, *Oscar Bluemner: A Daughter's Legacy: Selections from the Vera Bluemner Collection* (Stetson University Art Department, 2004), 22.

19. William Carlos Williams, from "Full Moon," *The Dial* (Jan. 1924).

20. Arthur Garfield Dove letter to Oscar Bluemner, 1928 March 22. John Davis Hatch papers, 1790-1995. Archives of American Art, Smithsonian Institution.

21. Rachael Z. Delue, *Arthur Dove: Always Connect* (University of Chicago Press, 2016), accessed on Google Books in unpaginated format.

22. Clifton Johnson, ed., *What They Say in New England: A Book of Signs, Sayings, and Superstitions* (Boston: Lee and Shepard, 1896), 144: "I see the moon, the moon sees me./ The moon sees somebody I want to see." Other early references do not mention a loved one and end the couplet "God bless the moon and God bless me." For example: Mrs. C. A. White, "Lunar Observations," *The Ladies Companion and Monthly Magazine*, v. OOXIII, Second Series (London, 1868), 10.

23. "[i carry your heart with me(i carry it in]" © 1952, © 1980, 1991 by the Trustees for the E. E. Cummings Trust, from *Complete Poems: 1904-1962* by E. E. Cummings, edited by George J. Firmage.

24. Edward Estlin Cummings, *Complete poems, 1913-1962* (Harcourt, Brace, Jovanovich, 1972), 698.

25. Henry David Thoreau, "Night and Moonlight," *The Atlantic Monthly Magazine* (Nov. 1863), 579.

26. Martin Heusser, "Transcendental Modernism: E. E. Cummings' Moon Poems," in Andreas Fischer, Martin Heusser, Thomas Hermann, *Aspects of Modernism:Studies in Honour of Max Nänny* (Gunter Narr Verlag, 1997), 55-74. Also, brochure by Ken Lopez, "E. E. Cummings' Art," undated.

27. John I. H. Baur, *George Ault: Nocturnes* (Whitney Museum of American Art, 1973), unpaginated.

28. Alexander Nemerov, *To Make a World: George Ault and 1940s America* (Smithsonian American Art Museum, 2011).

29. E. E. Cummings, "what time is it i wonder never mind," *ViVa* (W. W. Norton & Company, 1997), xiv.

30. Most recent scholarship in Robert Storr, Susan Weininger, Robert Cozzolino, and Dinah Livingston, Dan Nadel, ed. *Gertrude Abercrombie* (New York: Karma Books, 2018).

31. From Wallace Stevens, "Study of Images II," *Auroras of Autumn: Poems* (Knopf, 1950).

32. From *Downtown Gallery Catalogue for The Artist Speaks Exhibition*, April 1949. Quoted in *The Selected Writings of John Marin*, by Dorothy Norman, Publisher: Pellegrini & Cudahy, 1949, 230.

33. Hilton Kramer, *John Marin: The Painted Frame* (Richard York Gallery, 2000), illustrated.

34. Clare Bell, Avis Berman, and Jack Cowart, ed., *Roy Lichtenstein: Between Sea and Sky* (Officina libraria, 2015). Also, Julia Felsenthal, "Artsplainer: Roy Lichtenstein and the Sea in East Hampton," Vogue.com, Aug. 3, 2015, https://www.vogue.com/article/roy-lichtenstein-between-sea-and-sky (accessed Sep. 9, 2018). Includes an interview with Jack Cowart, executive director of the Roy Lichtenstein Foundation, about the print, *Moonscape*.

35. Anne Collins Goodyear, "NASA and the Political Economy of Art, 1962-1974" in Julie F. Codell, ed., *The Political Economy of Art: Making the Nation of Culture* (Fairleigh Dickinson University Press, 2008), 192.

36. Goodyear, "NASA and the Political Economy of Art," 193.

37. "'Eyewitness to Space' Exhibition opens at National Gallery of Art," *The Sunday Star*, Washington, DC, Mar. 14, 1965; and "Artist in Space," *Tonawanda News*, Sep. 21, 1968; among others.

38. Goodyear, "NASA and the Political Economy of Art," 196-197.

39. "Catalogue Note" for sale of this painting at Sotheby's, *American Paintings, Drawings and Sculpture*, Dec. 3, 2009. Ecatalogue accessed Aug. 26, 2018.

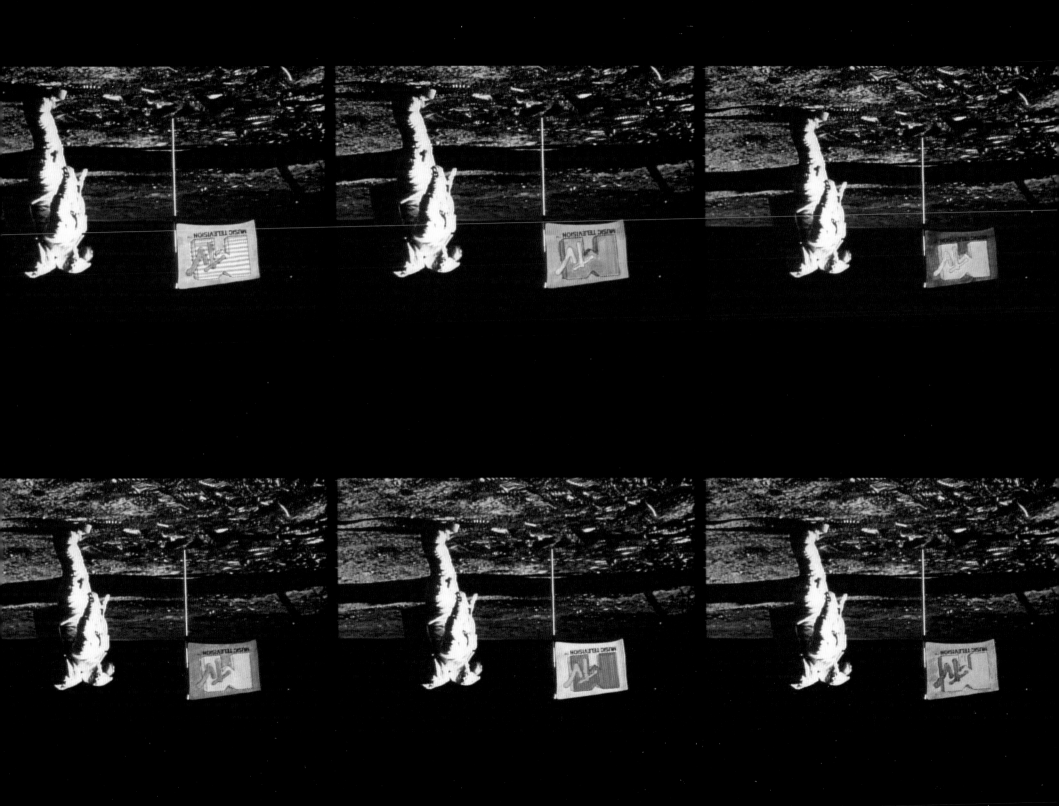

IMAGINING A JOURNEY TO THE MOON

Melissa Martens Yaverbaum

Crossing the threshold from orbiting object to colonial object, the moon suddenly seemed much closer.

Saturday August 1, 1981, one minute past midnight—American televisions broadcast a stylized video montage of the space shuttle's first launch, blended with footage of Neil Armstrong planting an MTV flag on the moon to an electric guitar riff. MTV had arrived, "on the moon" and in our living rooms, reminding us that "Video Killed the Radio Star" with a television makeover that planned to rewrite our relationship to rock and roll. Moon imagery branded MTV for more than a decade, reminding us at the top of every hour of the technological leaps of mankind.

A dozen years after Apollo 11 had successfully delivered its crew to the lunar surface, the "Moon Landing" was such a familiar event that it was regular fodder for pop culture (Fig. 33). By the time teens tuned in to watch MTV in the 80s, the moonscape was already an easily deciphered backdrop—its rocks and footprints so recognizable that its appearance was more scenery than subject. The implied humor in MTV's opening sequence counted on a youth culture already versed in the visual language of the moon landing, and ready to transfer its pioneering aspirations onto a new medium.

Fig. 33. **MTV launches on August 1, 1981, using images of the moon landing.** Video stills. Photograph Viacom

The moon landing of 1969 instilled in people around the globe a sense of the moon as a *place* one could actually reach, touch, and perhaps even visit someday. Armstrong's first step fulfilled a long-standing tactile craving embedded in popular culture—in science, art, fiction, music, film, novelties, and amusements. Reaching the moon marked a moment of profound accomplishment and also anxiety, as mankind contended with its physical reality. Crossing the threshold from orbiting object to colonial object, the moon suddenly seemed much closer—measurable in definitive miles from a launch pad in Florida, and just a few terrifying steps outside of Major Tom's imagined capsule. As David Bowie put it, "Here am I floating 'round my tin can, far above the moon, planet earth is blue, and there's nothing I can do."

As humans pursued—and then fulfilled—the dream of reaching the moon, the relationship between Earth and its object of orbit was profoundly rearranged to reconcile romantic yearnings with technological ones. Scientific advances unfolded in intuitive and unfathomable ways, inspiring new verbal and visual vocabularies to illustrate mankind's quest for the moon.

THE HUNDRED-YEAR JOURNEY TO THE MOON

Armstrong's first contact with the moon in 1969 made real a fantasy that had been ripening for more than a century. Turn-of-the-century developments in technology, communication, and transportation fueled the human incentive to reach the moon, and begged new questions and

their answers. For if we could propel a bullet from an automatic handgun (as of 1892)[1], how far could we shoot an object into space? If we could transmit radio signals between Cornwall and Newfoundland (1902), how far might we communicate into the cosmos? And, if flight was possible in an airplane (as of 1903), how long until an aircraft might carry us to the moon? What was once a mythical craving became a foregone technological conclusion and natural byproduct of the Machine Age—man would reach the moon.

The ability to move people and signals around the globe at great speed excited the popular imagination for space travel and turned it into a public preoccupation. Humans delighted in their quest to touch the moon, but also in the very notion of traversing the space between the earth and the moon's mysterious surface. Reaching the moon was a fantastic, kinetic dream that found its way into the collective human imagination and the individual human hand of production. Scientists, artists, and everyday citizens processed—consciously and unconsciously—the imagined steps needed to journey to the moon. Resulting images and descriptions played out human fantasies and anxieties about the moon, and even prepared mankind for what was to come.

Well before any realistic equipment existed to send man into orbit, Jules Verne's wildly popular book *From the Earth to the Moon*, published 1865, explored the scientific possibilities in detail. The novel follows members of an antebellum Gun Club in Baltimore who—having no peacetime use for their expertise—decide to build a cannon to blast a rocket to the moon:

. . . up to the present day there is no bond in existence between the Earth and her satellite. It is reserved for the practical genius of Americans to establish a communication with the sidereal world. The means of arriving thither are simple, easy, certain, infallible. . . . might not [it] be possible to project a shot up to the Moon?[2]

Using their knowledge of ballistics and artillery, the characters determine the size of the cannon, the materials needed to construct it, and the launch location in Tampa Town, Florida. Remarkable in its scientific acumen, the book outlines calculations for the cannon itself, drawing upon Newton's law of universal gravitation. Verne's narrative centers the action on the preparations needed for launch rather than the journey—tapping into a growing fascination with the unrealized technology. The climax of the book is the launch itself—leaving the destinies and experiences of the three passengers unknown when the book concludes.

In contrast to Edgar Allen Poe's 1835 hoax story "The Unparalleled Adventure of One Hans Pfaall" about a man trying to reach the moon in a hot air balloon, Verne's novel (though also humorous) was taken at face value as part of a shared dream for bridging the gap between Earth and Moon (Fig.34). Filled with vivid illustrations and thick descriptions of the inventions, Verne's novel became a defining text for the popular imagination and stimulated numerous visualizations for blast off.

Inspired by *From the Earth to the Moon*, composer Jacques Offenbach premiered his opéra féerie (fairy opera) *Le Voyage dans la Lune* in 1877, capitalizing on the popularity of moon fantasy through live performance and spectacle. The operetta was noted for its theatrical

Fig. 34. Jules Verne (French, 1828–1905). **From the Earth to the Moon, Direct in 97 Hours 20 Minutes and a Trip Round It.** New York: Scribner, Armstrong & Company, 1874. Hudson River Museum. Purchase, 2018. [Victorian illustrations for Verne's novel emphasized the imagined technologies needed for space travel.]

Fig. 35. Georges Méliès (French, 1861–1938). **Iconic scene from** *Le Voyage dans la Lune*, 1902.
http://cinespect.com/2011/10/saving-projecting-and-celebrating-cinema-at-moma/
[Frame from the only surviving hand-colored print of this silent film.]

ingenuity that created a sense of wonder and possibility: sets that included mother-of-pearl galleries and a glass palace without iron supports, trap doors that revealed surprise effects, and an Arabian camel live on stage. The libretto even specified a phosphorescent ballet with costumes encrusted with electric jewels and induction coils. The hit production ran for 185 performances, and was noted for its "semi-scientific path . . . an amazing geography, a physics of the kind you see in Robert-Houdin's magic shows."[3] Its closing scene, "Claire de Terre" (Light of the Earth) flipped the gaze of the characters back towards Earth, now informed by their exhausting trials on the moon.

With the invention of silent film, Georges Méliès took up the subject in his *Le Voyage Dans la Lune* in 1902—a landmark work of early cinema and the first instance of a science-fiction film (Fig. 35). Similar to the plots of its antecedents, *Voyage* follows a team of French astronomers who decide to shoot a bullet-shaped capsule to the moon. After landing and exiting the capsule, the characters seek shelter in a cave of giant live mushrooms and Selenites (insect aliens) whom they promptly destroy. Returning to Earth after the voyage, the film concludes with a celebratory parade and the unveiling of a commemorative statue inscribed, "Labor omnia vincit" (work conquers all).

Numerous *fin de siècle* works retooled the basic narrative of visionary adventurers propelling themselves to the moon and facing the unknown. With the invention of dark-ride amusements, even members of the public stepped into the familiar story. Buffalo's Pan-American Exposition of 1901 featured A Trip to the Moon—an extravagant ride designed by architect and showman Fred Thompson. Unlike anything

before it, the ride required $85,000 to build, a massive structure to house, and 220 actors and employees to operate. Every half hour, riders aboard its spaceship *Luna* set sail to the moon past a series of painted backdrops, through a simulated electrical storm, and into a lunar crater where actors costumed as Selenites greeted them. Guided through a maze of stalactites, fairgoers entered the City of the Moon, complete with souvenirs and samples of green cheese. An elaborate stage show in the Man in the Moon Palace concluded the experience, featuring live performers and illuminated colored fountains.

A *Trip to the Moon* was so successful at the Exposition that Thompson brought it to Coney Island's Steeplechase Park the following year, where it became the hit attraction of the resort. Along with his business partner Elmer Dundy, Thompson used the proceeds from the Steeplechase season to mastermind Luna Park—a theme park glorifying the moon. Luna Park opened in 1903 featuring the signature dark ride, numerous impressive attractions, and 250,000 electric bulbs that illuminated the park at night like a galaxy.

As authors, artists, and the public dreamed about reaching the moon and pondered the implications of space, they faced ominous subplots. Whether battling Selenites, facing King Cosmos, or enduring lunar snowstorms and volcanoes—descriptions of moon journeys often included otherworldly obstacles. By the start of the 20th century, plot lines included a man–vs.–creatures scenario, as well as unusual natural phenomena and disasters. Many plots worked through themes of nationalism, imperialism, and competition, including *The Man in the Moon* board game (Fig. 36) that challenged players to eliminate all game pieces

Fig. 36. McLoughlin Bros. **Game of the Man in the Moon**, 1901. Cardboard, paper, wood, 1 x 14 x 14 3/4 in. New–York Historical Society, 2000 (2000.497). Photograph © New–York Historical Society

of their opponent. As desires to reach the moon ripened in the public imagination, sinister narratives played out in popular culture.

The birth of science fiction in the late 19th century gave words to the imagined consequences of space travel to dramatic effect. H.G. Wells contended with angry Selenites in his own 1901 novel *The First Men in the Moon* but it was his 1898 book *War of the Worlds* that conjured terrifying images of alien beings from Mars arriving on Earth (Fig. 37). In an interview with London's *Daily News*, Wells described the inspiration for his story line, "there came to me suddenly a vivid picture, clean into my head, of the invaders just arrived in one of those inter–planetary cylinders which I borrowed from their inventor, Jules Verne."[4] *War of the Worlds* became a powerful and enduring narrative, tapping fears of the dire consequences of technology used against us.

By the time Orson Welles aired his dramatic retelling of "War of the Worlds" as a live radio piece in 1938, the narrative was surprisingly believable and fueled public anxiety. The piece broadcast on October 30 (Halloween) and unfolded as a series of "news flashes," describing a Martian invasion beginning in Grover's Mill New Jersey and spreading across America and the world. Airing in the months just before the start of World War II, the nightmare of an enemy invasion from the skies seemed completely fathomable to listeners, whether they understood "War of the Worlds" to be fact or fiction.

As would be witnessed on the world stage, World War II would be a war of modern weaponry and unprecedented speed, advanced by Boeing B–17 planes, automatic weapons, and the first atomic bombs to detonate in warfare. When America dropped atomic bombs on

Drawn by
Warwick Goble.
" PROJECTED BY MEANS OF A PARABOLIC MIRROR."

Fig. 37. Warwick Goble (English, 1862–1943). "**Projected by Means of a Parabolic Mirror**," *The Cosmopolitan*, May 1897. Hudson River Museum, Museum purchase, 2018. [Goble's illustrations for *The War of the Worlds* by H. G. Wells appeared in *Pearson's Magazine* in Great Britain and *The Cosmopolitan* in the United States. Wells did not find them terrifying enough.]

Hiroshima and Nagasaki in 1945, technology took on terrifying new implications as it threatened to obliterate life on earth. Though America and Russia emerged victorious allies at the conclusion of World War II, their nuclear competition would launch a Cold War of secrets and scientific showmanship that largely played out in space.

While nuclear weaponry was developed in discrete operations, space achievements were often spectacles. The Soviet launching of *Sputnik* in 1957 earned the admiration of the world, but surprised Americans and accelerated the race to space. Though the *Sputnik* satellite was no bigger than a beach ball, it could orbit the earth in only ninety–eight minutes while transmitting radio pulses across the globe. Speeding up its own efforts to traverse space and reach the moon, America successfully launched its *Explorer* satellite in January of 1958, and a few months later formally established NASA (National Aeronautics and Space Administration).

To the American public, space travel was a seemingly achievable goal by the mid–20th century, and instilled a sense of pride and optimism in the younger generation. When Disneyland opened in 1955, its Tomorrowland featured the tallest structure in the park—a TWA *Moonliner* containing the *Rocket to the Moon* film about possibilities for commercial passenger service to the moon. Walt Disney himself was explicit in his agenda to illustrate a future for Americans, saying, "Tomorrow can be a wonderful age. Our scientists today are opening the doors of the Space Age to achievements that will benefit our children and generations to come. The Tomorrowland attractions have been designed to give you an opportunity to participate in adventures that are a living blueprint of our future."[5]

By 1961 America's intent to reach the moon was explicit and specific, as put forth by President John F. Kennedy in his famous speech at Rice University:

No nation which expects to be the leader of other nations can expect to stay behind in the race for space. . . . Its hazards are hostile to us all. Its conquest deserves the best of all mankind, and its opportunity for peaceful cooperation may never come again. But why, some say, the Moon? Why choose this as our goal?

. . . We choose to go to the Moon. We choose to go to the Moon in this decade and do the other things, not because they are easy, but because they are hard, because that goal will serve to organize and measure the best of our energies and skills, because that challenge is one that we are willing to accept, one we are unwilling to postpone, and one which we intend to win.[6]

Kennedy's stirring speech instilled in listeners a concrete vision of *Americans* touching down on the moon before the close of the 1960s. Framed not only as a great achievement of science, the goal represented for Americans an ingredient of democracy and a natural step in their manifest destiny. The moon was officially the next frontier, and Americans were brought along for the ride as spectators and "co–pilots" in the journey. For unlike military operations of the past, America's first Moon landing would be a shared event—anticipated, televised, and talked

Know All Ye by These Presents that

has become a certified member of Pan Am's

"FIRST MOON FLIGHTS" CLUB

5893 *James I. Montgomery*

Number Vice President, Sales

Fig. 38. **"First Moon Flights" Membership Card.** National Air and Space Museum, Smithsonian Institution (Image number: NASM 9A14823). [Pan Am Airways issued memberships to its First Moon Flights Club to space enthusiasts eager to make a reservation for the first commercial flight to the moon. Issued at no cost, the membership cards were numbered according to priority.]

about in public life for a decade.[7]

To come to terms with the foreseeable event, popular culture anticipated the moon landing with new visualizations. The 1964 World's Fair in New York featured a 360–degree Cinerama that simulated a trip *To the Moon and Beyond*, sponsored by KLM Airlines at the Travel and Transportation Pavilion. Much like its precursors, the attraction brought visitors through a "dandy and dizzying illusion of being whirled into outer space." Yet *To the Moon and Beyond* concluded with a twist—a visual plunge "into the successive components of a human cell. The ultimate is a throbbing image of the infinitesimal nucleus, wherein the existence of energy is suggested by a progressively magnifying boom of sound."[8] The Cinerama finale reminded viewers of the ultimate power resting within humankind.

As NASA got closer to landing a man on the moon, Americans joined in the fantasy of touchdown and prepared for the day they might also take flight. Airlines were eager to make good on the vision; as early as 1968 Pan Am was selling memberships to its First Moon Flights Club (Fig. 38). The airline issued more than 93,000 membership cards to those eager to hold a spot on a future Pan Am flight to the moon—expected to launch in the year 2000.[9]

Children delighted in envisioning a future on the moon, and manufacturers delivered toys, games, and other amusements to feed the fantasy. The *Magic Moon Rocks* kit contained a miniature lunar landscape for seeding an "outer space garden" of colorful mineral spires. A plethora of aluminum toy rockets and rovers assisted children in enacting blast off, space flight, landing, and the exploration of the moon. An elaborate

Moonbase set contained 65 plastic pieces for erecting a miniature American base, an advertisement suggesting scenes to dramatize, "Play to witness the arrival of the first man on the moon as astronaut climbs from space capsule. Watch space platform whirl overhead and help scientists fire rockets from underground silos, track enemy missiles."

By the end of the 60s, Americans braced themselves for a moon landing as NASA fulfilled its sequential Apollo missions. In 1966, *Look* magazine commissioned Norman Rockwell to paint a scene of what Americans might realistically expect to see. Rockwell worked with space artist Pierre Moin to create *Man's First Step on the Moon* (Fig. 39), with Moin developing its lunar color scheme, the configuration of stars in the background, and technical aspects of the spacecraft.[10] The resulting image appeared in the January 1967 issue of *Look*, more than two years before the actual Moon landing. In the painting's details, Rockwell included subtle social commentary: an American flag visible on the spacecraft, a video camera in the hand of an astronaut, and the earth appearing as a crescent moon. New imagery of the earth from the perspective of the moon symbolized a feat of technology and also the literal repositioning of man in the universe.

In December 1968, Apollo 8 became the first manned mission to orbit the moon, witnessed through live telecasts transmitted in real time. During a telecast on Christmas Eve, the crew took turns reading verses from Genesis, while broadcasting images of the earth and moon as seen from the spacecraft. The photograph *Earthrise* from the mission became an iconic image—depicting the moon's surface in the foreground with the earth glowing as heavenly object in the distance (Fig. 40).

Astronaut William Anders commented that despite their extensive training and preparation for Moon exploration, what the astronauts ended up discovering was Earth.[11]

In the days leading up to the launch of Apollo 11, the world watched and waited to see Americans finally walk on the moon. David Bowie released his single "Space Oddity" five days before the event—describing an astronaut forever lost in space when his equipment fails: "Ground Control to Major Tom your circuit's dead, there's something wrong. Can you hear me, Major Tom? Can you hear me major Tom? . . . " Bowie's first hit tapped a collective nerve – for who knew what would happen once man actually touched down?

On the day of the moon landing—July 20, 1969—the mission unfolded without incident, yet amazed the world. For thirty-two hours straight CBS covered Apollo 11, and ninety-four percent of television-owning households in America tuned in. Around the globe an estimated 500 million people watched the broadcast of the moon landing.[12] In "one small step" the gap between mankind and the moon had been bridged—fulfilling a craving that took more than a hundred years to satisfy.

The following morning *The New York Times* declared 'MEN WALK ON MOON.' The newspaper's front-page coverage opened with a transcript of the event's audio recording, followed by a poem written for the occasion, "Voyage to the Moon" by three-time Pulitzer winner Archibald MacLeish:

Fig. 39. Norman Rockwell (American, 1894–1978). **Man's First Step on the Moon**, 1966. Oil on canvas. National Air and Space Museum, Smithsonian Institution. Gift of Norman Rockwell. Photograph Eric Long, National Air and Space Museum, Smithsonian Institution (Image Number: NASM2014–06834). Printed by permission of the Norman Rockwell Family Agency. © 1966 the Norman Rockwell Family Entities.

Wanderer in our skies,
dazzle of silver in our leaves and on our
waters silver,
O silver evasion in our farthest thought—
"the visiting Moon," "the glimpses of the Moon,"
and we have found her.
From the first of time,
before the first of time, before the
first men tasted time, we sought for her.
She was a wonder to us, unattainable,
a longing past the reach of longing,
a light beyond our lights, our lives—perhaps
a meaning to us—O, a meaning!
Now we have found her in her nest of night.

Three days and three nights we journeyed,
steered by farthest stars, climbed outward,
crossed the invisible tide-rip where the floating dust
falls one way or the other in the void between,
followed that other down, encountered
cold, faced death, unfathomable emptiness.
Now, the fourth day evening, we descend,
make fast, set foot at last upon her beaches,
stand in her silence, lift our heads and see
above her, wanderer in her sky,
a wonder to us past the reach of wonder,
a light beyond our lights, our lives, the rising earth,
a meaning to us,
O, a meaning![13]

MacLeish's poem completed a century-long creative exercise in which writers, artists, musicians, showmen, and everyday people imagined the journey of man to the moon. Through its many iterations, the narrative evolved as it contended with scientific principles, expected life forms, implications of conquest, perils of technology, and the meaning of our home planet. With the first journey complete, the human relationship to the moon and the earth would be rewritten anew, again and again.

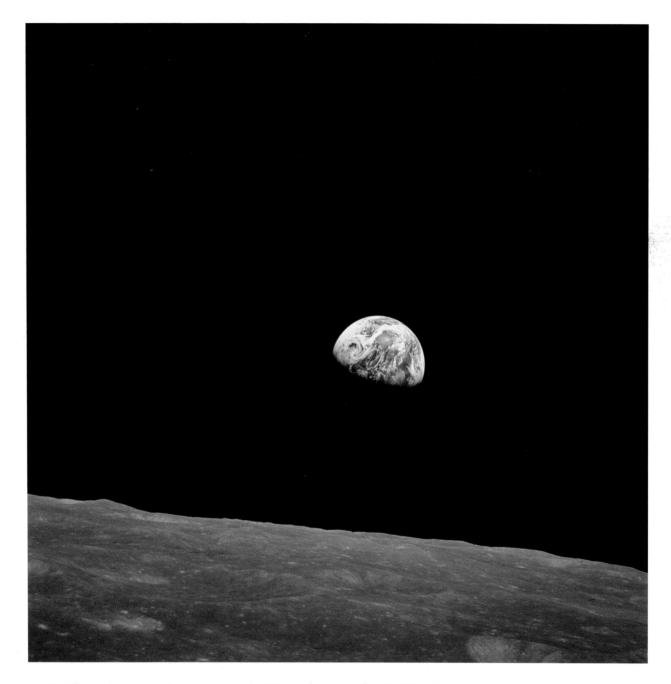

Fig. 40. William Anders (American, born in Hong Kong, b. 1933). **Earthrise, December 24, 1968.** Color photograph taken from Apollo 8 and broadcast live.
NASA/ Apollo 8

ENDNOTES

1. "History Detective Timeline" by PBS posted in http://www.pbs.org/opb/ historydetectives/technique/gun–timeline/.

2. Jules Verne, *From the Earth to the Moon*, Page 13, Pierre–Jules Hetzel Publisher, 1865.

3. Laurence Selenik, *Jacques Offenbach and the Making of Modern Culture*, Page 56, Cambridge University Press, 2017.

4. *The Daily News*, London, Jan. 26, 1898.

5. Walt Disney, posted on http://www.visitdisney.com/magic–kingdom.html.

6. John F. Kennedy, speech transcript posted on er.jsc.nasa.gov/she/ricetalk/htm.

7. Joshua Rothman, "Live From the Moon," *The New Yorker*, Aug. 23, 2014.

8. Bosley Crowther, "Moon Show at the Fair; Film, Viewed on 80–Foot Dome, Offers Dandy, Dizzying Sensations," *The New York Times*, May 16, 1964.

9. Jeff Gates, "I Was a Card–Carrying Member of the 'First Moon Flights' Club," *Smithsonian Magazine*, Oct. 20, 2016.

10. "Man's First Step on the Moon," posted in airandspace.si.edu/exhibitions/outside–the–spacecraft/om-line/image–detail.cfm?id=9817.

11. "Apollo 8: Christmas on the Moon," Dec. 19, 2014 posted on https://www.nasa.gov/topics/history/ features/apollo_8.html.

12. Gates; and Ben Cosgrove "'To the Moon and Back': LIFE's Complete Special Issue on Apollo 11," *Life*, June 30, 2014.

13. "Voyage to the Moon," Archibald MacLeish, *The New York Times*, July 21, 1969.

CATALOG OF THE EXHIBITION

AUTHORS: **THEODORE BARROW** · **BARTHOLOMEW F. BLAND** · **LAURA VOOKLES**

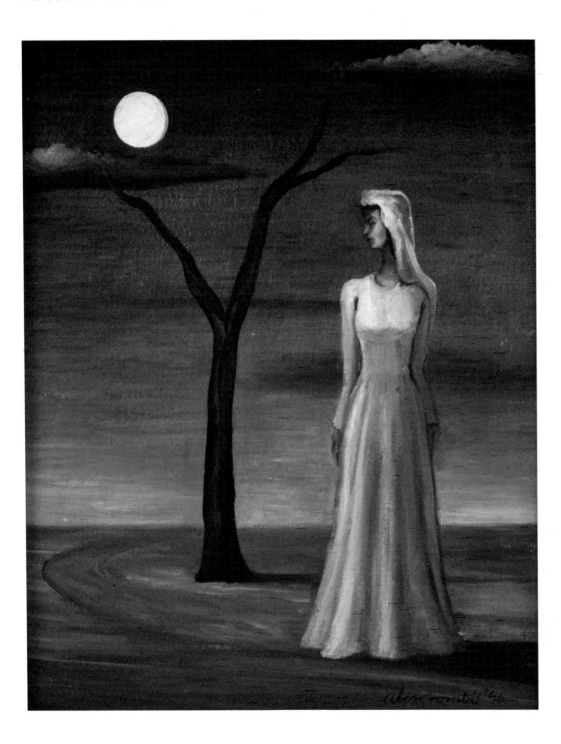

1

Gertrude Abercrombie (American, 1909–1977)
Woman under the Moon, 1946
Oil on board, 8 1/8 x 10 1/4 in.
Thomas Joseph Mansor, Treadway Gallery, Inc.
Photograph Treadway Gallery

We all carry cultural associations with the moon that make it a potent shorthand for artists. We see a full moon in a painting and imagine that it is the dead of night, a time of mystery and dreams. The moon features in so many of Gertrude Abercrombie's Surrealist compositions that she may have seen it as an attribute for herself, a reference to Greek and Roman associations of female deities with the moon. She also paints herself as a tall, still woman in long gowns, often sleepwalking or in a trancelike state. Here, in bride-like white, she towers above the low horizon of a desolate landscape, where the only sign of life is the green of her path. She turns her head back in the direction of the moon but does not look up. Because Abercrombie's images, however mysteriously combined, relate to the real world, she is also considered part of the Magic Realism movement.[1]

LV

2

George Copeland Ault (American, 1891–1948)
Silver Moonlight, 1918
Oil on canvas, 16 x 20 in.
Bernard Goldberg Fine Arts, LLC

George Ault is usually categorized as
a Precisionist because his mature works
of the late 1920s to the 1940s share their
style of delineating landscapes with smooth,
simplified forms. Paintings like this reveal
earlier influences of James Abbott McNeill
Whistler (1834–1903) and Impressionism.
The late John I. H. Baur, while director of the
Whitney Museum of American Art, noted in
the brochure for the 1973 Whitney exhibition
George Ault: Nocturnes that Ault painted
several moonlit landscapes like this in the
second decade of the 20th century.
The reflective properties of snow crystals
amplify the light of the moon and the resulting
effect has made this nighttime show irresistible
to generations of artists around the world. Full
moons direct the most light on the landscape.
In Ault's quiet scene, *Silver Moonlight*,
darkness and moonlight soften contours,
while in his later works crisp lines defy the
optical diffusion of night.

LV

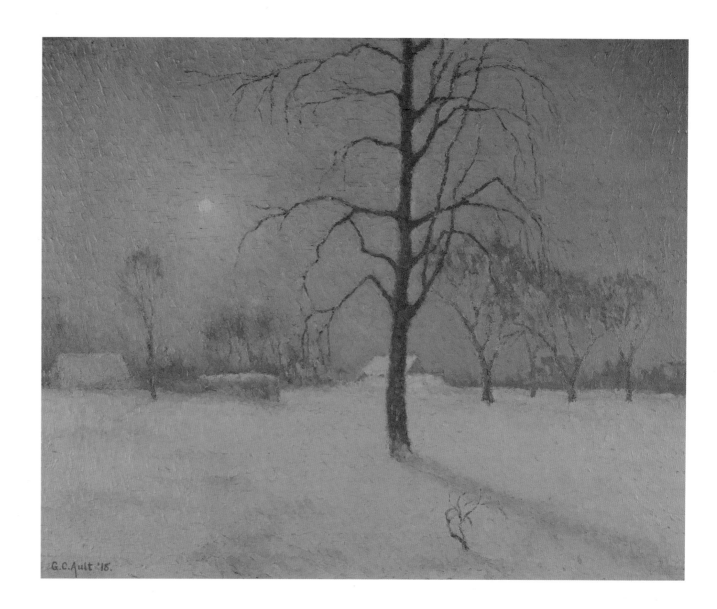

G.C.Ault '18.

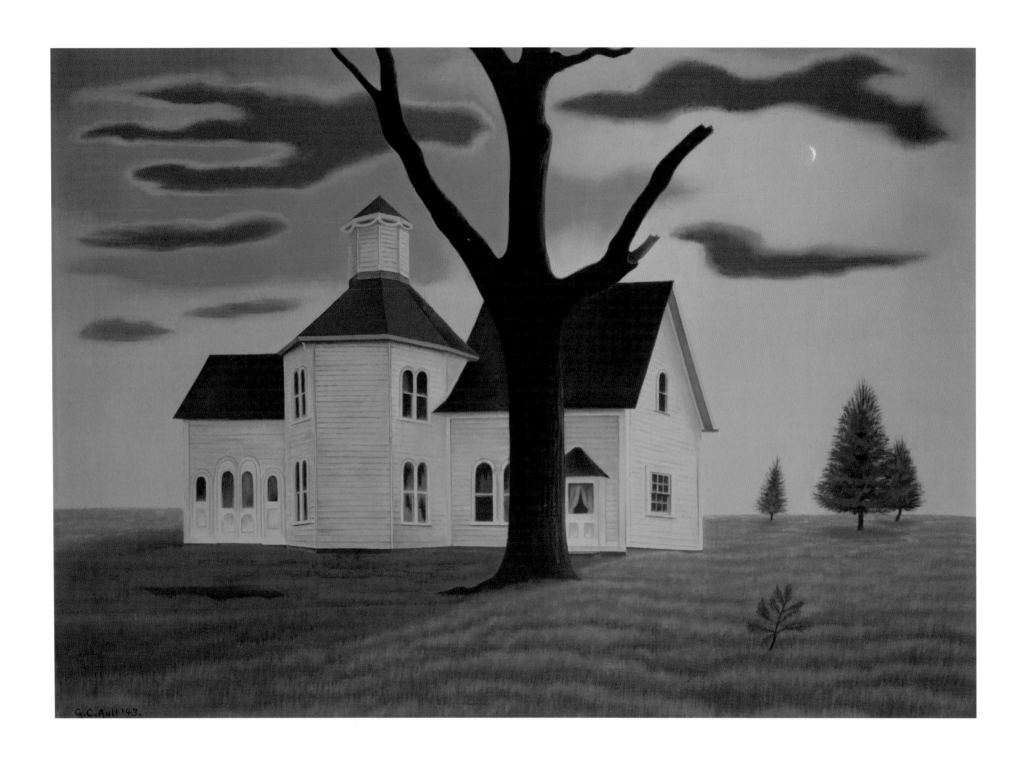

3

George Copeland Ault (American, 1891–1948)
Old House, New Moon, 1943
Oil on canvas, 20 1/8 x 28 in.
Yale University Art Gallery, Anonymous gift, 1961 (1961.48)

A sliver of a new moon, casting minimal light, is less tempting for artists than the full or crescent moon. George Ault was probably aware of superstitions associated with seeing the new moon, from divining spouses to amassing money, a subject that weighed heavily on him since the Great Depression.[2] He spent the last few years of his life painting the countryside around Woodstock, New York. He filled his landscapes with country houses, barns, and streets, rather than the industrial scenes more typical of other Precisionist painters such as Charles Sheeler (1883–1965). In 1973 Whitney Museum Director John I. H. Baur wrote, "Mood, in Ault's work, is always more important than the logic of geometry. It is not surprising, therefore, that night scenes played a very special role in his art."[3] Here, as well as in his earlier *Silver Moonlight*, he focuses the viewer's attention by placing a lone, leafless tree in a central position.

LV

4

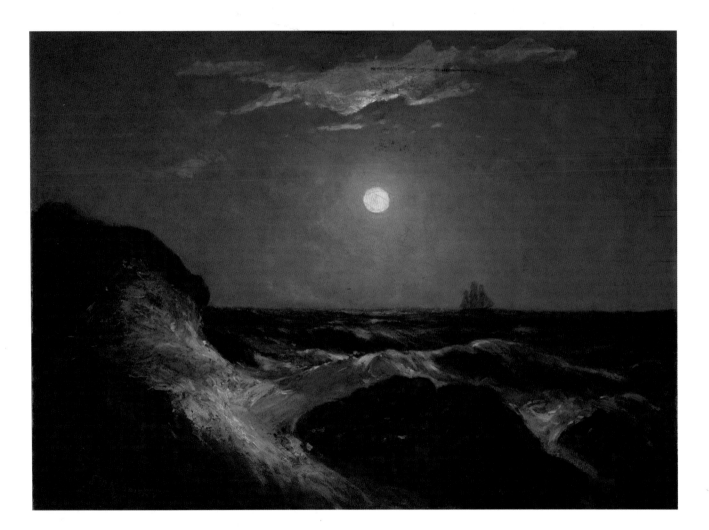

Edward Bannister (American, 1828–1901)
Moonlight Marine, 1885
Oil on canvas, 22 × 30 1/4 in.
Virginia Museum of Fine Arts, J. Harwood and
Louise B. Cochrane Fund for American Art, 2009
(2009.308)

The full moon over a roiling sea— illuminating clouds above crashing waves— is the subject of Edward Bannister's 1885 Moonlight Marine. Bannister was an African American painter born in Canada and based in Providence, Rhode Island. A renowned artist of the Tonalist school, he was acclaimed in spite of the pervasive and restrictive racial prejudice of the time. His early landscapes demonstrate his affinity for the realistic Barbizon school style promoted by many of his New England painter peers, most notably William Morris Hunt (1824–1879). In later marines such as this, Bannister departs from his earlier placid landscapes. The violence of the surf against the coastal rocks allows full painterly expression for Bannister's virtuosity in oil paint. While contemporaries like William Trost Richards (1833–1905) depicted similar scenes in crisp, precise detail, Bannister's strident marine falls right in line with other realists like Winslow Homer, also a contemporary on the East Coast, who would paint similar moonlit marines in the 1890s.

TB

5

Xavier J. Barile (American, born in Italy, 1891–1981)
42nd Street Nocturne, 1953
Oil on fabric: canvas mounted on paperboard
8 7/8 x 11 7/8 in.
Smithsonian American Art Museum, 1979
(1979.14.2)

Barile paints a thronged street off Times Square, depicting New York City's Apollo Theatre beneath a starry sky where a small crescent moon hangs against its field of midnight blue. Barile's diminutive moon is nearly overwhelmed by the blazing electric lights of the New York theater district, and it is interesting to note how rarely artists incorporated the moon in painted urban scenes of the 20th century. Perhaps they realized that the skyscraper and the streetlamp were extinguishing the romantic magic of the moon. In *42nd St. Nocturne*, Barile bolsters the moon's presence with signage for the film *The Moon is Blue* on the Apollo's marquee. Released without permission of the censorious Motion Picture Production Code, Otto Preminger's 1953 film starring William Holden caused a scandal because of its sensational story that centers on a young, virginal actress chased by a playboy architect. The film's script included such verboten words as "seduce" and "pregnant." Advertising above the title proclaims the film "spiced by more than a dash of sex."

BFB

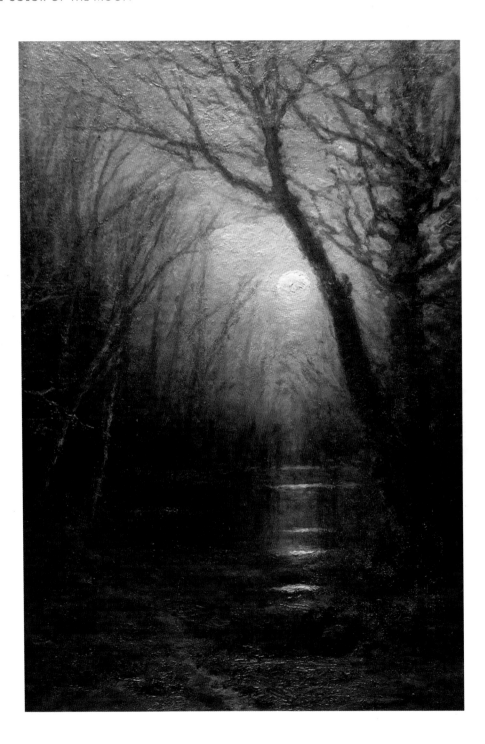

6

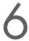

Susie M. Barstow (American, 1836–1923)
Night in the Woods, ca. 1890 –91
Oil on canvas, 20 x 14 in. Robin Gosnell.
Photograph Hawthorne Gallery

Based in Brooklyn, New York, Susie M. Barstow was known to take long, solitary walks through the wilderness, a rarity in the 19th century for a female painter. *Night in the Woods* demonstrates the rich artistic yields of her travels, in which an incandescent moon is nature's beacon in the forest. Framed by the irregular diagonal forms of barren trees suggesting late fall or early spring, the moon is a hazy glow in the humid night sky. Moonlight ripples in reflections across the pond and draws the eye toward the foreground, where a dirt footpath leads into a thicket to the left. Historically, the wilderness represents the untapped potential of the American landscape, and the unknown dangers it harbors. Painting at the end of the 19th century, Barstow aptly demonstrated the continuity of these notions, allowing the balance of the dark trees to conceal as much as the glowing moon reveals.

TB

7

Albert Bierstadt (American,
born in Prussia, 1830–1902)
The Burning Ship, ca. 1865
Oil on paper on paperboard, 11 7/8 x 15 7/8 in.
Hudson River Museum
Gift of Mrs. Edwin H. Finken and
Miss Madeleine Wolferz, 1955 (55.79)

The theme of orange-flamed shipwrecks set against the black night sky had been a staple of the European Romantic seascape tradition since the 18th century, yet Albert Bierstadt who painted *The Burning Ship* around 1865, may have been swayed by more contemporary undercurrents. While one ship burns, another sets out to sea, the moon its guide across the ocean. This painting seems to be study for a much larger canvas of the same subject, dated 1869, at the Shelburne Museum. The scene is probably a far-flung Civil War skirmish in the South Pacific's Caroline Islands. The temporary blaze of the ship will not outlast the moon, which signals cyclical continuity. Like other Hudson River School painters who connected historical epochs to natural metaphors, Bierstadt juxtaposes the natural rhythms of the moon with the chaos of the manmade conflagration on the water, inviting ruminative reflection toward the end of the Civil War.

TB

8

Albert Bierstadt (American, born in Prussia, 1830–1902)
Western Landscape—Deer Wading, ca. 1870s
Oil on canvas, 11 x 15 in.
David and Laura Grey

Eschewing the flashiness of a rising, swollen moon, Albert Bierstadt paints, instead, a small crescent obscured in the mists of evening. The fading sunset reveals the shadowy figure of a deer. Bierstadt found his artistic métier amidst the rugged landscapes that would make him famous, when he made his first trip to the American West in 1859. He traveled from Saint Joseph, Missouri, with Frederick W. Lander's survey party bound for the Rocky Mountains, and then successfully exhibited the fruits of his 2,000-mile journey at the National Academy of Design. Bierstadt felt great passion for the Western landscape, saying "truly all is remarkable and a wellspring of amazement and wonder. Man is so fortunate to dwell in this American Garden of Eden." He probably made this painting when he returned to California in 1871 and stayed for two years, painting the Sierra Nevada and Yosemite. Of all the Hudson River School painters, he came closest to matching his contemporary, Thomas Cole, in dramatic bombast, but in this nocturne, Bierstadt shows early evening in quieter key.

BFB

9

Ralph Albert Blakelock (American, 1847–1919)
Moonlight on the Columbia River, ca. 1885
Oil on canvas, 22 x 36 in.
Eileen Farbman

Choosing a horizontal format for *Moonlight on the Columbia River* allowed
Ralph Blakelock to spread yellow moonlight laterally across the picture plane,
highlighting the river below and the slightly subdued haze of the sky above.
His framing trees mediate between light and dark, flattening the depth of this
picture, which in this period is a bold step toward abstract painting.
The Columbia River, which he may have seen on Western travels in his youth,
refers to a specific river in the Pacific Northwest, yet moonlight dims its
identifying features. With the specificity of the place eliminated, our focus
is brought back to the tonal harmony of this moonlit scene.

Largely self-taught, Blakelock was the premier nocturnal painter
of moonlit landscapes in late 19th-century America, when many artists were
turning to poetic and musical approaches in their painting, favoring evocative
landscapes over narrative views. By the end of his life he was selling more
than any other American painter of his generation, in spite of being
in a mental asylum.

TB

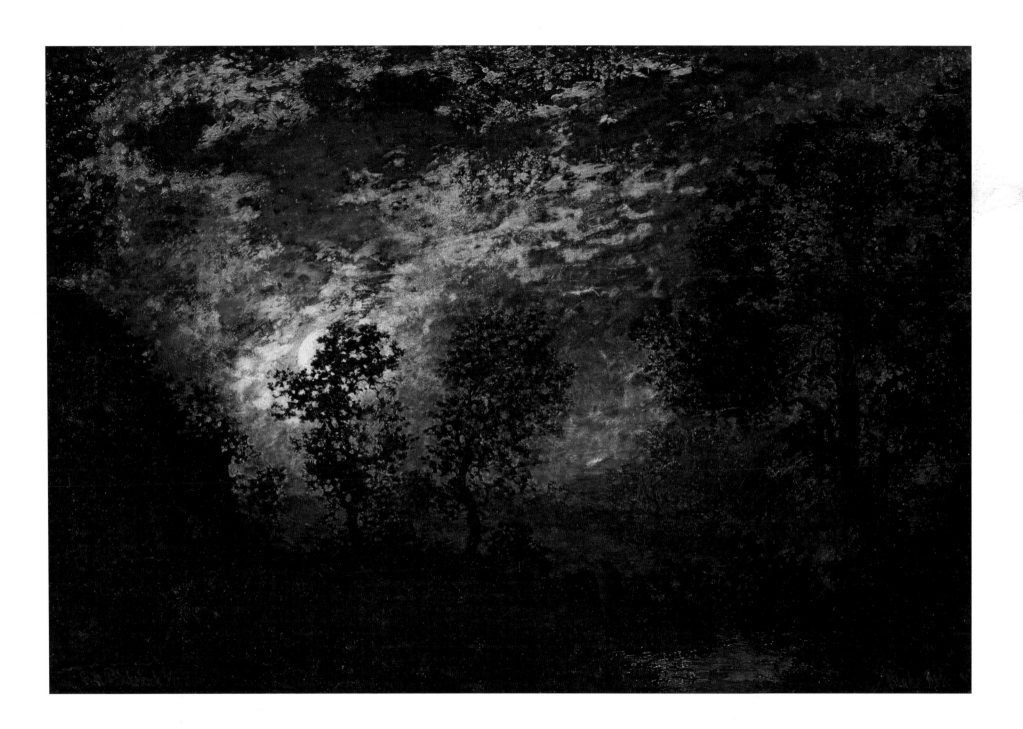

10

Ralph Albert Blakelock (American, 1847–1919)
Nymphs in Moonlight, n.d.
Oil on canvas. 16 1/4 x 24 1/4 in. Private collection
Photograph Questroyal Fine Art, LLC

Nymphs have been a fruitful subject for artists since the Renaissance when mythologies of Diana, goddess of the moon, and her nymphs gained popularity, into the late 19th century when paintings like William Adolphe Bouguereau's *Nymphs and Satyr* (1873, The Clark Art Institute), gained attention. This painting of Blakelock's, which shows figures leaving a brook as the moon shines, is unique in this artist's oeuvre. The rolling, verdant landscape in the dim, evanescent light of a moon that hides behind clouds suggests a closeness to nature the nymphs enjoy. While earlier mythological depictions of nymphs made a viewer's spectatorship forbidden privilege, Blakelock's atmospheric landscape invites us in: we see what the nymphs see in the dusk; we explore his nocturnal painting the way they explore the nighttime landscape.

TB

11

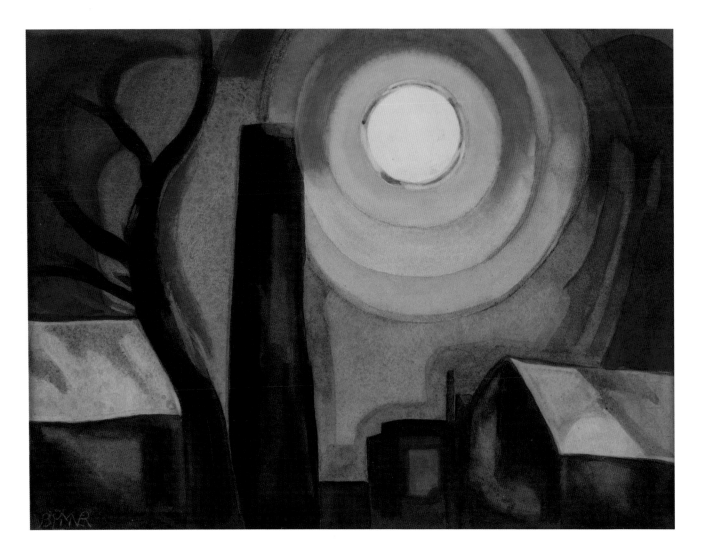

Oscar Florianus Bluemner (American, born in Germany, 1867–1938)
Ascension, 1927
Watercolor and gouache on wove paper mounted on board, 10 1/4 x 15 5/16 in.
Pennsylvania Academy of the Fine Arts, Philadelphia
John S. Phillips Fund, 1988 (1988.5)

By divorcing themselves from realistic representation, Modernists escape the monochromatic palette of the night. We see yellow, orange and red in Oscar Bluemner's moons, where sometimes only the title, color of the sky, or purple nighttime shadows tell us the moon is not the sun. The artist filtered his experiences outdoors through his own theories about color and emotion. In 1924 he wrote: "I prefer the intimate landscape of our common surroundings, where town and country mingle. For, we are in the habit to carry into them our feelings of pain and pleasure, our moods, in fact Nature with her own color combinations causes our soul to vibrate and furnishes themes."[4] The rooftops or trees of "our common surroundings" in Bluemner's lunar paintings have the effect of drawing attention to the grand size of his moons. Though the views are subjective and abstract, scale is one reason the moon appears huge when it hovers on the horizon.

LV

12

Oscar Florianus Bluemner
Moon Radiance, 1927
Watercolor with gum coating on hot pressed
off-white wove paper laid down by the artist
to thick wood panel, 9 1/2 x 12 1/2 in.
Karen & Kevin Kennedy collection
Photograph Joshua Nefsky

Moon Radiance and *Ascension* are part of
a large group of related watercolors exhibited
by Alfred Stieglitz at The Intimate Gallery in
1928.[5] His brochure describes the paintings as
"A series of 'water colors' (synthetic medium)
and 6 oils—of suns, moons, etc., facts and
fancy—strains or moods." Of 22 watercolors,
12 featured the moon, in hues ranging from near
white to blood red. Most are ringed with colorful
halos; here, we find blue and green, which he
associated with serenity and repose, encircling
yellow, his color for aggression.[6] These paintings
all embody the mood of spiritual yearning that
Bluemner felt after his wife died. The bright
colors, more vivid than possible at night,
demonstrate his "fancy." "Strains" may mean
"tension" or "strains of music," both primary
experiences for Bluemner. "Synthetic medium"
probably refers to the artist's experiments with
primers and varnishes to maximize and preserve
the intense glowing colors of his watercolors.

LV

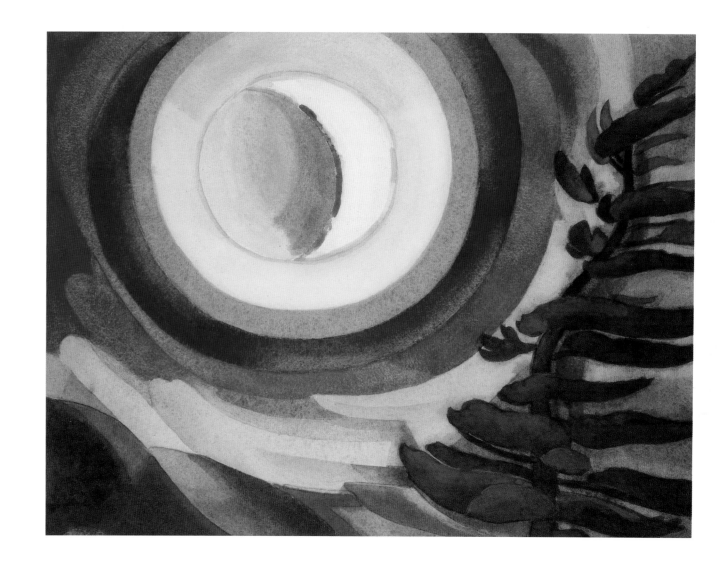

13

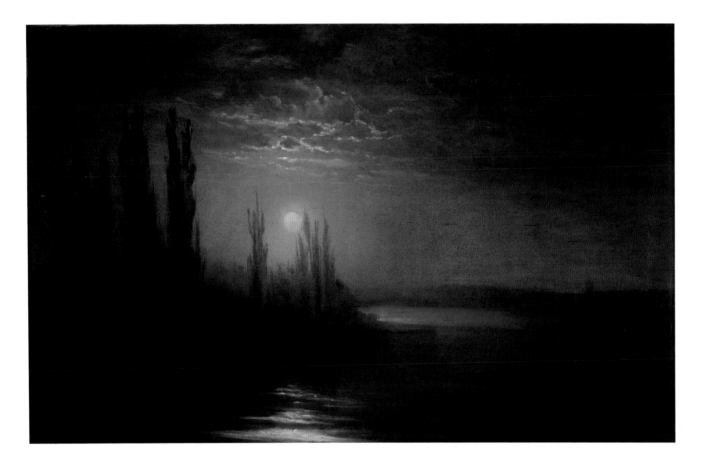

George Henry Bogert (American, 1864–1944)
Untitled Moonscape, n.d.
Oil on canvas, 14 x 22 in.
Hudson River Museum.
Gift of Julius Lowy Frame & Restoring Co., Inc.
New York, 2015 (2015.08)

With muted tones and sparse detail, George Bogert paints a landscape which, under the veil of darkness barely relieved by a full moon, hints at a river view. Throughout much of his career, Bogert, who studied under Thomas Eakins in America and Pierre Puvis de Chavannes in France, focused on capturing the unique color and light of nocturnes. Equally at home along the banks of the Grez-sur-Loing and the Hudson, Bogert's Tonalist landscapes find unity and balance that transcend geography. The specificity of this painting—whether it is in France or America—matters less than the transcendent effect of the moonlight that illuminates this landscape. For an artist of Bogert's vision, the universal is favored over the particular.

TB

14

Charles Burchfield (American, 1893–1967)
Moon and Queen Anne's Lace, 1960
Watercolor and gouache on paper laid down
on board, 44 3/4 x 34 11/16 in.
Private collection.
Photograph Questroyal Fine Art, LLC

Charles Burchfield studied nature and the sky
directly, and distorted scale and appearance
to enhance juxtapositions that make us look
at things a new way. His close view on the
foreground of this painting shows the flower
heads on par with the moon and its halo, while
a butterfly near the moon seems impossibly high
and large. Burchfield lets the white clouds and
flowers light the night. Around the same time, he
painted a similar effect in *Dandelion Seed Heads
and the Moon* (1961-65, Private collection).
The artist would have been aware that halos
around the moon are themselves an illusion that
creates a false impression of the moon's size and
closeness to us. Halos are caused by moonlight
that illuminates clouds made of ice crystals in the
upper atmosphere of Earth. Because the moon
reveals these clouds, the age-old belief that these
halos foretell rain or storms has basis in fact.

LV

15

Howard Russell Butler (American, 1856–1934)
The Moon and Venus at Sunset, ca. 1923
Oil on artist's board, 16 x 21 in.
Hudson River Museum Purchase, 2018 (2018.14)

Howard Butler began his career as a lawyer during the Gilded Age,
before applying himself entirely to art. While studying in France, he exhibited
Lever de Lune (Moonrise) at the Paris Salon in 1887. Throughout his life, he
painted the moon and, from 1918 to 1932, documented four solar eclipses.
British astronomer Norman Lockyer complained in the late 19th century that
artists did not take care to depict the correct scale and direction of light when
they painted the moon.[7] In this scene, Butler, rather than enlarge the moon
for dramatic effect, paints the waxing crescent high and small in the sky.
 Venus shines like a star, because this small planet, like the moon, reflects the
light of the sun. Based on the positions of Venus and the moon, Butler probably
painted this landscape around June 3, 1923, in the mountains outside
Santa Barbara, California, where he was living. Three months later he
would paint the solar eclipse from a similar vantage.

LV

16

Howard Russell Butler (American, 1856–1934)
Solar Eclipse, ca. 1923
Oil on canvas, 38 1/2 x 31 1/2 in.
Staten Island Museum
Gift of H. Russell Butler Jr., 1964 (A1964.5.1)

In 1916 Howard Russell Butler was painting a moonlit scene at his summer home in Maine, when a chance observation of the Aurora Borealis (Northern Lights) sparked his interest in astronomy. At the time, artists could still play a role in lunar research. Butler would paint four solar eclipses of the moon. In 1918, he traveled to Oregon from his home in New Jersey, joining scientists from the United States Naval Observatory to observe the June 8 eclipse. He painted color details of the solar corona, which were, at the time, impossible to capture on film. He devised a method to annotate quick sketches of the changes caused by the moon's movement across the sun, with the help of someone on the expedition counting down the seconds. On September 10, 1923, he painted this second eclipse, which he could see where he was living in California.

LV

17

Thomas Chambers (American,
born in England, 1808–1869)
Storm Tossed Frigate, 1845
Oil on canvas, 21 7/16 x 30 3/8 in.
National Gallery of Art, Washington, D.C.
Gift of Edgar William and
Bernice Chrysler Garbisch, 1969 (1969.11.1)

Thomas Chambers paints a wild scene—a ship
tossed among waves under the probing light of
a full moon. Moonlight radiates everywhere—far
more than this natural source of illumination from
the sky should do. The artist was born an
Englishman and came to the United States as
a young man in 1832. He is best known today
as a maritime painter, regularly deriving his
narratives from shipping disasters and perilous
sea journeys reported as contemporary events.
Stories of the sea in popular literature inspired
some of his other works. It is possible Chambers
found inspiration for this painting in the novel
The Pirate, which Captain Frederick Marryat
wrote in 1836. Although supposedly emanating
from behind the ship, the moon lights the waves
from the sides and front, creating the sensation
of a story with eerie ending foretold.

BFB

18

Thomas Chambers (American, born England, 1808–1869)
Old Sleepy Hollow Church, ca. 1850
Oil on canvas, 18 3/4 × 24 3/8 in. Flint Institute of Arts
Gift of Edgar William and Bernice Chrysler Garbisch, 1968 (1968.18)

Thomas Chambers' moonlit churchyard is a moody creation that suggests supernatural presence, and his scene of a roofless, abandoned stone church and old cemetery lit by the moon conjures all the associations of a slightly sinister Romanticism. The artist was inspired by landscape themes drawn from literature, and he frequently found inspiration in the Hudson Valley, close to his sometime-home in New York City. He likely recognized the commercial appeal of the rich visual associations that could be made with art that depicted stories such as *The Legend of Sleepy Hollow,* first published by one of America's earliest writers and humorists Washington Irving, in 1820. Though details of the composition of this painting are likely derived from William H. Bartlett's popular print of *Alloway, Kirk,* with Burns' *Monument in Scotland* (Fig. 18), Chambers may have based his narrative subject on the churchyard so vividly described by Irving, where the hapless Ichabod Crane famously and frighteningly meets the Headless Horseman. Or, this painting's title, *Old Sleepy Hollow Church,* may have been given to the piece by an early owner.

BFB

19

Frederic Edwin Church (American, 1826–1900)
Hudson River with Factory by Moonlight, 1844–45
Brush and oil paint on paperboard, 8 11/16 x 8 15/16 in. (sheet)
Cooper Hewitt, Smithsonian Design Museum
Gift of Louis P. Church, 1917 (1917-4-44)
Photograph Cooper Hewitt, Smithsonian Design Museum/Art Resource, NY

Scenes of industry in Hudson River School painting are rare. Most 19th-century American landscape artists followed the path of revered artist Thomas Cole, known for his idealized paintings that reveled in the natural world, eschewing signs of civilization other than the occasional domesticated cow or split-rail fence. While Cole's paintings did not feature the industrialization quickly edging out from America's cities, he did instruct his students to paint with honesty. The only son of a wealthy family, Frederic Church was Thomas Cole's first accepted pupil. In 1844 his father arranged for him to study under Cole for two years, during which the young pupil produced this work. Church paints a manmade volcano, that is primarily an exercise in aesthetic effects. He obscures the moon with smoke belching from a factory into the nighttime heavens to merge ominously with the dark clouds of nature. The moon's reflected light illuminates this small-scale scene in which Church avoids Cole's overt moralizing tone but powerfully shows industry's sublime yet devastating progress.

BFB

20

Frederic Edwin Church (American, 1826–1900)
Moonrise (also known as **The Rising Moon**), 1865
Oil on canvas, 10 x 17 in. Olana State Historic Site,
1981 (OL.1981.11)

Church created this beautiful painting in a moment
of optimism as the Civil War was drawing
to a close, and this artist's fame was on the rise.
He painted the canvas to celebrate the birth of
daughter Emma Frances into his growing family,
and it was intended as a pendant to the earlier
Sunrise (The Rising Sun) (Fig. 14), which he
painted in 1862 for another celebration—the
birth of his cherished son, Herbert Edwin. Church
occasionally indulged in lurid coloration and
melodramatic compositions, but here is a successful
simple painting, and its restrained palette and
slightly streamlined composition prefigure works
by 20th-century artists, such as Rockwell Kent
(1882–1971). Here the moon rises over the
horizon with a bedazzlement that suggests a
second sun. The painting's mood of calm and quiet
optimism was shattered by the sudden death from
diphtheria of both children within a week of one
another in March 1865. The two paintings were
transformed from joyous tokens to somber memento
mori—reminders to us of the ultimate folly of all of our
plans—and that, in the words of Thomas à Kempis,
"Man proposes, God disposes."

BFB

21

Thomas Cole (American,
born in England, 1801–1848)
Autumn Eve at Vallombrosa, n.d.
Oil on board, 8 3/4 x 7 in.
The Frances Lehman Loeb Art Center at Vassar College.
Gift of Matthew Vassar, 1864 (1864.1.19)

Cole became a prolific painter of plein air sketches
during a five-year tour of Europe, begun in 1829,
to deepen his art by absorbing its mellow, poetical
landscape, so different from the rough-hewn terrain
of the young United States. Cole's composition shows
the monastery at Vallombrosa, outside Florence and
beneath a crescent daub of a moon that hovers over
the horizon before night fully descends. Founded in
1038, Vallombrosa was already nearly 800 years
old at the time Cole visited, and suitably picturesque
it engaged the artist's imagination. Cole may have
also been drawn to this Benedictine abbey because
English poet John Milton brilliantly referred to it in
his 17th-century epic poem *Paradise Lost:* "on the
Beach / Of that inflamed Sea, he stood and call'd
/ his Legions, Angel Forms, who lay intrans't /
Thick as the Autumnal Leaves that strow the Brooks
/ In Vallombrosa, where the Etrurian shades / High
overarch't imbow'r" In his paintings, Cole
repeatedly attempted to address the poetic, and here
he turns to Milton's poetry to find written parallels of
what he conveyed on canvas: "examples of nature
elevated to moral and spiritual stature."[8]

BFB

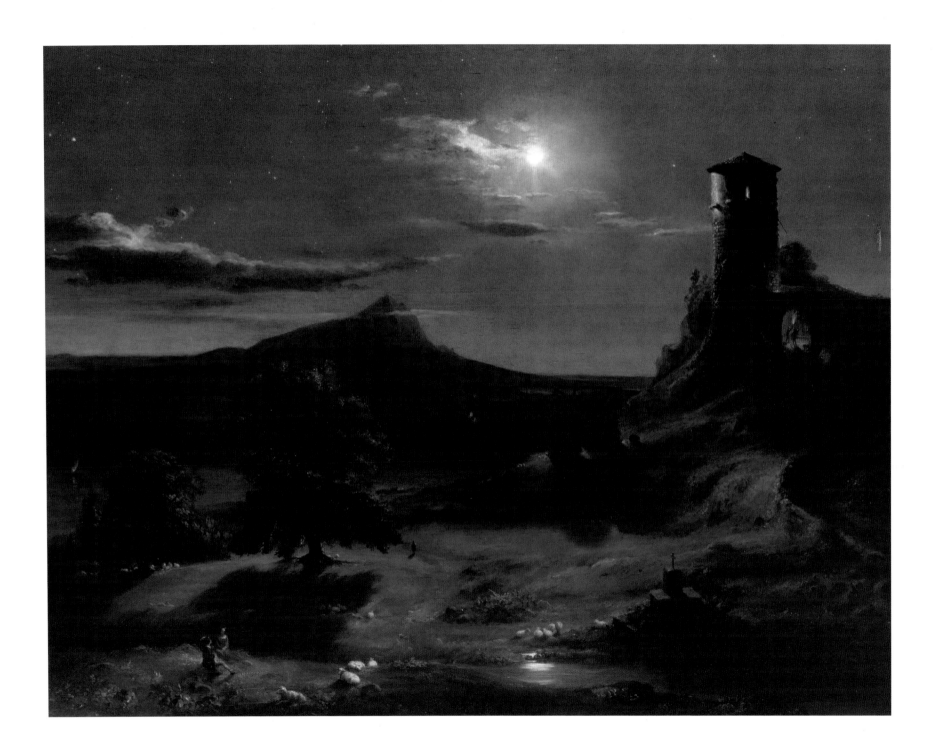

22

Thomas Cole (American,
born in England, 1801–1848)
Landscape (Moonlight), ca. 1833–34
Oil on canvas, 24 5/8 x 31 3/4 in.
The New-York Historical Society, New York, New York
Gift of The New-York Gallery of the Fine Arts, 1858 (1858.31)
Photography © New-York Historical Society

Moonlight can conceal the shocking. Thomas Cole painted this canvas for his best-known patron Luman Reed, using as his source material sketches similar to *Autumn Eve at Vallombrosa* (Cat. 21), which he made on his first European tour between 1829 and 1832. Cole also turned to literary references for his landscape inspiration and to add narrative impact to his canvases. Here the artist uses Lord Byron's 1816 poem "Parisina," which tells of an incestuous affair between a queen and her stepson, who were beheaded when their affair was uncovered. Although there is no exact parallel between Cole's scene and a specific episode in the poem, lines from "Parisina" accompanied the painting when it was exhibited at the National Academy of Design in 1834. Cole's work did not deal directly with the lurid story, but still suggests the sensual goings on that came with the fall of darkness that Byron describes, "And in the heaven that clear obscure, / So softly dark, and darkly pure, / Which follows the decline of day, / As twilight melts beneath the moon away."

BFB

23

Joseph Cornell (American, 1903–1972)
Portrait of Emily Bronte, ca. 1962
Paper/canvas board collage, 12 x 9 in.
Hudson River Museum.
Gift of C & B Foundation, 1975 (75.22.3)
© The Joseph and Robert Cornell Memorial
Foundation/Licensed by VAGA at Artists Rights
Society (ARS), New York, NY

Though not a painter, Joseph Cornell is an
important art-world figure who combined his
unique mixed media boxes and collages with
his deep interest in astronomy and poetry.[9] In
two and three-dimensional works, he included
images of the moon as collage elements and in
the early 1960s, he produced several collages
in which women appeared outdoors.[10] In this
collage, a woman in Victorian dress looks up
at a sunset-streaked sky and rising moon, as
she trails oversized bouquets of flowers on
darkened ground. Cornell certainly knew that
the moon appears frequently in Bronte's verses.
One imagines he may have had in mind the last
lines from her 1840 poem, "Moonlight, Summer
Moonlight," though the hour she speaks of is
midnight and her figure stands: "And there in
those wild flowers / A lovely form is laid / Green
grass and dew-steeped flowers / Wave gently
round her head."

LV

24

Jasper Francis Cropsey (American, 1823–1900)
Mediterranean Sea Coast, 1855
Oil on canvas, 27 1/2 x 41 in.
Newington-Cropsey Foundation (NCF 48)

Cropsey likely created this "poetic piece of Italian scenery, quite in his best vein" from memories of his sojourn in Italy. Critics waxed lyrical reviewing this painting when it was presented at the National Academy of Design exhibition in 1855.
The Independent noted, "the delicate gradations of vapor round the moon, with the exquisite rendering of the halo, the ripple of the water touched by the moonlight, and the tree at the right with the flaming sunset caught in its leafy bough."
The Knickerbocker said that Cropsey painted "the merest bit of sea-coast, [which was] rendered by the master, in a poetical and feeling manner. The sun has set, but has left its lurid reflections on clouds and shore, and the ruined tower on the right. The moon has just risen, and throws her steely light over the tumbling waves. The blended effect of sun-light and moon-light! —it is a daring success."[11]

BFB

25

Jasper Francis Cropsey (American, 1823–1900)
Castle Garden, New York, 1859
Oil on canvas, 15 1/8 x 24 1/4 in.
The New-York Historical Society, New York, New York
Photography © New-York Historical Society.
Purchase, Thomas Jefferson Bryan Fund, 1972 (1972.13)

Castle Garden, now known as Fort Clinton, was originally built to defend
New York City, but by 1850 the structure functioned as a theater. It was
here that Jasper Cropsey saw a performance given by the Swedish opera
star Jenny Lind (1820–1887) and gifted her with a painting based on his
drawing of the castle.[12] Cropsey returned to the subject of the Castle Garden
several times, and eight years later executed this nocturnal version. He varied
details from his earlier versions, enlarging the sailing vessel to the right of
the Castle and including the moon's shining reflection on the calm water.[13] A
painted red speck of a glowing lantern on a vessel appears on the left. Small
compositional changes, they nevertheless conspire to shift the tone
of the painting from a documentary to the deeply romantic.

BFB

26

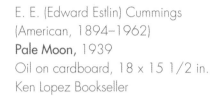

E. E. (Edward Estlin) Cummings
(American, 1894–1962)
Pale Moon, 1939
Oil on cardboard, 18 x 15 1/2 in.
Ken Lopez Bookseller

Poet E. E. Cummings painted throughout his life, primarily for his own pleasure.[14] Over a dozen paintings representing all phases of the moon survive and this lunar obsession was equally present in his poems. Like artists Oscar Bluemner and Arthur Dove, Cummings exaggerates the halo he paints around the moon, and his wavering brushstrokes add mysterious energy to this work. The moonlight almost seems like a force from which the tree leans away—the very opposite of a tree's daytime attraction to the sun. The title *Pale Moon* may not be original but added by a subsequent owner, yet is still suggestive. In 1921, Dorothy Parker wrote "While the pale moon gleams, we will dream sweet dreams" in the poem "The Passionate Freudian to his Love."[15] Cummings' lonely hilltop seems more sinister. In an early sonnet, he wrote: "beyond night's silken immense swoon/ the moon is like a floating silver hell/ a song of adolescent ivory."[16]

LV

27

Maurits Frederik Hendrik de Haas
(American, born in the Netherlands, 1832–1895)
New York City by Moonlight, n.d.
Oil on canvas, 13 x 11 1/2 in.
Robert Grey

Maurits de Haas recognized that the moon could be the "secret ingredient" on an artist's canvas. He rhapsodized, "moonlight-scenes in and near New York are, I think, finer than any other locality, except, perhaps, on the ocean. They are more luminous, more highly-coloured, and more atmospheric, than in Europe. The cloud-scenery in the suburbs of New York is the noblest and most beautiful in the world."[17] *New York City Harbor by Moonlight,* like *Castle Garden, New York* painted by Jasper Cropsey in 1859 (Cat. 25), shows the business of a harbor. Both painters demonstrate that along with the shadowy vessels and romantic mystery of the moonlight, the growing metropolis of New York City, even then, was bustling and open for business around the clock. The pink and amber haze that de Haas' moon illuminates nostalgically harkens back to the Golden Age Dutch paintings the artist would have seen while studying in his native Rotterdam, but also presages the dawning era of smog suggested by dozens of smokestacks.

BFB

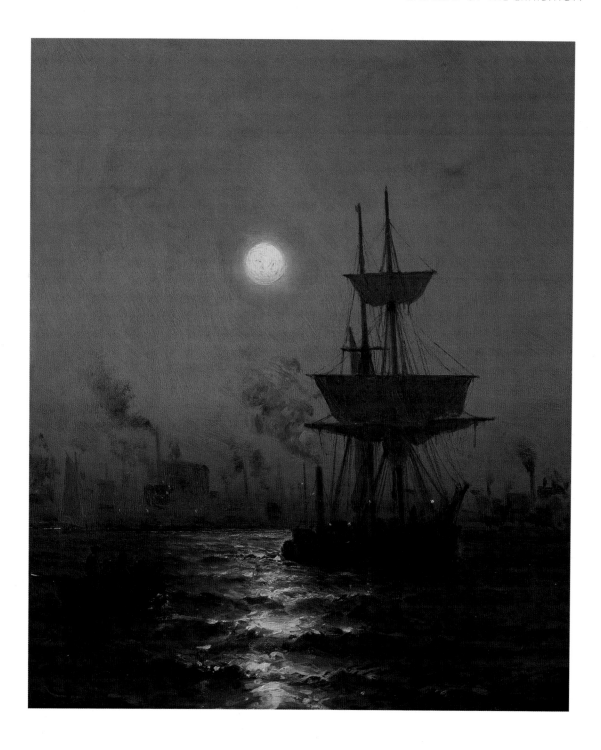

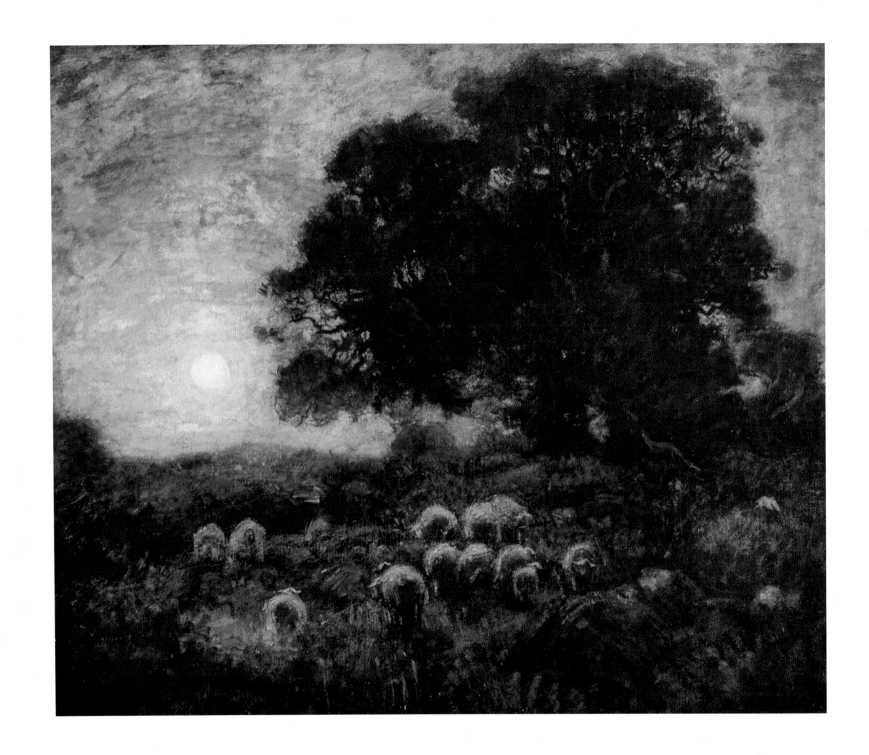

28

Louis Paul Dessar (American, 1867–1952)
Moonrise, 1904
Oil on canvas, 26 x 30 in. Hudson River Museum
Gift of Mrs. Louise Backus, 1953 (53.64)

In this pastoral nocturne, Louis Paul Dessar reveals his allegiance to the
Barbizon style of landscape painting tending toward Realism with a softness
of form, which inspired him in France. Often concerned with the passage
of time and the fragile continuity of country traditions in the face of modernity,
French Romantic landscape painting held great sway for many American
painters in the decades following the upheaval of their country's Civil War.
The appeal of simple country life was felt on both sides of the Atlantic in this
period: as Jean-Francois Millet showed his shepherds in the Paris Salons,
Frederick Law Olmsted and Calvert Vaux planned a Sheep Meadow with an
adjacent fold in New York City's Central Park. In this painting, the darkening
landscape obscures detail. Lit by the moon, the wool of the flock of sheep
amplifies the intensity of its light, while Dessar's title tacitly alludes to the
passage of time—as the moon rises, the day ends, and the sheep must return
to the fold. This painting's display and illustration in the catalog of the
Ninth Annual Exhibition at the Carnegie Institute, in Pittsburgh, in 1904,
confirms its title as original.

TB

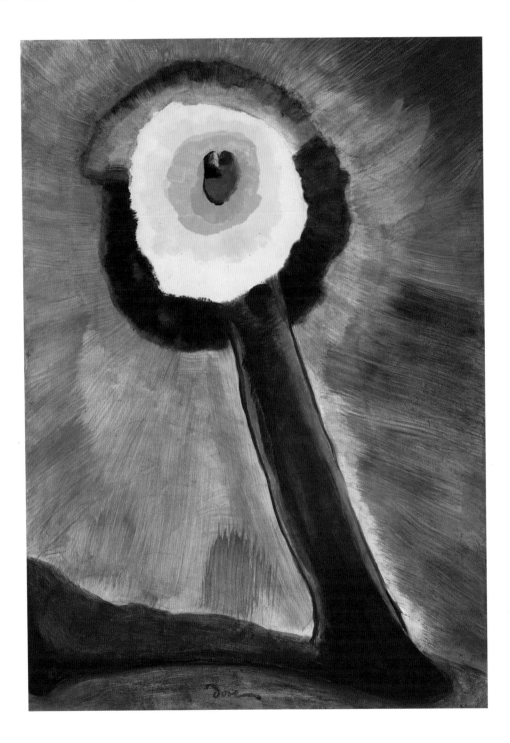

29

Arthur Dove (American, 1880–1946)
Moon, 1935
Oil on canvas, 35 x 25 in.
National Gallery of Art, Washington, D.C.
Gift of Barney A. Ebsworth, 2000 (2000.39.1)

Eight years before Dove painted this abstract and luminous moon, he exhibited at the Intimate Gallery of Alfred Stieglitz and wrote for the exhibition brochure: "Why not make things look like nature? Because I do not consider that important They exist in themselves, as an object does in nature."[18] His words apply well to this painting, with its composition so abstracted to a few simple shapes and the sky such an unreal hue that its subject could be missed without its single-word and sufficiently descriptive title—*Moon*. During the 1930s, Dove made a conscious decision to return to painting after working extensively in collage for the past ten years. He experimented with adding wax to his pigments, and the lustrous layers and radiating brushstrokes of the sky pulsate with a magical sense of life.[19]

LV

30

Arthur Wesley Dow (American, 1857–1922)
Marsh Creek, ca. 1914
Color woodcut, 4 1/2 x 7 in.
Hirschl & Adler Galleries, New York

Arthur Wesley Dow depicts a gibbous moon,
between half and full, which is uncommon in art.
In 1992 astronomer William Livingston theorized
that artists find its asymmetry "aesthetically
displeasing."[20] In the 1890s, Dow was assistant
curator of Japanese art at the Boston Museum
of Fine Arts and studied woodblock prints in
that collection, many featuring the moon. He
admired the way Japanese artists balanced light
and dark as a way to give "an impression of
beauty entirely independent of meaning."[21] In
his own art, he used Japanese print techniques
and design theories to create artworks that were
strikingly modern in their abstraction. He carved
and printed the blocks himself and experimented
with different color combinations. No two copies
of *Marsh Creek* are the same.

LV

31

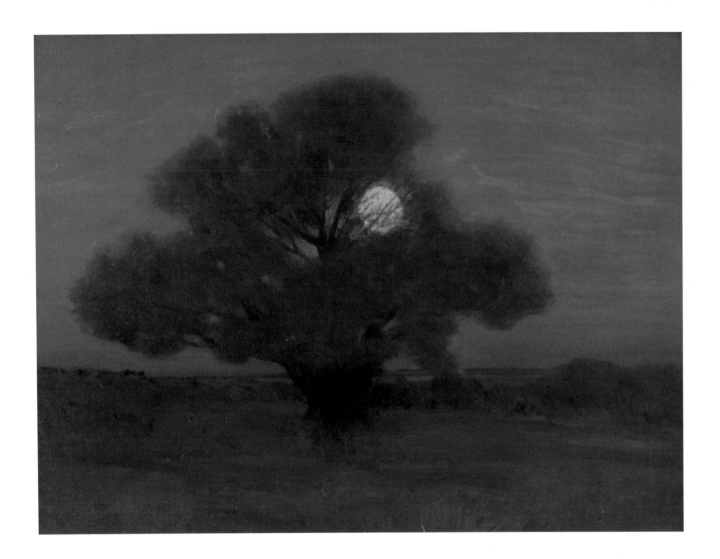

Arthur Wesley Dow (American, 1857–1922)
Moon Caught in Tree, ca. 1910
Oil on canvas, 24 x 32 in. Associated Artists, LLC,
Southport, Connecticut

In its dark palette, this painting recalls the limited
colors the late 19th-century Tonalists used to create
somber scenes. At the same time, Arthur Wesley
Dow's pared down composition of dark sky, flat
meadow, and a single, symmetrical tree reflect his
importance as a teacher of art and design and
as a major figure in the American Arts and Crafts
movement. The intensity of the full, golden moon
shining through the tree is a foil for the overall
darkness. For Dow, the moon was a decorative
light shape, as much as a romantic vehicle
of age-old lore.

LV

32

Sanford Robinson Gifford (American, 1823–1880)
The Column of St. Mark, Venice, Moonlight, 1870
Oil on canvas, 26 1/4 x 21 3/4 in.
Family of the artist, courtesy Menconi + Schoelkopf

Sanford Gifford tarried for six weeks in Venice during his second and final trip to Europe from 1868 through 1869. The glories of Venice, coined "The Queen of the Adriatic," had long been catnip for artists. Enchanted by the beauty of the city, Gifford made particularly strong use of his time there. In the years immediately after the Civil War of which he was a veteran, Venice became a growing tourist mecca for Americans abroad, triggering a commercial market for paintings of Italian subjects that recalled the allure of the Old World. Gifford traveled with fellow Hudson River School artist Jervis McEntee, and met another artist from this group, Frederic Church, while in Rome. Gifford chose one of the best-known sights in Venice as the theme for this canvas—two large granite columns adjacent to St. Mark's square that bear symbols of the two patron saints of Venice. The first column represents Saint Theodore, the second shows a winged lion, the symbol of St. Mark. In a great penumbra of golden light, as stylish tourists come and go on the plaza below, Gifford transforms the mythical beast, paw raised, into a pagan moon-worshiper.

BFB

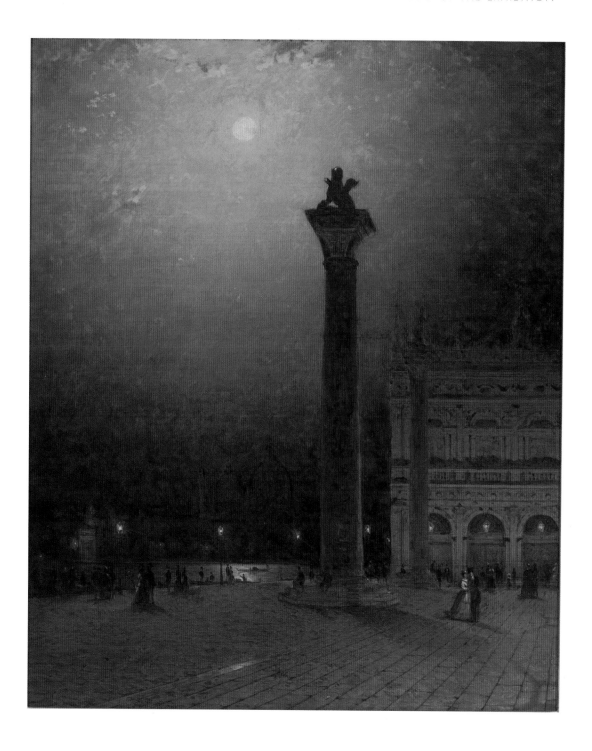

33

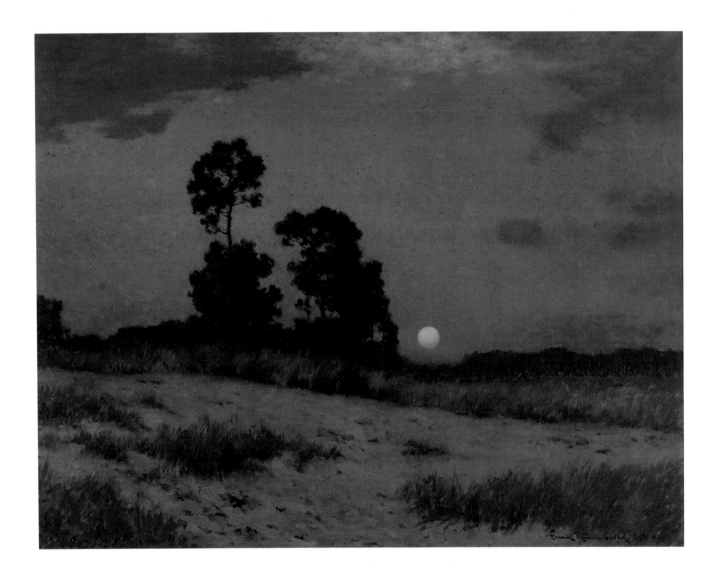

Frank Russell Green (American, 1856–1940)
The Coming of Night, ca. 1904–08
Oil on canvas, 28 x 36 in. Hudson River Museum.
Gift of Mr. and Mrs. Richard Manney, 1972
(72.43.2)

In the fading sunlight of this scene, the sandy path in the foreground glows, while the trees at the rear darken below a rising moon. Frank Russell Green was an American artist who carried on the French Barbizon style of soft form and loose brushwork. This painting exemplifies his dedication to the sentimental landscapes of melancholic hues favored in France, especially in the middle years of the 19th century. At the same time, the flattened forms and thick application of paint—the way he treats the form of the gathering of trees against the sky—signal a modern approach to picture-making consistent with Green's association with other artists and illustrators who worked at this time. This painting, with its strong focus on nature, is a traditional Barbizon subject set in a distinctly American landscape.

TB

34

Red Grooms (American, born 1937)
Shoot the Moon, 1961
Ink on paper in a box
Box: 14 x 20 x 9 1/2 in.
Filmstrip: 8 x 210 in. Collection of the artist
Photograph Lysiane Luong Grooms
© 2018 Red Grooms, Member of Artists
Rights Society (ARS)

Red Grooms created this paper film as an
entertainment for his artist friends. Its bright
colors and humor reveal his early love of theater,
carnivals and the circus, which later inspired
his film productions and his sculpto-pictorama
art. Here, the decorative proscenium frames an
opening for the "movie," which can be rolled to
display different scenes. The figure with top hat
and the moon man reveal his fantastical source
material: *Le Voyage dans la Lune (A Trip to the
Moon)* by Georges Méliès (Fig. 35). Grooms saw
the classic 1902 film when it was included as a
prologue to the 1956 movie *Around the World in
80 Days*. In 1962, Grooms launched an ambitious
project to produce a live action film based on this
art work. Artist Alex Katz and photographer Rudy
Burckhardt were among the stars and Grooms
played the Moon Wizard.[22] He was amused that
the strips of newspaper he used to make papier-mâché
set props bore headlines about NASA's plans for
the United States to land on the moon.[23]

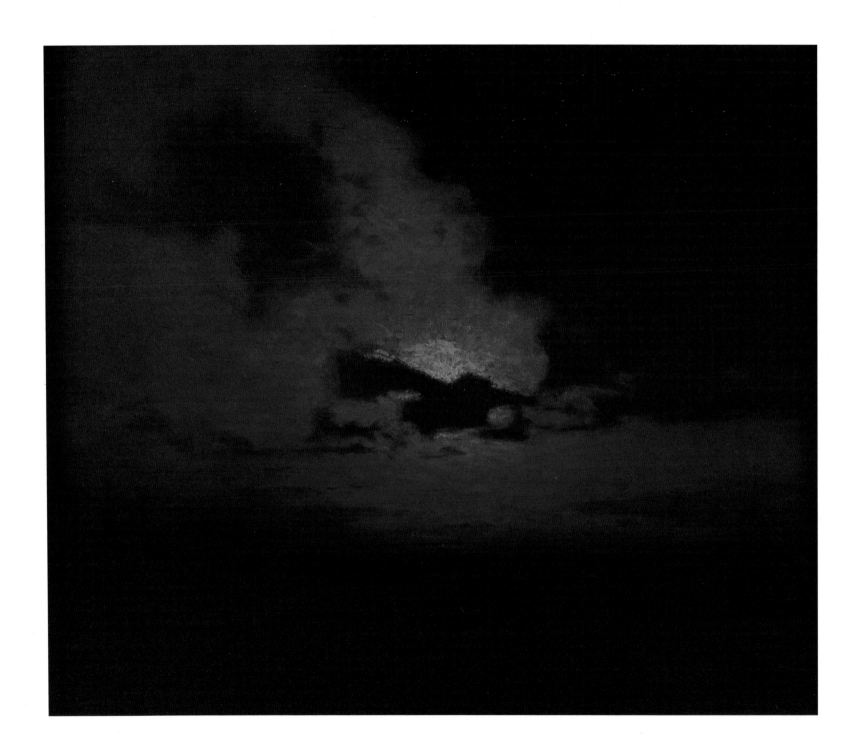

35

Birge Harrison (American, 1854–1929)
The Hidden Moon, ca. 1907
Oil on canvas, 25 1/4 x 30 1/8 in.
National Academy Museum, New York, New York (539-P)
Photograph National Academy of Design/Bridgeman Images

Ironically, the moon is indeed hidden, and yet the moon's presence behind the clouds is one of the only verifiable elements in Birge Harrison's painting. In this rendering of diffuse moonlight, Harrison has reduced the landscape below to dark, amorphous shapes. The crisp outline created by the overlap of the dark cloud forms and the moon establishes the most extreme contrast at the center of the painting, which then bleeds out into a vague glow towards the edges. More than a mere observation of the night's sky, this nocturne serves as a manifesto for Harrison's approach to landscape painting, which emphasized the importance of one's internal response to nature seen in the sky above, rather than an informative rendering of the landscape below.

TB

36

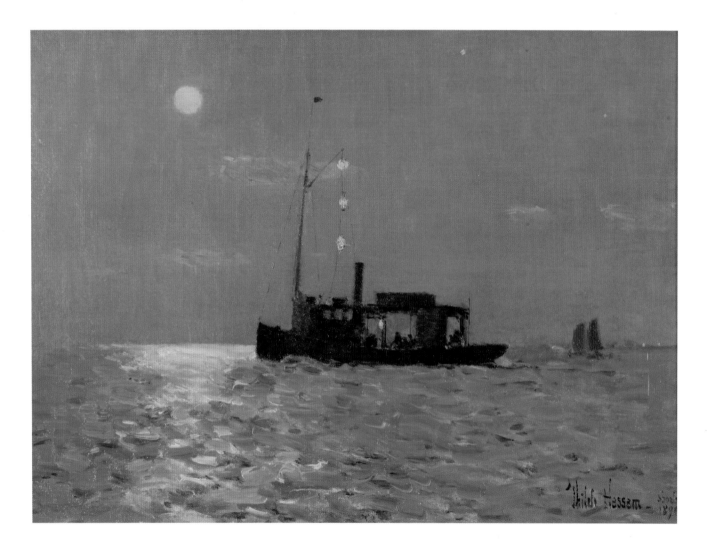

Childe Hassam (American, 1859–1935)
Isle of Shoals, 1890
Oil on canvas, 9 1/2 x 10 3/4 in.
Fitchburg Art Museum.
Gift of Rosamond F. Pickhardt, 1994 (1994.4)

American Impressionist Childe Hassam directed his gaze not to the moonlight but its reflection —for him the sight of dynamic interplay and radiant optical effect. Looking off the Isle of Shoals, a favorite destination for this artist of the late 19th century, Hassam juxtaposes a gauzy white moon against the pale blues of a night sky highlighted by a scattering of clouds and stars. The fishing boat at the painting's center, strung with artificial lights that hang vertically, intimates nocturnal activity. As the boat moves across the picture plane, breaking the line of the horizon, the composition takes on energy. The main event, however, is not the churning fishing boat but the ravishing effect of moonlight glinting off the choppy surface of the water. As the celestial bodies of moon and stars travel across the sky and the boat drags its lights across the water, the most dynamic and fleeting movement—the most modern, in fact, is the most ephemeral: the moonlight on the water off the Isle of Shoals.

TB

37

Childe Hassam
On the Balcony, 1888
Pastel on paper laid down on canvas
29 5/8 x 17 3/4 in. Adelson Galleries

In powdery pastel, Hassam uses quick, dashing strokes to capture a woman at a window, inhabiting the space between indoors and out. Her slim figure is gowned in white and bathed in silvery light, and Hassam performs a wonderful masterclass in the pastel medium, expertly highlighting the moon's shimmer on the railing, flower blossoms, and the woman's diaphanous sleeve. Like her spatial placement, the woman's pose is tentative. Arms at her sides, she does not stare intently at the moon as the men do in Friedrich's *Two Gentlemen Contemplating the Moon* (Fig. 13) or Rockwell's *Boy and Girl Gazing at the Moon* (Cat. 52). Instead, Hassam's genteel lady lowers her lids and defers, rather than engages. The change of the position of the face, upwards to downwards, changes the work's tone to subtle disappointment. Hassam, like many artists, realized that that the moon was useful as an artistic light source, but its presence actually shifts a painting's subject. Conditioned by our experience of viewing the actual moon, an artist's painted moonlight induces in us the same reflective mood.

BFB

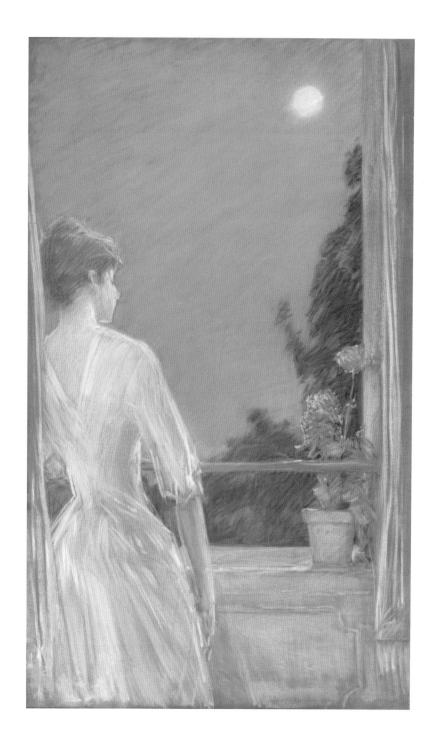

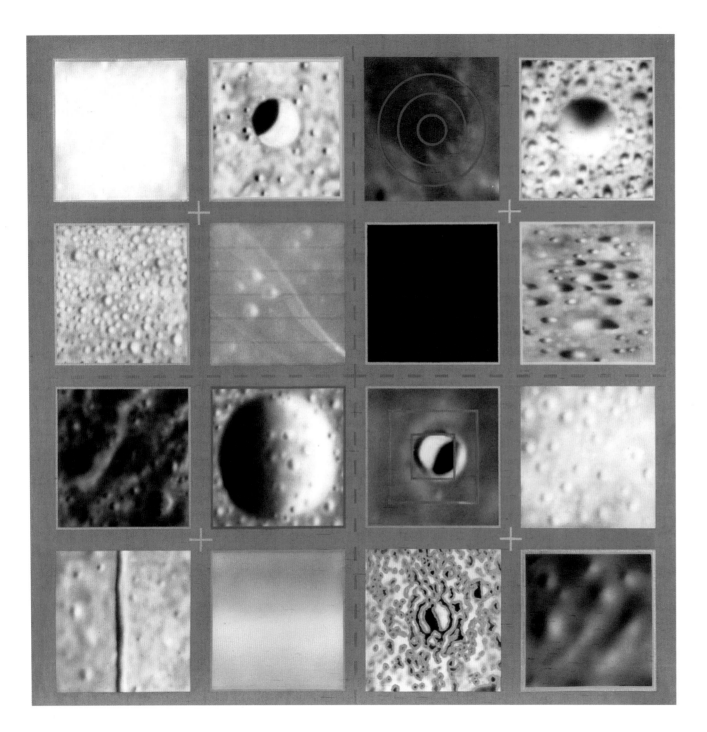

38

James Hendricks (American, 1938–2017)
Moon Sites, 1969
Acrylic on canvas, 48 1/4 x 48 1/4 in.
Hudson River Museum. Gift of the artist, 1972
(72.38)

James Hendricks was painting the moon from published NASA photographs for several years before the space program commissioned him to document the 1971 Apollo 14 mission. He called the moon "the most exciting subject matter of our time" because "photographs of the lunar surface reveal the imprint of cosmic forces."[24]
This artist, who studied the moon as a teen with his own telescope, began his art career as a Photorealist and produced a series of gridded paintings of lunar probe photographs, which the Hudson River Museum displayed in 1970.[25] Hendricks submitted his images to NASA, which led to their exhibition at the Smithsonian near its first display of moon rocks, as well as in the National Gallery of Art's *The Artist and Space* in 1970. He also painted detailed circular paintings of the moon's surface and apparent colors, including *Golden Moon* (1969) and *Blue Moon* (1970). After 1971 he worked in an abstract expressionist mode with spiritual overtones inspired by his feelings for the sublimity of space.[26]

LV

39

Harry L. Hoffman (American, 1871–1964)
The Harvest Moon Walk, ca. 1912
Oil on canvas, 24 1/4 x 26 1/4 in.
Florence Griswold Museum. Anonymous Donation,
1972 (1972.214)

Although one of the few paintings in this
exhibition which does not show the moon,
Harry L. Hoffman's *The Harvest Moon Walk*
shows a moonlit celebration of the revered
celestial orb. A beloved tradition among artists
and local townspeople of the Old Lyme art
colony in Connecticut, this painting provided
an opportunity for ribald celebration, lanterns,
and festive costumes, all on display in Hoffman's
painting. The lanterns establish a bouncing
rhythm across the picture plane, bathing the
dancing "moonwalkers" in dubious glow.
Hoffman appears to pay playful tribute to earlier
American Impressionist works like John Singer
Sargent's *Carnation, Lily, Lily Rose* (1885, Tate
Britain), which also focuses on the seductive
effects of artificial light against a twilighted
backdrop. Hoffman's humorous rejoinder strikes
a welcome note of levity.

TB

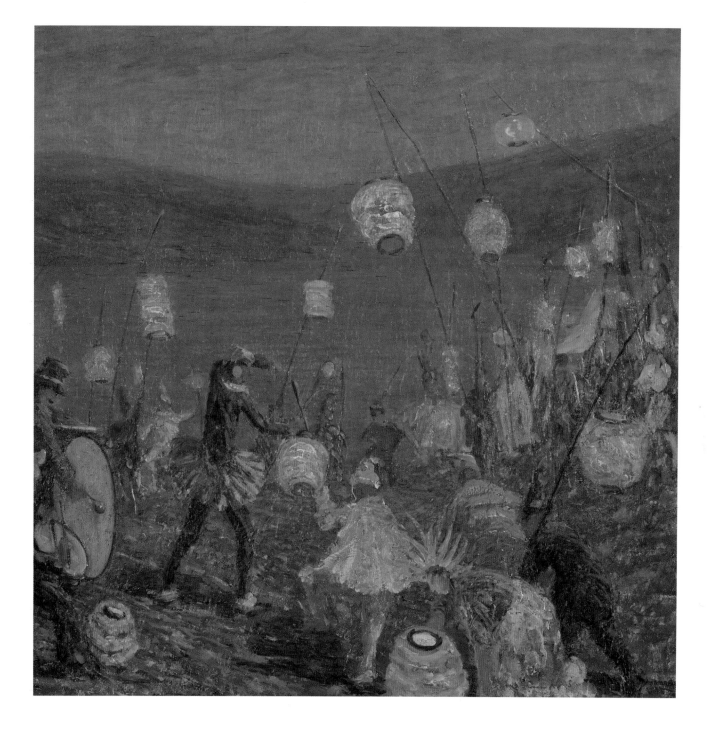

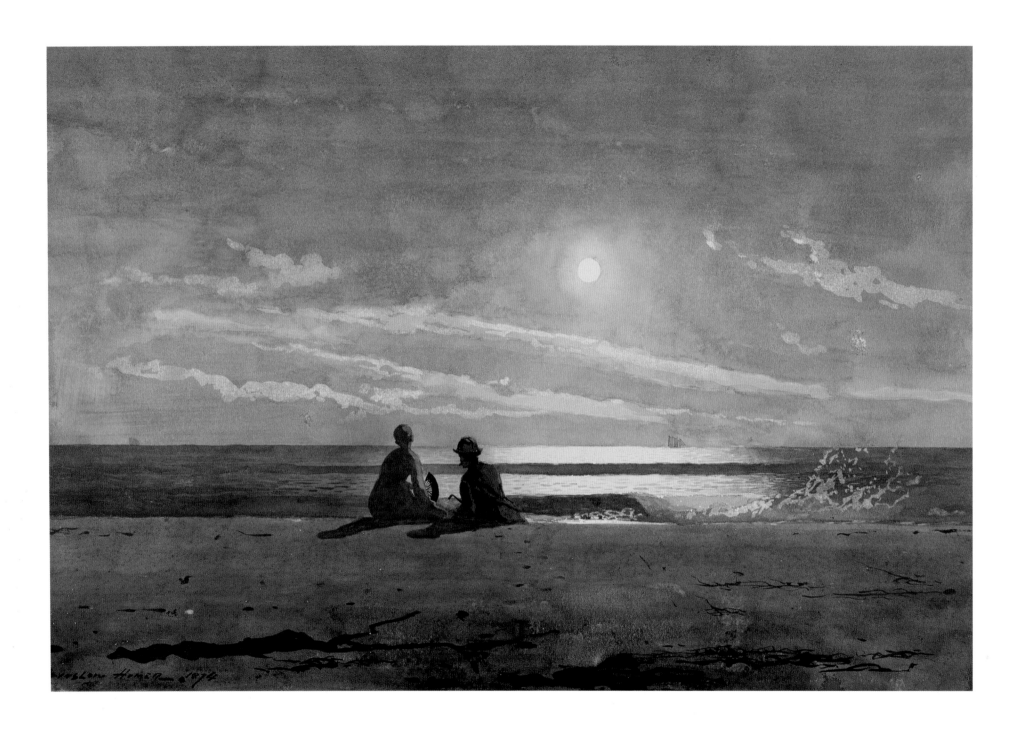

40

Winslow Homer (American, 1836–1910)
Moonlight, 1874
Watercolor over graphite on paper, 14 x 20 in.
The Arkell Museum at Canajoharie
Gift of Bartlett Arkell (317103)

This painting marks a turning point for Winslow Homer: a relatively large watercolor, it was an early shift on the part of this artist to exhibit watercolors as works of art in their own right. Fashionable couples enjoying a popular watering place or resort were recurring subjects for Homer in the early 1870s, particularly in his illustrations for the culture magazine *Harper's Weekly*. Yet, here, nature's mysteries loom from above: a pervasive air of ambiguity, established by the moonlight, heightens the tension of an otherwise conventional scene of flirtation. The moon shines bright above the couple, and yet obfuscates as much as it illuminates. Starkly silhouetted against the moonlight's reflection on the water, the couple contrast one another through pose. What unifies them is they face the moon. Backs to us though, what each sitter thinks about the celestial scene, or each other, remains a mystery.

TB

41

John O'Brien Inman (American, 1828–1896)
Moonlight Skating, Central Park, the Terrace and Lake, 1878
Oil on canvas, 34 1/2 x 52 1/2 in.
Museum of the City of New York, Anonymous Gift, 1949 (49.415.2)

By the mid-19th century, ice skating was so popular in New York that
new-made bodies of water, such as the Great Lake at Central Park, were
enthusiastically embraced and used as skating places, even 10 years before
the park was completed. As early as in Dutch Colonial times, Manhattan's
residents skated on frozen bodies of water from the Broad Channel downtown
to the Collect Pond outside the city limits. The Great Lake at Central Park,
shown here, was the most popular, publicized, and democratic place
to skate, being open to all. The moon, partially obscured by clouds, sets
the snow-covered banks and icy lake ablaze with a silver light that
highlights the movement of the night's skaters. With the warm glow of the
Bethesda Terrace as a backdrop, the skaters flirt, fall, and frolic.

TB

42

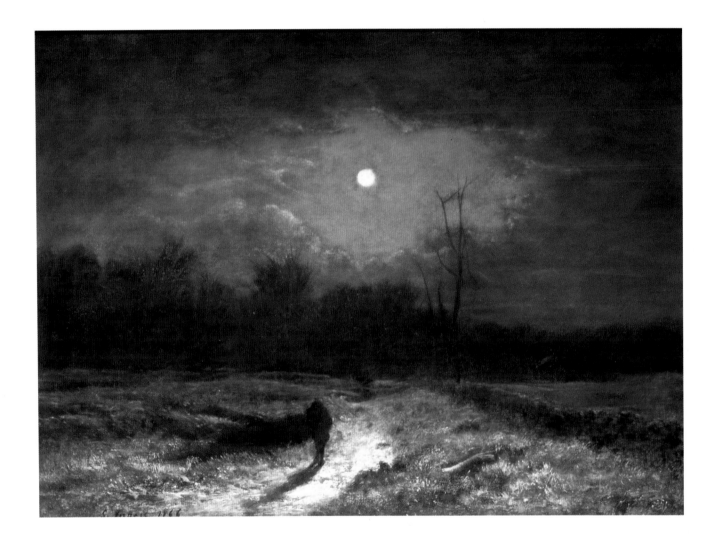

George Inness (American, 1825–1894)
Winter Moonlight (Christmas Eve), 1866
Oil on canvas, 22 x 30 in.
Montclair Art Museum. Museum purchase,
Lang Acquisition Fund, 1948 (1948.29)

In this mid-career nocturne, George Inness is still
working in a relatively straightforward Hudson
River School-inspired style. The moon, ringed by
broken clouds, shines in the sky. Below, moonlit
snow highlights the path of a solitary wanderer.
The title, *Winter Moonlight,* brings memories of
cold and snowy travel to the familial unions we
timelessly associate with Christmas. Yet Inness does
not offer any clues to a story in this painting. Who
is this traveler and where is he going? Despite the
brightness of the moon and its light reflected off
the snow, Inness leaves much to our imaginations.
Later in his career Inness continued his trajectory
away from the clarity of the Hudson River School,
leaning towards ambiguity of form, and twilight
scenes played well into this idiom (Cat. 43).

TB

43

George Inness
Spirit of the Night, 1891
Oil on canvas, 34 5/8 x 49 13/16 in. (framed)
Williams College Museum of Art
Gift of Mr. and Mrs. William H. Barnewall,
Class of 1924, 1961 (61.24)

The partially-obscured moon above the sky we see
through tattered clouds dimly illuminates an amorphous
landscape. Indeed, the clouds seem to almost merge with
the tree line at the right of the painting, while hovering
flat above the horizon like a stripe on the left. Towards
the end of George Inness' life, as this artist's spiritual
connection to the landscape intensified, he sought a
tonal unity in his paintings, where precise details were
obscured in favor of an evocative mood. The nature of
light on the landscape creates the prevailing mood here.
The pale glow of the blue sky and the green field reflect
the gentleness of light as day turns into night. Night is
intimated by fading light and, as suggested in the title,
experienced internally as much as directly observed.

TB

44

Roy Lichtenstein (American, 1923–1997)
Moonscape, from **11 Pop Artists,** 1965
Screenprint on blue Rowlux, 20 x 24 in.
Palmer Museum of Art, Penn State (68.1)

Roy Lichtenstein cultivated the process of looking at fine art in books, then compiling and distilling images into artificial Pop Art versions. If he wanted a type of scene so classic it could be a cliché, "a moon over water" is perfect. Jack Cowart, executive director of the Roy Lichtenstein Foundation, has called this print "a riff on German Romantic painting, these Caspar David Friedrich very moody nineteenth-century paintings. Roy knew his art history. There's also the American landscape, the Hudson River School…. These natural effects of moon, reflection, sky, sun, water, clouds—Roy just made it about as artificial a naturalistic setting I can imagine."[27] These prints look mass-produced, yet began with the artist cutting collage elements by hand. The design is printed on thermoplastic film with a molded structure of minute lenses to create iridescence. Each print, from moment to moment, will vary based on changing lighting conditions. In distancing his art from nature, Lichtenstein gave his moonlight a life of its own.

LV

45

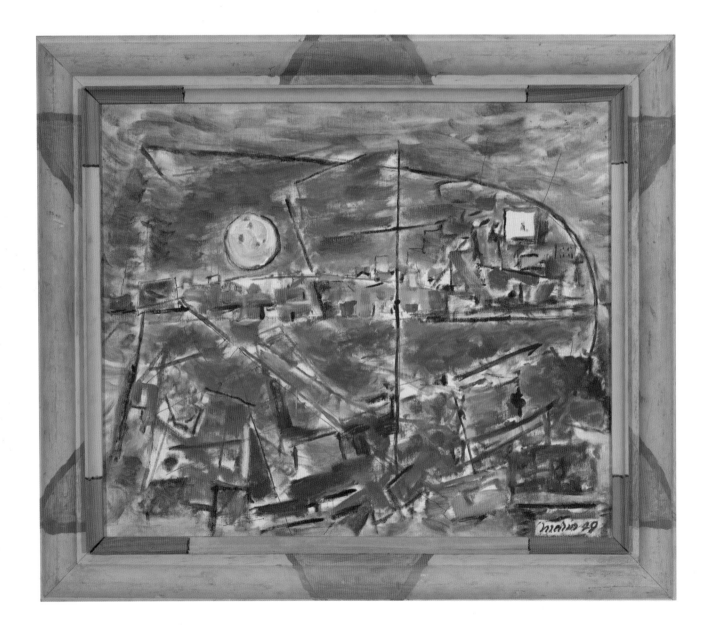

John Marin (American, 1870–1953)
Full Moon over the City No. 2, 1949
Oil on canvas, 24 x 28 1/2 in.
Norma Marin, courtesy Meredith Ward Fine Art,
New York
Photograph Luc Demers © 2018 Estate of John Marin /
Artists Rights Society (ARS), New York

Marin paints a reddish Moon and dots its surface to create the craters that have intrigued for eons. After the first year of World War I in Europe and 34 years before he painted this late work, John Marin wrote to Alfred Stieglitz, Modernist exhibition organizer, about the power the moon possessed for him: "I look at my work—very tame—pieces of paper blown to the winds. And if the moon were to say something to the Earth and the Earth laughed—more people could be killed than in all the wars put together."[28] The wash-like application of oil paint in this landscape reminds us that for many years Marin's primary medium was watercolor. On both sides of the Hudson River that winds over the canvas, humans scurry through life's activities but Marin's still, full Moon presides above it all. Much of the energy in Marin's painting comes from one long clean line, which sweeps across the sky, encircling the moon and the buildings below.

LV

46

Louis Remy Mignot (American, 1831–1870)
The Harvest Moon, 1860
Oil on canvas, 24 x 39 in.
The New-York Historical Society, New York,
New York. The Robert L. Stuart Collection
Gift of his widow Mrs. Mary Stuart (S-160)
Photography © New-York Historical Society

In March 1860 the magazine *The Crayon* reported that Louis Remy Mignot was painting this work, "its produce ripe for gathering and rich with the hues of the harvest season, over which, on the horizon, the full moon is just appearing in a cool blue, serene sky." Harvest was a popular theme for mid-century painters, and their viewers often associated it with moralizing about the state of the nation or the economy. Mignot, however, does not include any overt narrative. The "harvest moon" is the full moon nearest the start of the autumnal equinox. It often coincides with September's full moon, where its rise, soon after sunset, provides more light for farmers to gather the fruits of their fields. Mignot uses a distinctive, atmospheric coloration of blues and violets for the scene, reminiscent of his eye-popping paintings of jungles, mountains, and volcanos, based on his 1857 voyage across South America with acclaimed Hudson River School artist Frederic Church. So, despite being a New York scene, this work bears traces of decadent tropical lushness.

BFB

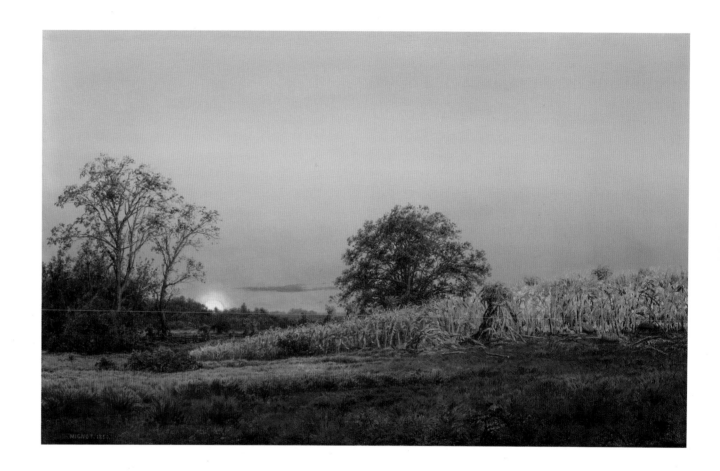

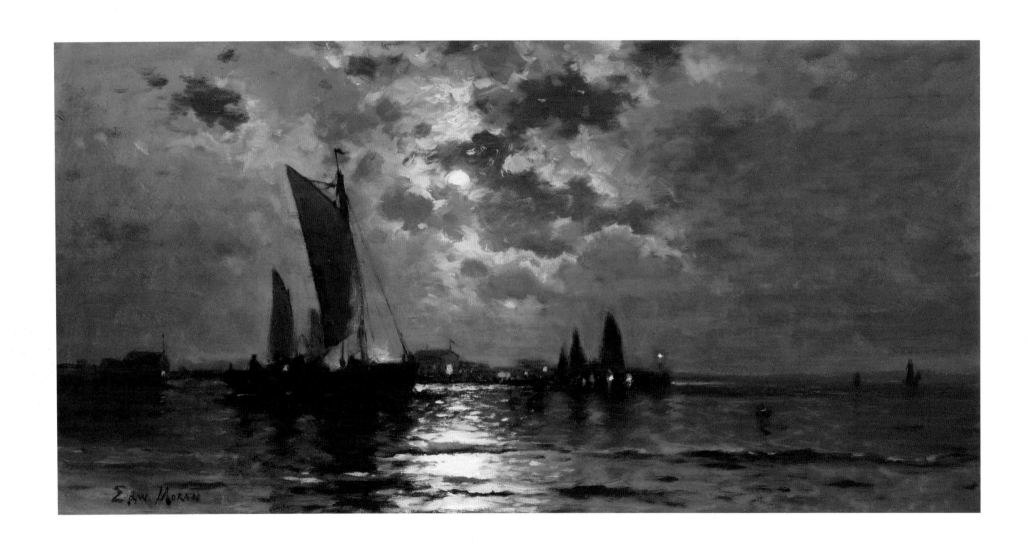

47

Edward Moran (American, born in England, 1829–1901)
Ships in Moonlight, ca. 1890
Oil on canvas, 12 x 24 in.
Private collection. Photograph Godel & Co, Inc.

Edward Moran was one of the Hudson River School's most prolific marine artists, often creating a historicized episode to frame his scenes, such as battles of the American Revolution. In a review of the 52nd exhibition of the National Academy of Design, the critic for *The Art Journal* wrote, "Moran is fond of painting night sea-scenes, the moon breaking through drifting clouds, and vessels, with their towering sails, cast in deep shadow, while the moonlight burnishes the crests of the waves. There is always an abundance of poetic effect in these pictures, with … their silvery lights … their sense, in the sweeping motion of the ships, of lonely majesty and power."[29] Edward, elder brother of another Hudson River School artist, Thomas Moran, was deeply inspired by the seascapes of British master J.M.W. Turner (1775–1851), as well as Dutch maritime paintings of the 17th and 18th centuries. *Ships in the Moonlight* benefits from Moran's characteristic vigorous brushwork, and as in Cropsey's *Castle Garden, New York* (Cat. 25), Moran uses the darkness of night and soft moonlight to cloak the hurly-burly of the harbor.

BFB

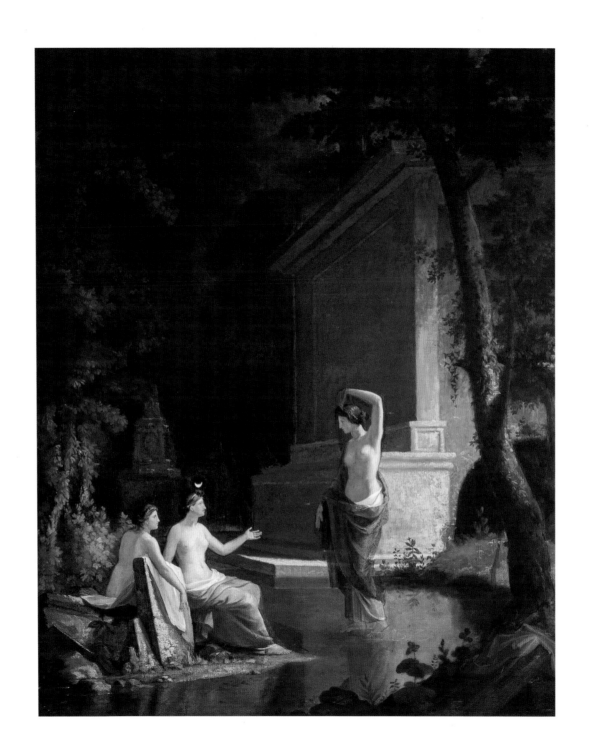

48

Samuel Finley Breese Morse (American, 1791–1872)
Diana at the Fountain, 1813
Oil on canvas, 30 1/2 x 25 3/4 in.
Hirschl & Adler Galleries, New York

Roman mythology links two goddesses, Luna and Diana, to the moon.
Diana, the virginal huntress, wears a crescent moon in her diadem.
In Samuel F. B. Morse's painting, a glowing moon seems magical, hovering
above this seated goddess. Her personal moon is the only one in the painting,
but light on the figures and reflections on the water show the moon's presence
outside the painting. Morse is from an earlier generation than most of the
artists in this exhibition, a time when the London art world was still a magnet
for American artists and historical and mythological figures still subjects more
prestigious than portraits and landscapes. He painted this classical scene
during a winter spent in Bristol, England, where Harman Visger, an American
merchant who lived there was supportive of his work and bought it.[30] Returning
to New York, Morse pursued his painting career, becoming the first president
of the National Academy of Design, but not gaining critical or financial
success stopped painting, and achieved everlasting fame as the inventor of
the telegraph.

LV

49

William Edward Norton (American, 1843–1916)
Boston Harbour by Moonlight, ca. 1885
Oil on panel, 4 7/8 x 8 1/2 in. Private collection

Moonlight on water has fascinated painters as far back as the Dutch Old Masters of the 1600s, and artists who are also sailors have ample opportunity to observe the moon's magical effects. This was true for Norton, who painted a misty full moon that barely illuminates the inky night that envelops the shore of his hometown, Boston. He came from a family of shipbuilders and worked at sea before becoming an artist. He studied with George Inness, a devoted painter of the moon (Cat. 42, 43).

Norton returned often to this nocturnal theme and probably painted small studies like this outdoors at night. Here he shows rings around the moon (an age-old sign of an impending storm), shimmering effects on coastal water, and with flecks of paint suggests the night lights of an urban environment. The artist was living in London in the late 19th century but may have come to the United States to visit Boston in 1885, when he exhibited the painting *With the Tide* at the American Art Galleries in New York City.[31]

LV

50

Howard Pyle (American, 1853–1911)
The Mermaid, 1910
Oil on canvas, 57 7/8 x 40 1/8 in.
Delaware Art Museum. Gift of the children of Howard Pyle
in memory of their mother, Anne Poole Pyle (1940-12)

This final canvas of Howard Pyle's was on his easel and
not quite finished when he died. Painted in Florence while
Pyle was on vacation in Europe, it was described by
his biographer in 1925 as having "a cold white moon,
and in its light the eerie loveliness of a mermaid siren,
winding white arms about a fisher-lad."[32] The painting
is wildly romantic—literally dripping with sensuality.
Scholars have differed on interpretation, questioning if
the mermaid is attempting to save a drowning fisherman
or if she is a siren trying to kill him. The critic for the
journal *St. Nicholas* described her as "dragging him
down, down, into the deadly depths below the white
lacing foam."[33] In all of this, there is a suggestion of
gender reversal. Although lower on the canvas, the
mermaid's embrace is commanding, and the fisherman,
one leg perched on a boulder, embodies a more
feminine stance. Pyle understood drama, and we are left
wondering if the fisherman will live through the moonlit
night to greet another dawn.

BFB

51

Robert Lewis Reid (American, 1862–1929)
Moonrise, ca. 1897
Oil on canvas, 72 x 48 in.
The Lambs Foundation, New York

Floating above irises and surrounded by dogwood blossoms, this figure seems of the earth, not meant to be Luna, Diana, Selene, or any other moon deity. American Impressionist Robert Reid was known for such paintings of idealized women. Critics took note of this painting but only one gives a clue to the figure's identity: a sylph. When it was shown at the at the New York Athletic Club in 1898, a writer noted "a graceful sylph floats up to catch the glow of the twilight . . . "[34] The viewer, and perhaps this artist, may have been aware of the traditional association of the sylph, a spirit of the air, with night and the moon. American poet Paul H. Hayne wrote a poem "The Sylph in the Laurel Tree," where he said, "In the soft moonlight I behold her glide, / All glorified / In the passionate pathos of parting Day"[35] In 1897, members of The Lambs, a private club for theater professionals, purchased *Moonrise* for display in their new clubhouse. Reid, himself, was a lifelong member.

LV

52

Norman Rockwell (American, 1894–1978)
Boy and Girl Gazing at the Moon (Puppy Love), 1926
Cover illustration for *The Saturday Evening Post*, Apr. 24, 1926
Oil on canvas, 24 x 20 in.
Norman Rockwell Museum. Given by Bill, Casey, Maggie,
Jenny and Jesse Millis "in honor of Norman Rockwell,
an incredible American" (NRM.2015.04). Printed by
permission of the Norman Rockwell Family Agency.
Copyright © 1926 the Norman Rockwell Family Entities

In the sense that a connective theme running throughout
The Color of the Moon is the romanticism of our
relationship with the moon, Norman Rockwell's 1926
Saturday Evening Post cover, perfectly expresses this
sentiment. The artist shows a boy and girl in a moment
of quiet companionship, looking at a full moon.
The rustic bench and fishing equipment mark this as
country. Rockwell, who grew up in a lower middle-class
neighborhood in Manhattan, spent childhood vacations
on farms and later said, "During the summer I lived
an idealized version of the life of a farmboy … and
my memories of those days had a lot to do with what I
painted later on….I paint life as I would like it to be."[36]
The mournful dog, ignored by the couple, gives double
meaning to an alternate title, *Puppy Love*.[37] Looking up
at night in the country, far from the light pollution of city
street lights, the young Rockwell must have noticed more
sparkle in the sky. The children, struck by the size, color,
and beauty of the rising moon, pause to admire
the scene.

LV

53

Norman Rockwell
Man on the Moon (United States Space Ship
on the Moon) – Study, 1966. Painted for "Man on the
Moon" by John Osmundson, *Look*, Jan. 10, 1967
Oil on board, 19 3/4 x 12 3/4 in.
American Illustrators Gallery (LNM #S418a). Printed
by permission of the Norman Rockwell Family Agency
Copyright © 1966 the Norman Rockwell Family Entities

Norman Rockwell is one of numerous artists who
participated in the NASA art program, which began
in 1962. Because Rockwell was involved with
this project, he had direct access to prototypes of
spacesuits and the lunar module when *Look* hired
him to paint illustrations for the magazine three years
before the actual lunar landing. Rockwell's painting
is a study for *Man's First Step on the Moon* (1966,
National Air and Space Museum, Smithsonian
Institution), published by *Look* in January 1967.
Rockwell was able to see and photograph NASA's
model of the moon surface and life-size spacecraft;
and the scientists used an apple, a balloon and a
lightbulb to show Rockwell what Earth would look
like from the astronauts' on-high perspective.[38] In the
final painting, Rockwell changed the earth to a sliver
of a crescent, but here it is more recognizable as our
home planet.

LV

54

Norman Rockwell (American, 1894–1978)
**Study for The Final Impossibility: Man's Tracks
on the Moon,**1969
Painted for *Look*, Dec. 30, 1969
Oil on photographic paper mounted on board,
14 x 21 1/2 inches (image)
Norman Rockwell Museum.
Norman Rockwell Art Collection Trust (NRACT.1976.13)
Printed by permission of the Norman Rockwell Family
Agency. © 1969 The Norman Rockwell Family Entities

55

Norman Rockwell
**Study for The Final Impossibility: Man's Tracks
on the Moon,** 1969
Painted for *Look*, Dec. 30, 1969
Oil on photographic paper mounted on board,
14 x 21 1/2 inches (image)
Norman Rockwell Museum
Norman Rockwell Art Collection Trust (NRACT.1976.12)
Printed by permission of the Norman Rockwell Family
Agency. © 1969 The Norman Rockwell Family Entities

According to notes made by Norman Rockwell
for a talk at his Monday Evening Club in Pittsfield,
Massachusetts, *Look* contacted him well before the
actual lunar landing to commission images of the
event.[39] He visited NASA's Manned Spacecraft
Center in Houston, Texas, just a few weeks
after this historic event to collect more research
information and visuals.[40] Both studies and the final
painting (National Air and Space Museum) show
Neil Armstrong on the moon's surface and Edwin
(Buzz) Aldrin, Jr., on the ladder. Despite the figural
detail obscured by the spacesuits and helmets,
Rockwell manages to convey a sense of both men
captured in a moment of action in the low gravity.

LV

56

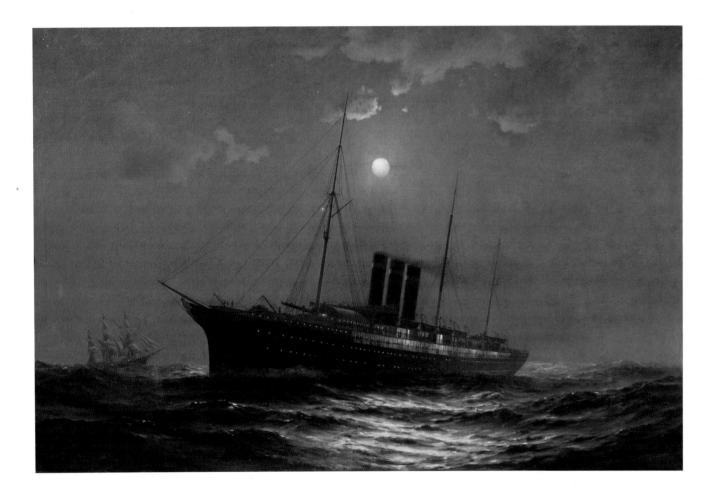

Warren W. Sheppard (American, 1858–1937)
The City of Paris, ca. 1892
Oil on canvas, 39 x 60 in.
Post Road Gallery,
Fine American Paintings

Warren Sheppard may have painted this
moonlight marine to celebrate the crossing of the
Atlantic by the Inman Line ship *The City of Paris.*
Bearing 738 passengers, the liner made New
York's port on October 20, 1892 in the record
time of 5 days, 14 hours, and 22 minutes. In
this context, perhaps the moon's presence high
in the sky signals the human command of time
in this period of ocean liner competition during
the Gilded Age. On canvas the masts stretch
above the moon, and surf bubbles beneath the
hull as it cuts through the North Atlantic waves.
Still considered one of the most beautiful ships to
have crossed the Atlantic, it soon had its record
time eclipsed by a ship from the White Star Line.
During the Spanish American War, six years after
Sheppard finished this painting, *Paris* served the
U.S. Navy as a cruiser, renamed USS *Yale,* and
eventually was scrapped after World War I.

TB

57

Edward Steichen
(American, born in Luxembourg, 1879–1973)
The Yellow Moon, 1909
Oil on canvas, 24 x 25 in.
Washington County Museum of Fine Arts,
Hagerstown, Maryland,
Gift of Mrs. Conger Goodyear, 1953
(A0736,53.0003) © 2018 The Estate of Edward
Steichen / Artists Rights Society (ARS), New York

Painting a full moon low on the horizon encourages
the illusion that this heavenly body is part of Earth's
landscape. Edward Steichen implies this connection
in his autobiography: "The romantic and mysterious
quality of moonlight, the lyric aspect of nature
made the strongest appeal to me."[41] In the early
20th century painters and photographers found the
combination of darkness and moonlight that cloaked
the nighttime world irresistible. Steichen painted
Yellow Moon while living in Voulangis, France,
about 30 miles east of Paris. During World War I,
he remained in Europe as chief of the Photographic
Section of the American Expeditionary Forces but
the horrors of war jaded him toward the "idyllic
compositions...beautiful effects of atmosphere and...
exquisite poetic feeling," noted by critics in his oil
paintings, and in 1922 he burned all of the canvases
still in his possession and is today most remembered
as a photographer.[42]

LV

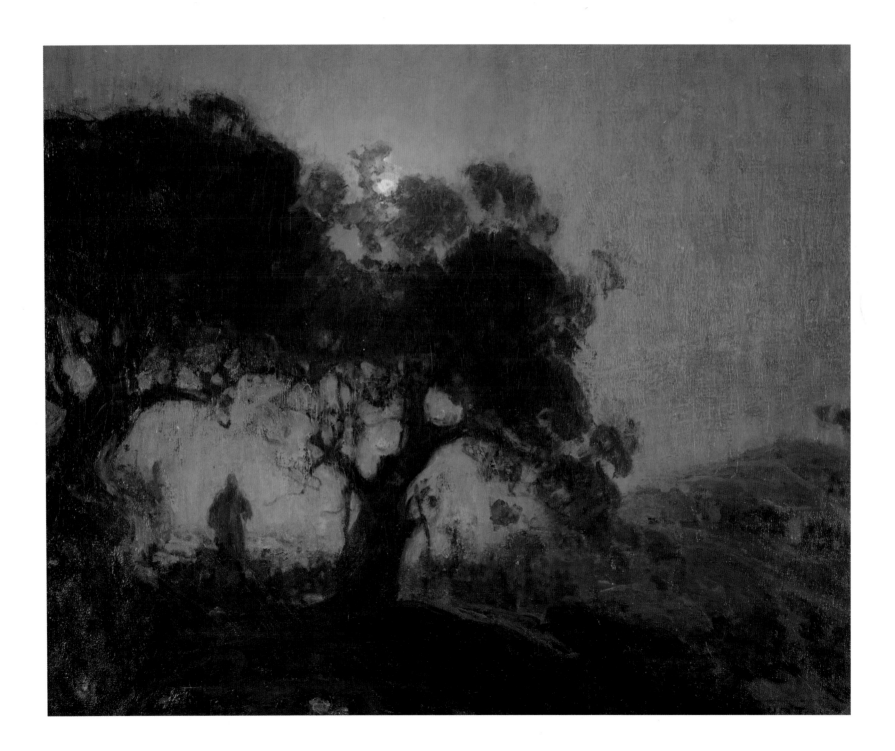

58

Henry Ossawa Tanner (American, 1859–1937)
The Good Shepherd, 1902
Oil on canvas, 26 15/16 x 31 15/16 in.
Zimmerli Art Museum at Rutgers University
In memory of the deceased members of the Class of 1954 (1988.0063)
Photography Peter Jacobs

Moonlight for artist Henry Ossawa Tanner was a metaphor for faith: a demonstration of the sun's presence through oblique reflection, and a beacon for the figure in this painting. As an artist who came of age in the racialized environment of post-Civil War America, Tanner bore witness to the rapid technological development of the Northeast, while the racism of his native Philadelphia eventually led to his expatriation to Paris. Both in the City of Light, and on his intermittent returns to the United States, Tanner witnessed with increasing frequency the artificial illumination of modern cities. His biblical paintings can be seen as inward reflections, often moonlit, of one's spiritual life set against modernity. Here, the moon, partially obscured by two trees, lights the sky and frames the shepherd and his flock in vaporous but steady light.

TB

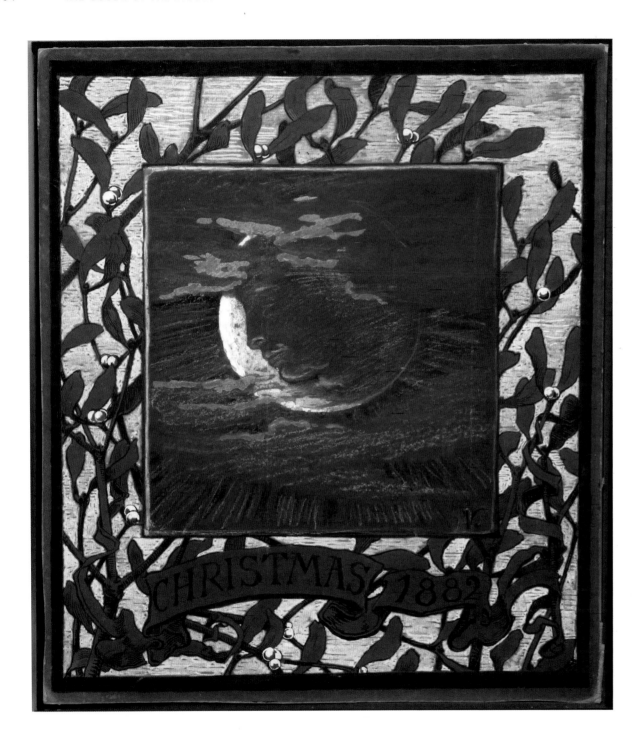

59

Elihu Vedder (American, 1836–1923)
Luna, Christmas, 1882
Mistletoe border by Alfred Parsons (1847–1920)
Watercolor and pastel and black and blue ink on artist's
board, 12 3/8 x 10 7/8 in.
Cover of *Harper's Christmas 1882*, "Pictures and
Papers, Done by the Tile Club and its Literary Friends,"
Harper & Brothers, New York. Gill & Lagodich Gallery

The moon was one many of celestial themes that
were lifelong interests for Elihu Vedder: it showed
up personified, mythologized, and illustrated in the
drawings, prints, and paintings of the artist's long and
diverse career. Visionary and stubbornly ambiguous,
Vedder was likely drawn to lunar subjects because the
moon was both apparent and evasive. Although he
lived most of his adult life in Rome, he returned often
to the United States, and was rewarded with many
mural and illustration commissions. This illustration
was on the cover of the holiday issue of the monthly
Harper's Magazine in 1882. Luna, the name of the
ancient Roman goddess of the moon, was identified
by the two-pronged crescent moon she often wore
as a crown. Here, Vedder has combined her face in
profile and the crescent shape of the moon, putting
a modern twist on a classical subject. Clouds and
a frame of mistletoe, illustrated by Alfred Parsons,
bring the mystical associations of the moon down to
earth, mixing ancient pagan mythology with modern
Christmas associations.

TB

60

Hans Weingaertner (American,
born in Germany, 1896–1970)
Small Eclipse, 1938
Oil on wood panel, 17 1/2 x 19 1/2 in.
Hirschl & Adler Galleries, New York

Eclipses kept the moon on the pages of American
newspapers in the first half of the 20th century,
before the space race shifted the focus of
people's curiosity. Newspaper articles told where
the phenomena could be viewed, and published
diagrams and explanations by astronomers.
Hans Weingaertner painted eclipses at least four
times.[43] The painting depicts a lunar eclipse,
caused when the moon is covered by the earth's
shadow.[44] The artist could have seen two lunar
eclipses from his Rutherford, New Jersey, home
in 1938. The *New York Times* described the
November eclipse as particularly dramatic:
"A full moon rose from the sky ... in the form
of a tiny crescent of orange, with its remainder
hidden behind a transparent copper-colored
veil....Unlike a total eclipse of the sun, the totally
eclipsed moon does not become covered with
a black shadow, but is seen through a copper-
colored haze, due to the bending of light by the
atmosphere in such a way as to allow the red
rays of the spectrum to get through."[45]

LV

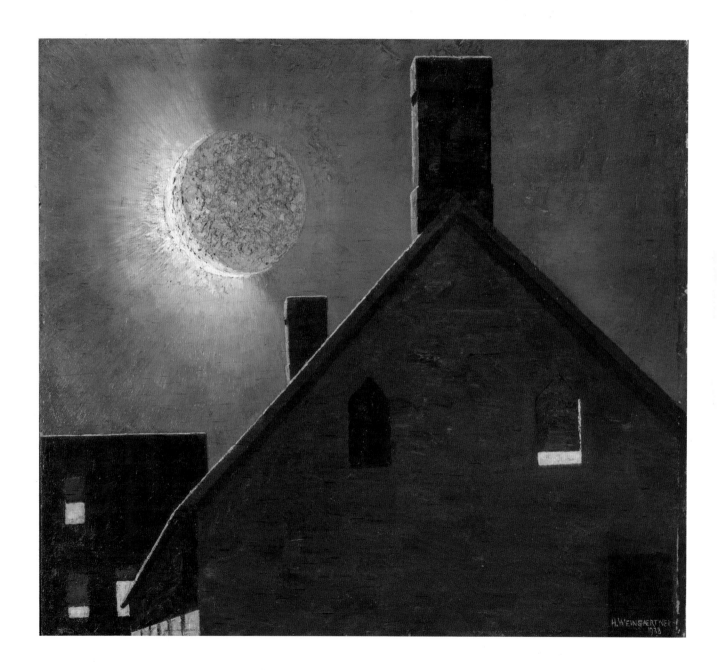

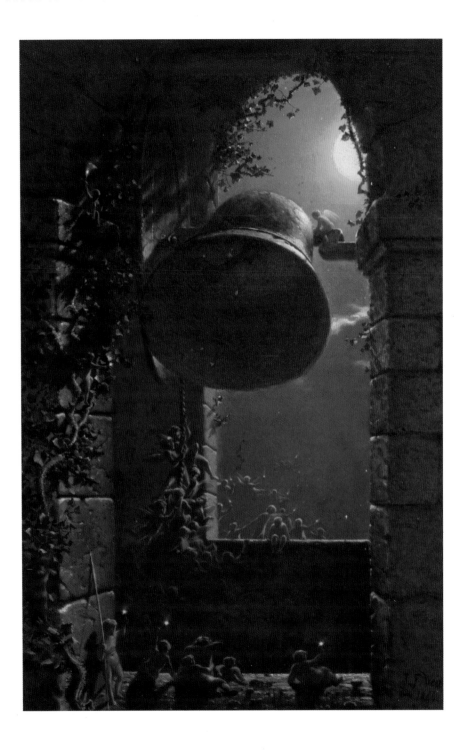

61

John Ferguson Weir (American, 1841–1926)
Christmas Bell, 1866
Oil on canvas, 16 x 10 3/8 in.
The Butler Institute of American Art,
Youngstown, Ohio (958-O-145)

Fairies dance in the moonlight, gathering in the
belfry of a church to ring in Christmas. As midnight
approaches, the moon provides just enough
illumination to capture the magical goings on.
As one critic described Victorian fairy painting:
"moonbeams provided an almost compulsory
backdrop to the increasingly popular depictions of
fairyland. And as industrialism advanced, a moonlit
rural landscape dependent on the fruits of agriculture
and the benevolence of the seasons came to
symbolize a yearned-for world of lost innocence and
abundance."[46] Weir painted the first of what came to
be known as his *Christmas Bell* series, which would
eventually number at least five paintings, during the
height of the Civil War. The artist referred to the
series as his "Chimes," and he was likely inspired
by his experience living near the neighborhood
fire bell on West 10th Street, which, because of the
noise, he described as "the torment of my life."[47] But
here, Weir transforms his daily irritation into a scene
that presents us with a vision equally nostalgic for a
romanticized past and optimistic for a better future.

BFB

62

Jamie Wyeth (American, born 1946)
Apollo XI — To the Moon, July 16, 1969, 1969/2009
Watercolor on paper, 27 1/2 x 20 in.
Adelson Galleries
© 2018 Jamie Wyeth / Artists Rights Society (ARS), New York

As the moon missions progressed, NASA commissioned artists to depict not the moon, the ultimate destination, but the human technology and personal efforts to reach it. Jamie Wyeth first painted watercolors documenting the space program in 1966, when there were five manned Gemini missions and he was just turning 20. The son of artist Andrew Wyeth (1917–2009) and grandson of iconic illustrator Newel Convers (N.C.) Wyeth (1882–1945), Jamie had an impressive artistic heritage but was already gaining attention for his own talent and unique view of the world. He traveled to Cape Canaveral, then known as Cape Kennedy, to observe launches; and NASA even took him by helicopter to see rocket splash downs, including the first manned trip to the moon in 1969. In most of his watercolors, Wyeth zooms out to include the grassy, sandy topography and wide, sunny skies of Florida as a foil for the technology of rising launch towers.

LV

63

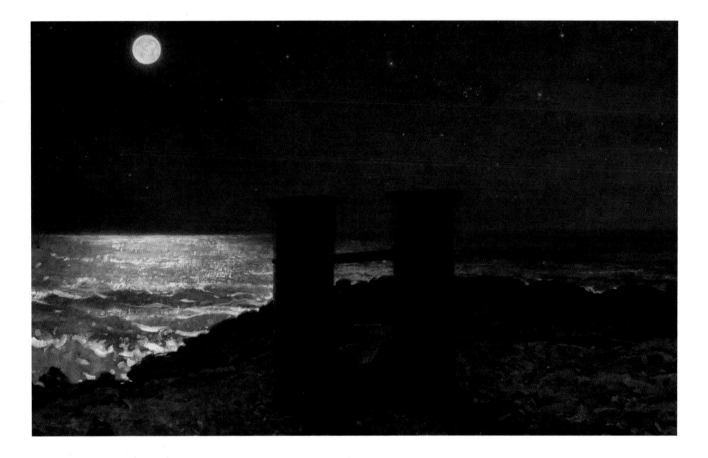

Jamie Wyeth (American, born 1946)
Moon Landing, July 1969
Oil on canvas, 29 x 43 in.
Adelson Galleries © 2018 Jamie Wyeth / Artists
Rights Society (ARS), New York

After working with NASA and seeing the launch to the moon in person, Jamie Wyeth looked out on the dark, rocky beach in front of his Maine home and imagined it to be the moon. Beginning with Galileo in the 1600s, telescopes revealed the moon in greater detail than can be seen with the naked eye, and astronomers and artists imagined its shadows to reveal a topography much like Earth.[48] Throughout the 1960s, the mounting photographic record of space missions replaced these artistic and romantic conceptions with visual facts. Armed with new knowledge of the moon's actual appearance, Wyeth flipped these old notions of the moon looking like the earth and saw his own world of Monhegan Island related to lunar images seen on television coverage of the Apollo missions. In the foreground is a ship's bollard (double posts for securing mooring ropes) from the *D.T. Sheriden*, which crashed on Monhegan in 1938. Wyeth imagined the sturdy relic as the "lunar lander" and employed a low angle to exaggerate its height.[49]

LV

64

Marguerite Thompson Zorach
(American, 1887–1968)
Figure in Moonlight, 1916
Oil on canvas, 23 1/2 x 18 in.
Palmer Museum of Art, Penn State (73.106)

An abstraction, this painting is a balance of straight and curved lines, symmetry and asymmetry, representation and forms of pure design. The woman in the moonlight has been linked to the character "Life" in a one-act play, *The Game,* by Louise Bryant, for which Zorach created a stage backdrop visually related to this painting.[50] The moon does not figure in the play's dialogue or in its stage direction, but, instead, Zorach added this age-old indicator that action is taking place in the dead of night. Here in the painting, Life presides over the harbor town, monumental and serene, under the moonlight. The decorative composition of Zorach's painting—with its parallel waving lines and neat line of boats, houses, and clouds—shows how varied the American responses to Modernism from Europe were in the early years of the 20th century.

LV

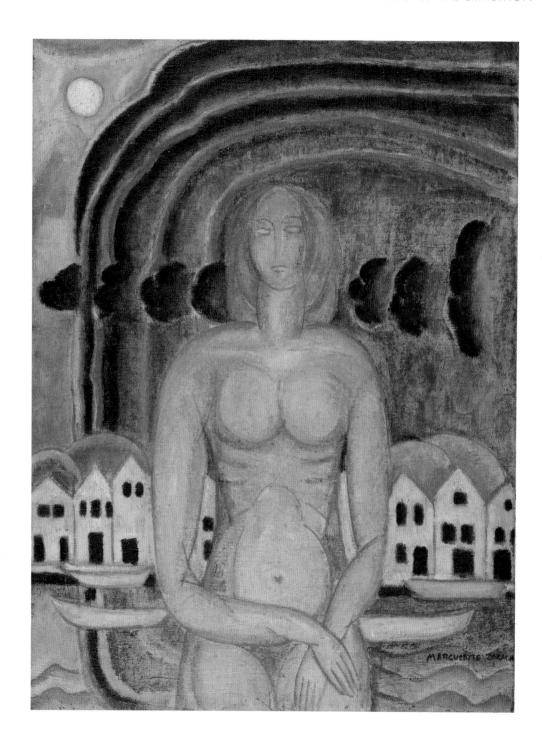

ENDNOTES

1. Julie Novarese Pierotti, *Modern Dialect: American Paintings from the John and Susan Horseman Collection* (Dixon Gallery and Gardens, 2012), 103.

2. Fanny D. Bergen (ed.), *Current Superstitions: Collected from the Tradition of English Speaking Folk* (The American Folk–Lore Society, 1896), 117–119.

3. John I. H. Baur, *George Ault: Nocturnes* (Whitney Museum of American Art, 1973), unpaginated.

4. Oscar Bluemner Papers, Archives of American Art, reel 343, frame 1360. Quoted in Roberta Smith Favis, "Painting "the Red City": Oscar Bluemner's *Jersey Silkmills*," *American Art* 17, no. 1 (2003), 32. http://www.jstor.org/stable/3109416.

5. *Oscar Bluemner: New Paintings*, organized by Alfred Stieglitz at The Intimate Gallery in the Anderson Galleries building in New York, NY, 1928.

6. Barbara Haskell, *Oscar Bluemner: A Passion for Color* (New York: Whitney Museum of American Art, 2005), 98.

7. American publications, such as the *Boston Journal of Chemistry* ("Physical Science and Painting," Jul. 1878), reprinted his arguments.

8. Eugene R. Cunnar "Ut Pictura Poesis: Thomas Cole's Painterly Interpretations of L'Allegro and Il Penseroso" in *Milton Quarterly*, v. 24, n. 3 (Oct. 1990), 88.

9. Bonnie Costello, *Planets on Tables: Poetry, Still Life, and the Turning World*, Cornell University Press, 2008), 108.

10. Joseph Cornell, Donald Windham, Howard Hussey, *Joseph Cornell: Collages 1931–1972 with Texts* (Castelli Feigen Corcoran, 1978).

11. Qtd in Anthony M. Speiser, ed., *Jasper Francis Cropsey: Catalogue Raisonne Volume 1, 1842–1863* (Newington–Cropsey Foundation, 2013), 206.

12. Anthony M. Speiser, ed., *Jasper Francis Cropsey: Catalogue Raisonne Volume 1, 1842–1863* (Newington–Cropsey Foundation, 2013), 111–112.

13. Speiser, ed., *Jasper Francis Cropsey*, 197.

14. *ee cummings art* (Ken Lopez Bookseller, undated brochure).

15. Dorothy Parker, "The Passionate Freudian to his Love," *Life*, Apr. 14, 1921.

16. E. E. Cummings, "Unrealities XII," *Tulips and Chimneys*, W. W. (Norton & Company, 1996; first edition 1923), 131.

17. Mauritz Frederik Hendrik de Haas qtd. in "The Methods of a Marine Painter," *The Art Journal* 4 (1878), 186.

18. Anderson Galleries catalog for Intimate Gallery *Arthur G. Dove Paintings*, exhibition, 1927. Arthur and Helen Torr Dove papers, 1905–1975, 1920–1946. Archives of American Art, Smithsonian Institution.

19. Bruce Robertson et al., *Twentieth–Century American Art: The Ebsworth Collection* (Washington, DC, 1999), 93.

20. William Livingston, "What's Wrong with a Gibbous Moon," *Sky & Telescope* (Feb. 1992), 160.

21. Arthur Wesley Dow, *Composition: A Series of Exercises in Art Structure for the Use of Students and Teachers*, 9th edition (New York: Doubleday, Page & Co., 1914), 54.

22. Janet K. Cutler, "The Films of Red Grooms," in *Red Grooms, A Retrospective 1956–1984* (The Pennsylvania Academy of the Fine Arts, 1985), 19–21.

23. Recounted by the artist in conversation with Laura Vookles, Dec. 4, 2018.

24. Hudson River Museum Press Release on James Hendricks' "Lunar Paintings" and "Moon Room," displayed with *To the Moon: the Last 10 Years*, 1970. Collection files, Hudson River Museum.

25. Wayne Andersen, "James Hendricks in the Space of Time," http://www.jameshendricksart.com/writing.html, Accessed Nov. 11, 2018.

26. Andersen, "James Hendricks in the Space of Time."

27. Jack Cowart interviewed in Julia Felsenthal, "Artsplainer: Roy Lichtenstein and the Sea in East Hampton," Vogue.com, Aug. 3, 2015, https://www.vogue.com/article/roy–lichtenstein–between–sea–and–sky (accessed Sep. 9, 2018).

28. Dorothy Norman, ed., *The Selected Writings of John Marin* (New York: Pellegrini & Cudahy), 26–27.

29. "The Academy Exhibition," *The Art Journal for 1877* (New York: D. Appleton & Company, 1877), 158.

30. Essay posted by Hirschl & Adler Galleries on the website incollect. Accessed Oct. 28, 2018. https://www.incollect.com/listings/fine-art/paintings/samuel-finley-breese-morse-diana-at-the-fountain-256723.

31. "Fine Arts. Prize Fund Exhibition at the American Art Galleries," *New York Herald*, Apr. 18, 1885.

32. Charles, D. Abbott, Howard Pyle: A Chronicle (New York: Harper & Brothers, 1925).

33. "The Spectator" in *St. Nicholas* (May 1915. v. XLII), 271.

34. "The Note-Book," *The Art Amateur: Devoted to Art in the Household* (New York and London, Jun. 1898), 2

35. "The Sylph in the Laurel Tree," *Russell's Magazine* (Charleston: Walker, Evans & Co., Mar. 1860), 505–506.

36. Norman Rockwell, as told to Thomas Rockwell, "My adventures as an Illustrator," *Saturday Evening Post* (Feb. 13, 1960), 112.

37. "Norman Rockwell Museum Received Gift of Beloved Norman Rockwell Painting," Feb. 13, 2015 press release on Norman Rockwell Museum website, affirms the title as *Boy and Girl Gazing at the Moon (Puppy Love)* https://www.nrm.org/2015/03/norman-rockwell-museum-receives-gift-of-beloved-norman-rockwell-painting/ accessed Dec. 1, 2018. The Saturday Evening Post online archive calls the painting *Little Spooners or Sunset* https://www.saturdayeveningpost.com/artworks/?artwork-artist=norman-rockwell&artwork-year=1926&artwork-theme= accessed Dec. 1, 2018. *Sunset* is unlikely to be the artist's original conception, because a sunset is too bright to behold until the sun is below the horizon.

38. "Monday Evening Discussion Group paper delivered Monday, Mar. 24, 1969," handwritten notes by Norman Rockwell made to prepare for a talk at the Monday Evening Club in Pittsfield, Massachusetts (he was a member). Norman Rockwell Museum Archives.

39. "Monday Evening Discussion Group paper delivered Monday, Mar. 24, 1969." Norman Rockwell Museum Archives.

40. Norman Rockwell Museum blogpost accessed Oct. 28, 2018. https://www.nrm.org/2012/08/man-on-the-moon/.

41. Edward Steichen, *A Life in Photography: Edward Steichen* (Garden City, NY: Doubleday & Company, 1963), unpaginated.

42. *Academy Notes*, v. IV, n. 2 (Buffalo, NY, 1908); Elizabeth Johns, Sarah Cantor, *One Hundred Stories: Highlights from the Washington County Museum of Fine Arts* (Hagerstown, MD: Washington County Museum of Fine Arts, 2008), 172.

43. *Eclipse Over the Old Bakery* (1939) and *Eclipse of the Moon (Two Lights)* (1965), both also lunar eclipses, were exhibited at The Montclair Art Museum in 1993. *Hans Weingaertner: A Retrospective* (The Montclair Art Museum, Montclair, New Jersey, Jan. 31–Apr. 4, 1993). Essay by guest curator, Elaine Evans Dee. A 1969 painting, *Eclipse of the Sun over Buildings*, was selling on eBay as of Oct. 14, 2018.

44. Scholarly essay on the painting prepared by Hirschl & Adler Galleries.

45. *The New York Times*, Nov. 8, 1938.

46. Paul Spencer-Longhurst, *Moonrise Over Europe: JC Dahl and Romantic Landscape* (London: Philip Wilson Publishers, 2006), 46.

47. *Qtd* in Betsy Fahlman, *John Ferguson Weir; the Labor of Art* (Newark: University of Delaware Press, 1997), 54.

48. Scott L. Montgomery, *The Moon and the Western Imagination*, 2nd ed. (University of Arizona Press, 2001), 114–19.

49. "Catalogue Note" for sale of this painting at Sotheby's, American Paintings, Drawings and Sculpture, Dec. 3, 2009. Ecatalogue accessed Aug. 26, 2018.

50. Unpublished research notes from the Palmer Museum of Art at Pennsylvania State University. Collected and documented by graduate assistant Kristina Wilson in 2012.

INDEX OF ARTISTS

CHECKLIST OF THE EXHIBITION

1
Gertrude Abercrombie
Woman under the Moon, 1946
Thomas Joseph Mansor;
Treadway Gallery, Inc.
Hudson River Museum only

2
George Copeland Ault
Silver Moonlight, 1918
Bernard Goldberg Fine Arts, LLC

3
George Copeland Ault
Old House, New Moon, 1943
Yale University Art Gallery

4
Edward Bannister
Moonlight Marine, 1885
Virginia Museum of Fine Arts

5
Xavier J. Barile
42nd Street Nocturne, 1953
Smithsonian American Art Museum

6
Susie M. Barstow
Night in the Woods, ca. 1890–91
Robin Gosnell

7
Albert Bierstadt
The Burning Ship, ca. 1865
Hudson River Museum

8
Albert Bierstadt
Western Landscape — Deer Wading,
ca. 1870s
David and Laura Grey

9
Ralph Albert Blakelock
Moonlight on the Columbia River,
ca. 1885
Eileen Farbman

10
Ralph Albert Blakelock
Nymphs in Moonlight, n.d.
Private collection

11
Oscar Florianus Bluemner
Ascension, 1927
Pennsylvania Academy
of the Fine Arts
Michener Art Museum only

12
Oscar Florianus Bluemner
Moon Radiance, 1927
Karen & Kevin Kennedy

13
George Henry Bogert
Untitled Moonscape, n.d.
Hudson River Museum

14
Charles Burchfield
Moon and Queen Anne's Lace,
1960
Private collection

15
Howard Russell Butler
The Moon and Venus at Sunset,
ca. 1923
Hudson River Museum

16
Howard Russell Butler
Solar Eclipse, ca. 1923
Staten Island Museum

17
Thomas Chambers
Storm Tossed Frigate, 1845
National Gallery of Art

18
Thomas Chambers
Old Sleepy Hollow Church, ca. 1850
Flint Institute of Arts

19
Frederic Edwin Church
**Hudson River with Factory
by Moonlight**, 1844–45
Cooper Hewitt,
Smithsonian Design Museum
Hudson River Museum only

20
Frederic Edwin Church
Moonrise (also known as
The Rising Moon), 1865
Olana State Historic Site

21
Thomas Cole
Autumn Eve at Vallombrosa, n.d.
The Frances Lehman Loeb Art Center
at Vassar College

22
Thomas Cole
Landscape (Moonlight), ca. 1833–34
The New-York Historical Society

23
Joseph Cornell
Portrait of Emily Bronte, ca. 1962
Hudson River Museum

24
Jasper Francis Cropsey
Mediterranean Sea Coast, 1855
Newington-Cropsey Foundation

25
Jasper Francis Cropsey
Castle Garden, New York, 1859
The New-York Historical Society

26
E. E. (Edward Estlin) Cummings
Pale Moon, 1939
Ken Lopez Bookseller

27
Maurits Frederik Hendrik de Haas
New York City by Moonlight, n.d.
Robert Grey

28
Louis Paul Dessar
Moonrise, 1904
Hudson River Museum

29
Arthur Dove
Moon, 1935
National Gallery of Art

30
Arthur Wesley Dow
Marsh Creek, ca. 1914
Hirschl & Adler Galleries

31
Arthur Wesley Dow
Moon Caught in Tree, ca. 1910
Associated Artists, LLC

32
Sanford Robinson Gifford
The Column of St. Mark, Venice, Moonlight, 1870
Family of the artist

33
Frank Russell Green
The Coming of Night, ca. 1904–08
Hudson River Museum

34
Red Grooms
Shoot the Moon, 1961
Collection of the artist

35
Birge Harrison
The Hidden Moon, ca. 1907
National Academy Museum

36
Childe Hassam
Isle of Shoals, 1890
Fitchburg Art Museum

37
Childe Hassam
On the Balcony, 1888
Adelson Galleries

38
James Hendricks
Moon Sites, 1969
Hudson River Museum

39
Harry L. Hoffman
The Harvest Moon Walk, ca. 1912
Florence Griswold Museum

40
Winslow Homer
Moonlight, 1874
The Arkell Museum at Canajoharie

41
John O'Brien Inman
Moonlight Skating, Central Park, the Terrace and Lake, 1878
Museum of the City of New York

42
George Inness
Winter Moonlight (Christmas Eve), 1866
Montclair Art Museum

43
George Inness
Spirit of the Night, 1891
Williams College Museum of Art

44
Roy Lichtenstein
Moonscape, from **11 Pop Artists**, 1965
Palmer Museum of Art

45
John Marin
Full Moon over the City No. 2, 1949
Norma Marin

46
Louis Remy Mignot
The Harvest Moon, 1860
The New-York Historical Society

47
Edward Moran
Ships in Moonlight, ca. 1890
Private collection

48
Samuel Finley Breese Morse
Diana at the Fountain, 1813
Hirschl & Adler Galleries

49
William Edward Norton
Boston Harbour by Moonlight, ca. 1885
Private collection

50
Howard Pyle
The Mermaid, 1910
Delaware Art Museum

51
Robert Lewis Reid
Moonrise, ca. 1897
The Lambs Foundation, New York

52
Norman Rockwell
**Boy and Girl Gazing at the Moon
(Puppy Love),** 1926
Norman Rockwell Museum

53
Norman Rockwell
**Man on the Moon (United States
Space Ship on the Moon)—Study,**
1966
American Illustrators Gallery
Hudson River Museum only

54
Norman Rockwell
**Study for The Final Impossibility:
Man's Tracks on the Moon,** 1969
Norman Rockwell Museum

55
Norman Rockwell
**Study for The Final Impossibility:
Man's Tracks on the Moon,** 1969
Norman Rockwell Museum

56
Warren W. Sheppard
The City of Paris, ca. 1892
Post Road Gallery

57
Edward Steichen
The Yellow Moon, 1909
Washington County Museum
of Fine Arts

58
Henry Ossawa Tanner
The Good Shepherd, 1902
Zimmerli Art Museum at Rutgers
University

59
Elihu Vedder
Luna, Christmas, 1882
Gill & Lagodich Gallery

60
Hans Weingaertner
Small Eclipse, 1938
Hirschl & Adler Galleries

61
John Ferguson Weir
Christmas Bell, 1866
The Butler Institute of American Art

62
Jamie Wyeth
**Apollo XI — To the Moon, July 16,
1969,** 1969/2009
Adelson Galleries

63
Jamie Wyeth
Moon Landing, July 1969
Adelson Galleries

64
Marguerite Thompson Zorach
Figure in Moonlight, 1916
Palmer Museum of Art

*Full credits in Catalog section